OIL PAINTING
Develop Your Natural Ability

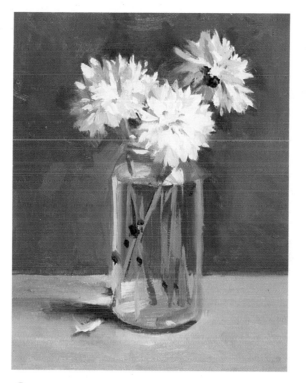

CARNATIONS
12" × 9", oil on canvas, private collection.

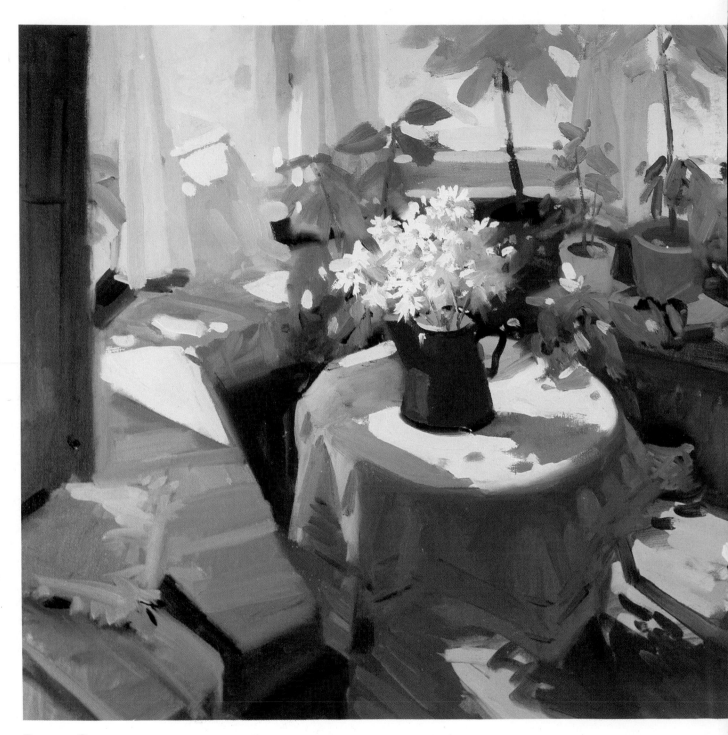

PEGGY'S CORNER
30" ×36", oil on canvas, private collection.

OIL PAINTING
Develop Your Natural Ability

■ CHARLES SOVEK ■

NORTH LIGHT BOOKS
CINCINNATI, OHIO

ACKNOWLEDGMENTS

My deepest thanks to Bonnie Silverstein, editor, friend and muse, whose definition of the word *organic* completely revolutionized my thinking. To Peggy Kerr, whose sharp eye, educated mind, caring attitude and outrageous sense of humor were indispensable. To Greg Albert for his generous availability, superb editing skills and all-around savvy of the publishing business and to Rachel Wolf for equally proficient talents and also for finally coming up with a title that said it all. Both of you deserve a medal for your patience with a very nervous, expectant author. To the memory of Kimon Nicolaides for setting the standard of what a natural approach to drawing and painting is all about. To my son, Chip, my daughter, Jeannie, and my son-in-law, Eric, whose joy in life and honest pursuit of their dreams continue to provide me with inspiration. To my mother, Mrs. Estelle Webster, and my sisters, Charlene Ikonomou and Estelle Long, for their interest and support. To Steve Karakashian, who helped me keep my act together. To M.B.A. for old times' sake. To Peggy Gomrad, whose insights and encouragement proved so helpful. To Zolton Henczel, whose skill with a camera is only surpassed by his genuineness as an individual. To Burt, Annie and Ned for simply being there. And finally, to the hundreds of students from Maine to California and Alaska to Florida whom I've had the privilege of teaching, for without their inquiring minds and dedicated hearts this book would never have been conceived.

Library of Congress Cataloging in Publication Data

Sovek, Charles.
 Oil painting : develop your natural ability / Charles Sovek. — 1st ed.
 p. cm.
 Includes bibliographical references (p.).
 Includes index.
 ISBN 0-89134-360-1
 1. Painting—Technique. I. Title.
ND1500.S677 1990
751.45—dc20
 90-13411
 CIP

Edited by Greg Albert and Rachel Wolf
Designed by Cathleen Norz

DEDICATION

This one's for you, Mom, with love and affection
and
for you, P. K., for more than I can say.

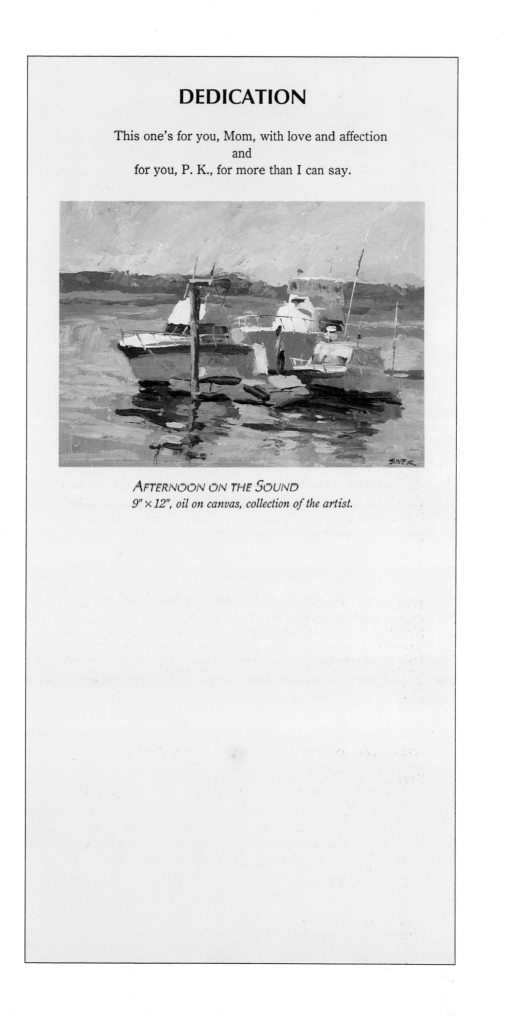

AFTERNOON ON THE SOUND
9″ × 12″, oil on canvas, collection of the artist.

CONTENTS

AUTUMN, DOWNTOWN EAST NORWALK
12" × 12", oil on canvas, collection of the artist.

· I N T R O D U C T I O N ·

Can you remember the first time you made a mark with a paintbrush? For me, it was a chance occurrence at about age nine. I was helping my family paint our garage and I can still recall the beams of pleasure I felt when an old housepainting brush was thrust into my small hand. I immediately dipped it into a pot of inviting brown housepaint and took a few swipes at a sheet of old newspaper. Next thing I knew my fingers were pushing the brush around and trying to form the profile of an Indian in full headdress. No drawing, just shapes and masses. I was hooked!

I like to think most painters share similar moments of nostalgia. For a lot of artists, however, their first contact with a brush is a fuzzy image, overshadowed by their first encounter drawing lines with a pencil or crayon.

While this seems to imply separate interests, painting and drawing are really two sides of the same coin. Some people feel more natural defining contours with a line. Others are more comfortable using tones. The common denominator here is that both groups are interested in making expressive marks on a surface. Many students I've worked with draw reasonably well and would like to venture into painting but hesitate because the seeming unpredictability of tones and colors is so contrary to their secure world of lines, where success and failure are more easily measured. The linear limitations of drawing give some artists the freedom to express themselves without inhibition. For others, however, these same limitations tend to bridle their creative spirit and act more as an obstacle to more painterly forms of expressions.

As artists living in a high-tech society, the aesthetic cards of creativity are becoming increasingly stacked against us. We're bombarded by printed words, numbers, signs, written directions, readouts and the myriads of other linear symbols our computerized way of life imposes upon us. In most occupations—even pastimes—facts and figures predominate. The gross national product, market-basket tallies and tax returns, not to mention football statistics and miles run and cycled in exact distances and times, keep us and our computers, calculators and stop-watches ever alert and occupied. All of our efforts seem to demand hard-boiled, tangible results.

Painting, on the other hand, asks for no such clear-cut conclusions. Here, the world of intangibles predominates. The language includes such carefree words as "atmosphere," "mood" and "why not?" A building can be brushed in lopsided and drip with gaudy color and yet be aesthetically pleasing. Paradoxically, a perfectly shaped and accurately rendered structure may appear all wrong. The accidental merging of colors is just as valid as preconceived mixtures. Spontaneity replaces predictability and all's well that ends well.

I believe everyone has a latent interest or desire to paint. Tonal imagery surrounds us on all sides and is an important part of our non-verbal language. When a friend appears from around a distant corner, for example, it's the shape, color and gesture that enable us to recognize him. Movies, television and the theater intrigue and entertain us. Again, the imagery is tonal and full of rich orchestrations of colors, shapes and textures—all of which could just as easily describe the surface of a painting. Who isn't stirred, while seated in a darkened theater, at the remarkable visual artistry that many of today's films attain? Scene after scene rich in atmosphere and everchanging mood, made exquisitely lifelike through the camera magic of sensitive cinematographers, attest to our love of a painterly form of communication.

The language of art belongs to us all, either as practitioners or connoisseurs. Like any other skill, painting demands interest, concentration and plenty of hard work. But I firmly believe its mastery is within the reach of anyone willing to risk simply being himself or herself.

A major source of inspiration for this volume came from Kimon Nicolaides' remarkable treasure of drawing lessons entitled *The Natural Way to Draw*. After reading this classic years ago and faithfully completing each of the exercises, I found myself returning to it time and time again to improve my skills. I then started to conjure up parallel exercises on painting, trying to instill the problems with the same stress on fundamentals as Nicolaides, and soon began incorporating them into my classroom and workshop assignments. This book is a result of those efforts.

I'm excited about painting and want to share my love of the art with you. My deepest wish for everyone who reads this book is that you will be able to pick up a brush and know that you're holding in your hand a powerful means of personal expression. If I can contribute in some small way to that end, this book will have been well worth the effort of writing.

Charles Sovek

EAST 63RD STREET
16" ×20", oil on canvas, private collection.

How to Use This Book

There are a number of ways this book can be used. While designed primarily to fill the need of a textbook, complete with lesson plans, exercises and a selection of time schedules to follow, the book can also be treated as a reference guide, enabling you to isolate the solution to a particular problem you may have. If you already know as much, or more, than I've written about, the book can serve as a refresher course, reacquainting you with the rich diversities of various principles, procedures and techniques. Or maybe you never picked up a brush before and simply need a nudge in the right direction. I like to think this book can also be used as an inspiration to artists caught in a rut who feel the need to freshen up their repertoire. Whatever your needs, the material is organized so you can choose either to browse, gleaning ideas from chapters at random, or to carefully work your way through the text, project by project, completing each of the lesson plans as you go along.

While in some ways similar to Nicolaides' *The Natural Way to Draw*, this book isn't meant to be a sequel but rather a complement to *The Natural Way to Draw* in that it gives a solid, well-rounded program upon which the student can build a mature and expressive painting style.

A Word About the Subject Matter

This book deals with essentially realistic subject matter. This isn't meant to discount nonrepresentational art but instead to use the common denominator of representational painting as a springboard from which a student may launch himself into whatever manner of painting comes most naturally. While my particular style of painting represents only one of the numerous schools of painting currently in fashion, I feel the principles involved are applicable to any style or mode of execution.

Working Conditions

If you don't have access to a classroom or outside studio, provide yourself with as ideal a work-at-home atmosphere as possible. Time spent painting should be of the highest quality, and a few preliminary arrangements can turn even the most confining space into a suitable place to paint. Your studio, no matter how small, should be well lit, either from a window—if you paint during the day—or from an overhead fluorescent light if you work at night. Paints, brushes and other supplies should be within easy reach. A sturdy easel or drawing table is important. Some painters are naturally neat and tidy, others carefree, and still others downright sloppy. Whatever your style, be yourself and let your studio evolve into an arrangement that makes the most conducive atmosphere for working. Eventually, the ambience of your studio alone should put you in the mood to paint.

A feeling for your materials will also evolve. Manipulating your brushes, for example, will change from the tentative handling of new tools to the familiar intimacy one associates with something personal.

Interruptions can be a hindrance. One way I protect the quality of my working hours is to use a telephone answering machine to take my calls. If you have small children, the investment of a babysitter or the recruitment of a spouse or older child to watch the kids for a few hours can be of enormous help. Street noise or loud stereos can be blocked out with earplugs or a radio or tape headset.

The best situation is to meet with other artists at a regular time each week, making a serious commitment not to miss unless absolutely necessary. The stimulation of painting with other people can also provide a collective energy difficult to duplicate when working alone. Getting together with a friend or group to do the lessons in this book also means you can model for each other, not to mention share ideas and critique one another's work.

Materials

Like any other worthwhile effort, the quality of your materials plays a big part in determining your success as a painter. Professional rather than student-grade paints and brushes are a must. Winsor & Newton, Grumbacher, Rembrandt, Robert Simmons, Liquitex and Shiva, among others, all produce high-quality art supplies. While the price may be higher than some of the lesser known "super savers," the superiority of the product is well worth the added expense. If you don't have an art store nearby, a list of mail-order suppliers can easily be found in the classified section of many art magazines.

The following list includes all the materials needed for any of the projects described in this book. However, this is not meant to be a volume about particular techniques but a working program to help develop your skills and expressiveness as an artist. While I've limited the demonstrations to oil, any of the exercises can just as easily be executed in other opaque mediums such as acrylics, gouache and pastel or even combinations of mixed media. If you need some basic facts about materials and methods, I recommend my previous book, *Catching Light in Your Paintings* (North Light Books, 1984), in which I carefully explain and demonstrate all the various mediums.

Of all the paraphernalia needed to paint a picture, the most crucial is your selection of paint and brushes. By developing a working knowledge of these tools, the quality of your craft as well as your expressiveness improve. As soon as you become familiar with the materials suggested here, begin experimenting with colors not found on the list. Also become knowledgeable about the ingredients of a color by reading the label on the tube. This may prompt you to do some brand switching because the makeup of tube colors can vary from one manufacturer to another. Brushes vary also. Your selection can run the gamut from square, short tips to long-tipped, oval-edged filberts, egberts, rounds, riggers and even three-foot-long mural versions. Brushes also vary in composition. Oil brushes can range from bristle to sable, fitch to nylon. Many oil painters like to trim the splayed hair from each

side of an old bristle brush. The result is a perfectly serviceable rigger useful for painting telephone pole wires or ship masts. Palette and painting knives also come in a wide range of shapes and sizes. As your knowledge grows, so will your stock of materials and your sensitivity to colors and brushes which, in turn, can't help but contribute to the quality of your painting.

The following is a list of suggested colors. They don't all have to be purchased right away. The first six exercises, for example, require only white and either burnt umber, Payne's gray or black. From the second chapter on, however, you'll get the most out of the exercises if you have as many of the colors as you can afford.

OIL COLORS

cobalt violet	Thalo red rose
alizarin crimson	brown madder
cadmium red light	cadmium orange
cadmium yellow medium	cadmium yellow light
	yellow ochre
cadmium yellow pale	raw sienna
Naples yellow	burnt umber
burnt sienna	sap green
permanent green light	Thalo blue
Thalo or viridian green	cobalt blue
cerulean blue	Payne's gray
ultramarine blue	white (large tube)
black	

Brushes

You need at least a dozen flat, bright or filbert bristles in sizes 1 through 12 (I use two of each of the even sizes nos. 2, 4, 6, 8, 10 and 12). A no. 5, 6 or 7 square sable softens edges and does detail work. Buy a small no. 2 or 3 square or round rigger for small accents and highlight unobtainable with any of the other brushes.

BRUSH WASHER — A brush washer is a mandatory item for keeping your brushes clean between strokes. Silicoil makes a jar with a coiled wire at the bottom especially made for cleaning oil painting brushes. I buy the jar and *not* the can of cleaning fluid that's sold with it. Turpentine or paint thinner will do the job just as well and at a fraction of the cost. After a day's painting I clean my brushes one last time by first swishing them out in the abovementioned jar and then thoroughly wiping them clean with my fingers using Ivory soap and warm water, making sure there's no excess paint left in the brush. You could also make your own brush washer by using an empty peanut butter or jelly jar with a coiled-up wire coat hanger at the bottom. Either way, your oil painting equipment isn't complete without one.

BRUSH DAUBER — For a brush dauber, use a tuna or cat food can stuffed with a couple of paper towels to daub off a drippy brush before mixing up a fresh mixture of paint.

PAINTING KNIFE — Be sure to get the kind of painting knife with an inverted handle. They're much easier to manipulate than a flat palette knife.

Painting Surfaces

Stretched or unstretched primed cotton or linen canvas, canvas board or ⅛″ Masonite (covered with two coats of gesso, one horizontal and one vertical) can all make a suitable surface for oil paint. Sizes can range from panels as small as 9″ × 12″ all the way up to 20″ × 24″ or even larger. Probably the best all-around size for the exercises is anywhere from 11″ × 14″ to 16″ × 20″.

Palette

Plate glass with a piece of white paper or cardboard beneath is ideal for studio work but impractical for travel and location painting because of its weight and fragile surface. White Plexiglas, on the other hand, is suitable for both purposes. Ideally, you should have both, with Plexiglas cut to fit your painting box for field work and the larger plate-glass palette on your taboret for studio work. White or gray paper tear-off palettes are fine in a pinch but tend to deteriorate after repeated brushing. If you do choose a paper palette, use two of them, a larger one for holding the colors squeezed from the paint tubes and a second, smaller one, placed on top of the first and reserved for the actual mixing of paint. When the smaller mixing palette is covered, simply tear off the filled page and you instantly have a fresh surface to work on without the inconvenience of disturbing the colors on the larger palette. I personally find tan or brown natural wood palettes distracting to work on because the warm color and deep tone hamper my judgment in mixing colors and values objectively (especially when working on a white canvas). If you're used to working on a wooden palette, however, don't change your preference unless you want to.

RAZOR BLADE SCRAPER — The hardware store variety made for scraping old paint from a building or window is particularly useful for quickly scraping wet or dry paint from your palette and providing a clean space for new mixtures.

Medium

I prefer stand oil (linseed oil cooked at a high temperature to prevent yellowing) mixed with anywhere from four to six parts turpentine. Occasionally I'll use stand oil undiluted, which permits easy overpainting on top of a wet underpainting. I'll also use undiluted turpentine for laying in a painting with thin washes or toning a canvas. Other useful mediums are Res-N-Gel (Weber), Win-Gel (Winsor & Newton) and Zec (Grumbacher); while not as flexible as the stand oil and turpentine combination, they do give

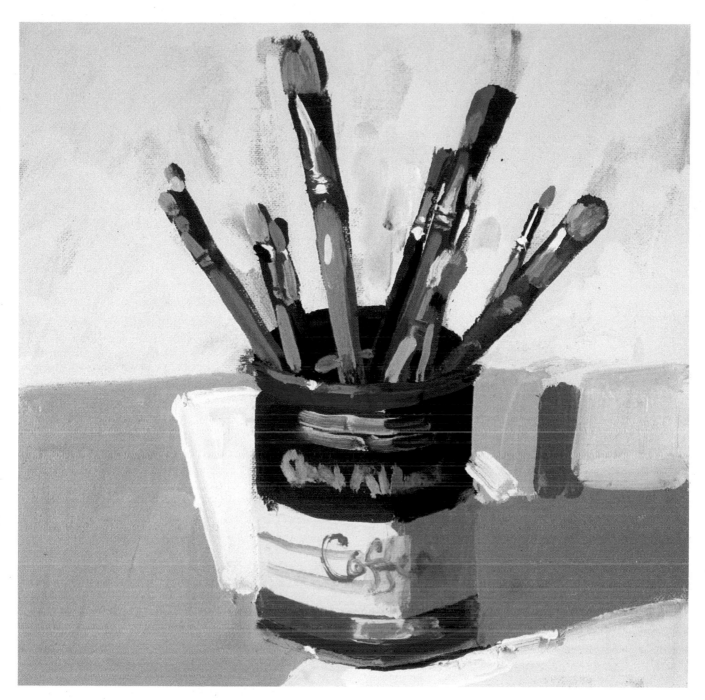

the paint a juicy quality that some painters find attractive. You'll also need some portable medium cups that can be stored in your painting box along with your paints and brushes.

TURPENTINE, PAINT THINNER — This is used for washing out brushes. Wood-distilled gum turpentine is less of a health hazard than petroleum-based paint thinner or mineral spirits. Turpentine does, however, have a definite odor you either love or hate. If the smell of turpentine is disagreeable, use odorless turpentine.

PAPER TOWELS OR RAGS — Rags are okay but tend to get saturated quickly, so unless you have a large stock available, use a high-quality paper towel (Bounty).

BRUSH CAN
12" × 12", oil on canvas, collection of Martha Rodgers, Atlanta, Georgia.
It took one two-hour session to complete this studio still life. What's particularly effective about this piece is the contrast between the nearly abstract shapes of the background and the more conventional treatment of the coffeecan and brushes. "Found" subjects such as this one can often have a freshness absent in more contrived compositions.

Location Equipment

Portability is the essence of location work. Either make an investment in a French easel (combination easel and paint box) or get a paint or tool box to hold your materials. Some artists also include a screw-on beach umbrella to attach to their easels. If you use an umbrella make sure it's white rather than the brightly colored variety which tends to influence the hues on your palette and canvas. This is also true with brightly colored clothing, so try to keep your wearing apparel grayed or more neutral.

Photographs

Whatever camera you now own is probably sufficient for gathering research. Portability should be your primary concern. You won't need a flash attachment because its glaring frontal lighting usually eliminates the very effect you're trying to capture. I prefer slides. Other painters use prints, often enlarging them to 5″ × 7″, 8″ × 10″ or even larger. Some artists prefer black-and-white pictures, feeling a tonal record activates their recollection of an effect more objectively than a color slide or print. Still others, shunning the clarity of a large format photo, favor a small Polaroid snapshot, using it like a quick sketch to help jog their memory.

Attitude

In my thirty-two years as an artist I've always tried to paint pictures that satisfied me and not a client or gallery. While there have been many painful failures, I still have a lot of fun at what I do. So right from the start, remind yourself how much you enjoy painting, and although it may seem like an uphill battle at times, don't let seriousness get the better hand of pleasure. Also try to avoid deflating inner dialogues like "I'm really a terrible artist" or "Why am I wasting my time when I know I'll fail anyway?" Approach painting as an adventure and think of the excitement of the unpredictable instead of dwelling on the fear of the unknown.

Work habits are important too. Get to know yourself and learn what times of day you function best. Are you a night or day person? Do you prefer working after dinner when the day's chores are done, or is a fresh start in the morning more stimulating? Most painting classes are run in three-hour sessions. If this isn't practical, cut the time in half and work in ninety-minute segments.

Breaks are nearly as important as painting time because they give you a chance to step back and view your work with a fresh eye. Length of work and break times vary from artist to artist. Realist painter Philip Pearlstein works for the duration of a phonograph record. If you like music, this could work well to time the model's poses or remind you when to take a rest. A more personal way of taking a break is to learn to listen to your "inner clock" which intuitively reminds you when to knock off for a while. Mine seems to go off every ninety minutes or so.

You'll also want to get into the habit of thinking about painting when you're *not* painting. Whenever you're stuck in a doctor's office or traffic jam, train yourself to use the time to analyze colors or values. Or carry a small pad and make a sketch. In painting, it seems you either go forward or backward; unfortunately, you don't stand still. This doesn't necessarily mean the more you paint the better you get. Sometimes growth is achieved by evaluation and contemplation rather than by frantically clocking up hours at the easel. Falling back does occur, however, when you cease thinking about painting altogether and stop responding aesthetically to subjects encountered in day-to-day living. I recall working with a student a few years ago who possessed great natural ability yet seemed to be in a perpetual state of frustration. One day she admitted to me that during semester breaks and vacations she put painting completely out of her mind. This resulted in her spending the session which followed her vacation catching up rather than concentrating on the more advanced problems the new course offered. By the time the next break came her abilities were about equal to what they were when she began. Realizing her dilemma, she began carrying a sketchbook in her back pocket during vacation breaks and is now, happily, fulfilling her potential. Usually growth follows a two-steps-forward one-step-backward pattern and that's where tenacity and discipline usually outdistance natural talent. The lesson is, no matter what your degree of proficiency, if you work at it, growth will occur.

Keeping a Notebook

The idea of a notebook full of paintings probably sounds a bit ludicrous. If the sizes of the pictures are reasonably uniform, however, it's a simple matter of binding the material together and backing the parcel with a sturdy piece of cardboard or Masonite. If you work 16″ × 20″ or smaller, you might consider a large, metal-ringed notebook or picture portfolio, available at stationery stores. Many of these come with clear plastic sleeves around the pages, which are ideal for holding unstretched canvases. If you like to work really big, make a bin out of a cardboard or wooden box. The only true requirement for size is that the pieces are manageable enough to carry around easily or store conveniently. It's also a good idea to put the date and the assignment on the back of each exercise. This kind of notebook helps you chart your progress. It also makes it easy to compare the quality of one lesson with another, which may prompt you to do some of the exercises over at a later date when the principles have become more clarified through practice. Then there's the luxury of having your own personal reference library of painting principles and methods to refer to when needed. The making of a painting notebook can also be inspirational. As you do the exercises you'll see your skills develop and grow. Soon you should find yourself getting caught up in the momentum of the project, looking forward to each new lesson and settling into a comfortable rhythm of work routines. Once completed, you can bask in that fine feeling

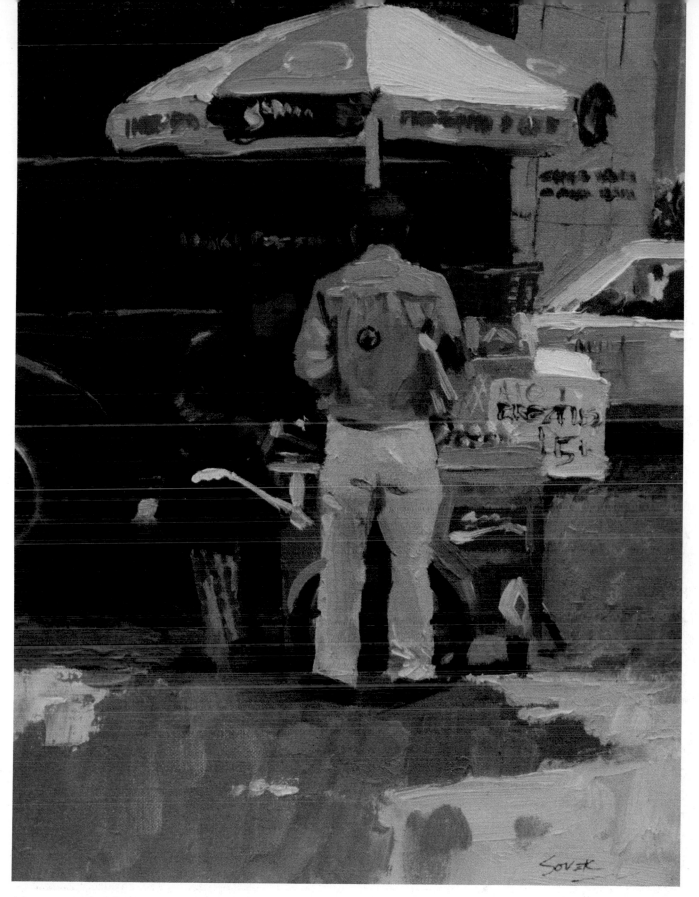

HOLD THE MUSTARD

20" × 16", oil on canvas, private collection.

This was my first in a series of paintings of New York which continues to be an ongoing pursuit. The painting breaks the composition rule of never putting anything directly in the center of a picture. The umbrella, hot dog stand and figure formed such an interesting shape, however, that I decided to disregard the axiom and featured them in a bull's-eye, front and center. This goes to prove that the only rule is there are no rules.

of accomplishment which accompanies the completion of a creative endeavor.

The Lesson Plans

Problems stimulate solutions, and I have found that most students far surpass their expectations when confronted with a challenge. So I have presented what I feel are challenging but obtainable goals. I've included demonstrations, showing how the various principles work. You'll also find a lesson plan describing the six exercises presented in each of the first five chapters, along with a suggested time schedule for each exercise. The final chapter is made up of six open projects that incorporate the material of the previous five chapters. All the exercises and accompanying demonstrations are similar to those given in my workshops and classes and will take you step by step through the fascinating avenues of tone, color and composition. The problems are carefully designed to convey the essence of the various principles featured in each chapter. The lessons can be followed to the letter or modified if the student feels better progress can be made by doing so.

No matter how you choose to follow the lesson plans, stay consistent and avoid skipping around, rushing or minimizing problems that give you trouble. Also try to discipline yourself not to stray too far from the time limit allotted for each exercise. It's easy to get carried away with a painting, lose all sense of time, and either overwork the picture or attempt to cover up unresolved solutions with elaborately finished details. Don't get discouraged if you draw a blank with some of the problems. It's the commitment that counts. If you can do all of the lessons flawlessly, you really don't need this book.

Each of the first five chapters includes a lesson plan consisting of six exercises and requires twelve hours to complete with a total of sixty hours needed to finish the entire set of thirty lessons. Three time schedules are suggested below.

20 weeks at 3 hours per week

For the very busy person who still wants to find time to paint, work times could be one three-hour evening or one three-hour day session once a week.

10 weeks at 6 hours per week

For the person who works a five-day week yet has evenings and weekends free, choose two weekday evenings, working for three hours each evening or work a full six-hour session during the weekend.

5 weeks at 12 hours per week

For the person who has free time during the day, evening and weekends, the twelve hours could be broken up into four three-hour daily sessions or various combinations such as one six-hour and two three-hour sessions each week.

Warming Up

All the exercises in this book can be done in any opaque painting medium such as oils, acrylics, pastel, gouache (opaque watercolor) or even mixed media. I've chosen oil because it best communicates my particular point of view.

Before beginning the first exercise, take some time to acquaint yourself with the various capabilities of the brush. You'll need three or four large sheets of inexpensive drawing paper or some pages from a newspaper—the want ads make a good neutral surface—a medium-sized brush and a dark color of your choice. Begin by brushing in some sketchy lines and shapes. Visualize yourself casually doodling on a telephone message pad, letting the marks go where they may. Load your brush with a dollop of fluid paint and begin sketching. Imagine the instrument in your hand as possessed with an energy all its own; your job is simply to guide it over the paper. Sketch some outline gestures of imagined objects, buildings or people.

Notice how the brush imparts a rhythm to the lines, changing tempo as different degrees of pressure are exerted. Step back occasionally and study what you've done. Observe the authority of the brush strokes and how the same sketches executed with a pencil would, by comparison, appear tentative and weak. Think of a brush as an extension of your hand, sensitive to every impulse your brain registers, betraying on paper your attitude and revealing the tentativeness, confidence or exuberance of your frame of mind while painting.

Work at a pace quick enough to outdistance self-consciousness. Hold the brush loosely between your fingers, letting your arm provide the motion. Avoid resting your hand on the surface and clutching the brush tightly between your fingers as if writing a letter. Three or four sheets of these warm-up exercises should be enough to loosen you up. Warm-ups are also a good way to relieve the tension of a particularly difficult painting problem as well as providing an effective way of getting back into the swing of things after a stretch of inactivity.

My Approach

Finally, I'd like you to have faith in my approach. At times you'll probably wonder why you're doing such and such an exercise and what it has to do with painting. Some projects may seem too technical, others too abstract or even thoughtless. But see it through. I can't guarantee to make you a great artist, but I can promise you exposure to the essentials of painting and a logical study program to understand them. The rest is up to you.

This warm-up exercise is especially important if you are a beginning artist and feel timid or awkward about the idea of applying paint to a canvas. Like a golfer taking a few practice swings or a dancer doing some preliminary stretches, warm-up sheets such as this not only relieve tension but also help focus your thoughts.

· C H A P T E R 1 ·

A FEELING FOR THE MASSES

Imagine you never held a brush in your hand before. Pick one up and study it for a few moments. Look at the shape, feel its weight, and examine the clean, structural simplicity of the design. Ponder the fact that this simple construction of wood, metal and animal hair hasn't changed all that much for many centuries, and remember that painters as diverse as Rubens, Monet and Picasso held similar tools in their hands when creating their masterpieces. It's truly a wonder when you consider the vast capabilities of a brush to impart magic to canvas or paper.

Learning and Unlearning

What is the secret in persuading this thin stick of wood and paint-filled hair to yield rich orchestrations of tone and color, evocative moods, and sparkling effects? The answer is, letting go: simply letting go of the idea that painting is difficult.

A good example of this contradiction is the ease with which most students can copy the work of another artist. In doing so, the student is not only relieved of the responsibilities of composition, color, harmony and mood, but he also is freed from the challenging emotional involvement most subjects demand. This is very revealing. It shows that although a student's powers of picture making and self-expression may be undeveloped, he usually possesses more skill than he gives himself credit for.

Between the craft of copying another artist's painting and the art of originating your own painting lies the hurdle of seeing a picture through to a satisfactory and expressive end. Without discounting the importance of craft, craft alone does not give a painting the one quality which makes it a work of art. That quality is expressiveness.

The beginning student is really in a better position than he or she suspects. The craft of painting is not as difficult as some may think and is possibly within a few months' grasp. The only hurdle remaining is personal expression. For this reason, I feel painting is first a learning process and then a letting go of what has been learned. In other words you start by acquainting yourself with the basics. You then master the various principles of tone, color, composition and technique, and finally you cast off your hard-earned knowledge—trusting it will surface when needed—to focus on the primary function of art, which is to paint how you feel about what you see. The whole process is similar to learning a new language. You start by walking around with a book in your hand stiffly repeating phrases and checking for mistakes. Once the language is mastered, however, the book is tossed aside and the words become a means of spontaneous personal communication.

The Importance of Direct Contact

We all react differently to a subject. Not only do our eyes take in the tones, colors and dimensions of a form, but we also respond with our other senses. A telephone pole is not only a brownish-gray form so many feet around and

STUDY PROGRAM
Lesson 1: A Feeling for the Masses

TIME	EXERCISE
1 hour	**1** Massing-in the shape and gesture of an object
1½ hours	**2** Defining the form of an object
1½ hours	**3** Changing the direction of light on a subject
2½ hours	**4** Indicating the various changes of home value within a subject
2½ hours	**5** Painting groups of objects
3 hours	**6** Painting an entire composition

MARY PAINTING
16" × 20", oil on Masonite, collection of the artist.

high, it's also rough to the *touch*. Flowers *smell* fresh. An apple *tastes* good. Waves *sound* like they're hitting a beach. Memory, too, influences our responses to further enrich and personalize a subject. Combined with the final ingredient of imagination, these things enrich our responses to life.

These responses become the basis for our artistic vision. It then becomes evident that thinking—in this case about the methods, principles and techniques of how to paint—can actually hamper that vision. It is for this reason we must undergo the eventual process of unlearning. Because each subject you paint reflects your own individuality, I encourage you to use real-life subjects as the basis for most of the projects in this book. In later chapters I'll show you alternate ways of making a picture employing sketches, memory and photographs as reference material. Until the basics are digested and a personal point of view is nurtured, however, your true potential will be best realized by working from life.

Drawing and Painting

This first chapter will deal with learning to form objects by working directly with a brush. Many students feel intimidated when confronted by a blank canvas or paper

with a loaded brush poised in their hand. Some of the questions I hear nervously whispered by beginning students are: "Why can't I begin with a pencil drawing?" "Should I outline everything and then fill it in?" "Don't I have to know something about proportions, perspective or anatomy before painting?" But the most often asked question is: "What if I make a mistake?" Every one of these questions is valid and will be answered in the next few pages.

The essential problem undermining most beginning efforts at drawing with a brush is the misconception that drawing is different from painting. Drawing has many definitions. The most prevalent is line, a definition drummed into us as children via linear drawing tools such as pencils or crayons and the admonition to "stay within the lines." Having been programmed to think linearly, some students are shocked to learn that a painter's approach to drawing minimizes line and relies more on shapes of color and tone.

11

MASSING-IN THE SHAPE AND GESTURE OF AN OBJECT

PREPARATION — For this first exercise you'll need a medium-sized brush, a tube of either burnt umber or Payne's gray and a canvas or canvas board. Place four or five objects on a table within easy sight of your easel or drawing board. The items don't necessarily have to relate to each other and can be as diverse as a shoe, frying pan, hat, coffee cup, apple or bottle. Choose materials that are complementary in shape, for instance, a busily patterned running shoe positioned beside a white ceramic coffee mug. Illuminate the set-up with an *indirect* source of light. An overhead fluorescent lamp is ideal. Less effective but still workable is natural light originating from either a window or skylight. Avoid using direct sunlight or any other powerful light source that casts strong shadows or splits the forms into harsh patterns of light and dark.

ASSIGNMENT — Thin a generous amount of paint with medium and daub a small mark no bigger than a penny anywhere on the canvas or paper. This breaks the tension of assaulting the formidable, untouched whiteness of the painting surface. It's surprising how many students — and a good number of professionals — can be overly timid about making their first marks on a clean canvas or fresh sheet of watercolor paper.

Beginning with whatever object in the grouping strikes your fancy, proceed to mass-in its overall shape. Start with the innermost part of the form and push the paint outward toward the edges. Avoid sketching any preliminary guidelines. Work *directly* with your brush. Use a value approximating middle gray and apply plenty of thinned pigment. Draw as you paint, trusting your sense of proportion, using the edges of the paint mass to define the outline of the object. Don't get fussy or try to get a perfectly shaped replica. Work in a relaxed manner and avoid being judgmental. Let your brush do most of the work as you simply steer it along, watching the magic of paint as it flows onto the surface and snares the shape and gesture of the object.

Work with the single, middle-gray tone, disregarding any value changes, highlights or cast shadows you may observe. Your only concern is to capture the shape and gesture of the subject. If you mistakenly paint beyond any of the form's boundaries, wipe off the area with a paper towel or tissue and restate the passage more accurately. Complete all five objects and remember you're just painting an exercise, not a masterpiece. Each sketch shouldn't take more than ten minutes to finish.

OBJECTIVE — Now step back and study what you've done. Are the proportions reasonably accurate? Is the object recognizable? If not, try a few more sketches. While this first exercise was only concerned with shape and gesture, a number of objectives have been achieved. First, a recognizable silhouette has been created. Second, massing-in has replaced the need for a preliminary drawing. Finally, a sense of substance and gesture has been conveyed.

■ *Let your brush do most of the work as you simply steer it along, watching the magic of paint as it flows onto the surface and snares the shape and gesture of the object.*

APPLICATION — While this may have seemed like a very basic exercise, think about how many art forms of the past were based on the idea of massing-in the shapes of objects. The ancient cave paintings of animals in Lascaux, France, the decorative paintings on Greek pottery, and the woodblock prints of such Oriental artists as Hokusai and Hiroshige, all reveal the graceful power inherent in the art of shapemaking. In our own century, Henri Matisse and American impressionist Maurice Prendergast are only two of the many artists who, after learning traditional painting methods, intentionally reverted back to the silhouette as a means of personal expression.

Silhouette of the subject massed in with thin washes of burnt umber.

Photograph of the subject.

This lesson will deal with lightening and darkening the tones of paint to give the subject a feeling of form and tactile solidity. When I first learned this principle in art school, my visual senses revolted because the idea seemed to contradict my usual "paint what you see" attitude. The term *tactile* really confused me. Up until then I assumed an artist simply painted what his eyesight took in. I soon discovered that visual painting is but one of many ways an artist can approach a picture. Surprisingly, painting exactly what you see is a comparatively new-found art form that originated around the time of Edouard Manet (1832-1883). An interesting footnote to that seminal period of art history during Manet's lifetime is the fact that the first known photograph was made just a few years earlier, in 1816.

Showing the form of an object tactilely means using various gradations of tone and color to guide the viewer's eye over the surface of an object. This enables the person viewing the painting to experience many of the same responses to the dimensions and volumes of the forms that the artist felt while rendering the subject. Visual painting, on the other hand, generally focuses entirely on the more two-dimensional effects of light and color.

PREPARATION—Rearrange the objects used in the last exercise or replace them with new ones. Add white to the burnt umber or Payne's gray already on your palette. Avoid being skimpy with your paint. Oils are meant to be used opaquely, so right from the start get into the habit of squeezing out plenty of pigment and applying it with the generosity of one who owns stock in the paint company!

ASSIGNMENT—Begin by brushing in a pale, flat wash to approximate the shape of the object, employing the same procedure as in Exercise One. *Use your sense of touch* rather than the visual impression of what you see. Reach out in front of you and feel one of the objects. Explore the form with your fingers, letting them explore the terrain, establishing points nearest and most distant from you. Imagine that you are a map-maker on an expedition, responsible for recording the geography of the location. Chart the ins and outs of the surface. What form feels highest? What areas go under, around and back? What parts feel deepest? Take as long as you need to become familiar with the surface characteristics of the object, re-tracing steps if need be, until the form is thoroughly clear in your mind.

Now pick up your brush and retrace your journey on the canvas. The light tone already painted will be reserved for the portions of the object closest to you. Start with the parts of the form that begin to recede, painting them and all the other receding areas of the object a slightly darker value. Keep darkening the values as you paint those forms

■ *Explore the form with your fingers, letting them navigate the terrain, establishing points nearest and most distant from your outstretched hand.*

further from you. Remember this rule: The closer a form is to you, the *lighter* the value you use to paint it; the further a form is from you, the darker the value you use. Avoid jumpy, isolated areas of tone. Think of the value progressions as water pouring over a rock, entirely enveloping the form and caressing even its most recessed cavities before moving on. Don't worry about paint handling, defining hard and soft edges or overworking things. Concentrate only on painting a tonal record of the tactile surface of the object in front of you.

OBJECTIVE—Complete all five objects in a similar manner. If done successfully, the items in your painting

will not only appear to be solid and convincing but will also appear to be illuminated by a light source positioned directly where your hand reached out to touch the objects.

Study your completed exercise and notice how each sketch takes on an almost sculptural solidity. The reason for this is not only the tactile method used to render the forms but also the disregard of any conflicting tonal changes caused by the actual light sources. Your sketches should appear to be lit by a source emanating from your outreached hand.

APPLICATION—It now becomes apparent that an object appears solid when lit with a single source of light—in this case the front. As your eyes read each tonal gradation as a change in form, a language is established which clearly shows the viewer the object's surface geography. Like a map in which the height of the mountains is indi-cated by darker browns and the depths of the sea by deeper blues, the tonal values of the forms you have painted should correspond to their relative positions in space. The lightest forms are the closest to you, and the darkest ones the furthest. As long as you keep the language of your light source consistent, the forms remain believable. One reason many paintings appear confusing and unconvincing is because more than one light source has been used and, unless these additional sources are used correctly, they can create a conflicting and contradictory "language" of tonal values in the painting.

Tactile painting is one of our oldest art forms, dating back to before the Renaissance. It's also one of painting's most enduring methods. The integrity of form, a term artists use to describe a subject when it appears convincingly solid, can result from tactile painting, and this method can be applied to any subject you choose to depict.

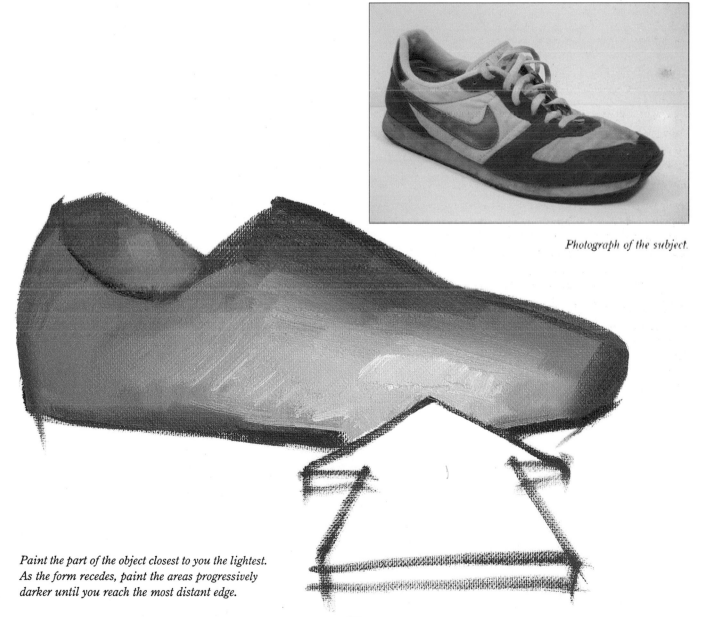

Photograph of the subject.

Paint the part of the object closest to you the lightest. As the form recedes, paint the areas progressively darker until you reach the most distant edge.

15

CHANGING THE DIRECTION OF LIGHT ON A SUBJECT

Working tactilely, as you did in the previous lesson, demonstrated how a light source is established by following the receding forms of an object with the touch of your fingers and duplicating the experience with gradated tones of paint. In this exercise, you will change the direction of the light by changing the direction from which your hand approaches and touches the object. The idea is similar to holding a flashlight in your hand and shining it at an object from different angles. With each change of position the flashlight will impart an entirely new "language" of value gradations.

PREPARATION— Rearrange your set-up or replace the items with new ones. First, mass-in a light gray tone to indicate the shape and gesture of the forms. Then choose a position either to the left or right of the object you're about to paint. You don't have to move yourself bodily from your chair but rather vary the angle and direction of your reach, approaching the object from say the left or top right.

ASSIGNMENT— Repeat the "touch and paint" method employed in the last exercise. The only difference is you're approaching the object from different angles instead of head-on. Do several of these studies and each time change your direction of approach. Explore not only right and left angles, but also high and low points of view.

After painting three or four of these exercises, it will begin to become second nature and you'll find you may not even have to touch the object to understand its structure. Your mind will become trained to visualize the tangibility of the form from whatever angle you choose, enabling you not only to render the object convincingly but also to light it from any angle you wish.

Later in the book, you'll be working from actual sources of light, but for now disregard any shadows you see because they will contradict the language of values established by your sense of touch. Remember, you're not really painting so much as learning to render the integrity of an object's form as if revealed by the varied directions of imaginary light originating from your fingertips.

■ *The idea of tactile painting is similar to holding a flashlight in your hand and shining it at an object from different angles. With each change of position the flashlight will impart an entirely new "language" of value gradations.*

Define the object by painting progressively darker values as the form moves away from the source of light.

*Begin with whichever object looks most manageable. As you work rely
on your tactile rather than visual sense of the forms.*

*Disregard cast shadows and reflected lights.
Paint only the values that describe the close-
ness or distance of the form from the light
source.*

Keep your strokes crisp and incisive.

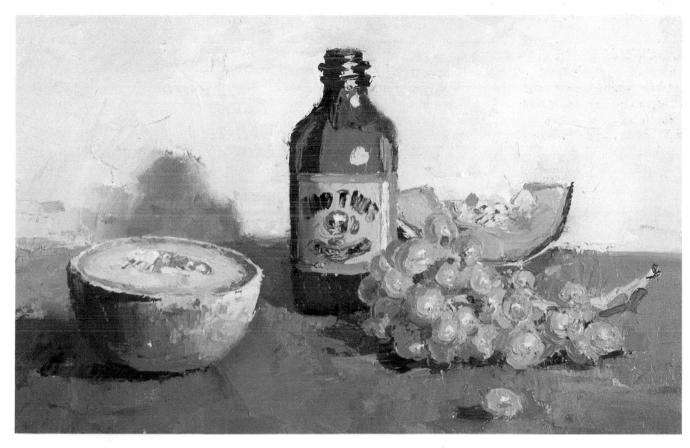

STILL LIFE WITH CANTALOUPE, GRAPES AND BOTTLE
*12″×16″, oil on canvas, collection of Marjorie Jones, McKinney, Texas.
Here's a full-color version of the same subject. The painting maintains a consistent "language" of values. Study how the painted forms
describe the volume of each object by getting progressively darker in value from right to left. Also notice the absence of any confusing cast
shadows.*

17

Until now, all of the objects you've been painting have been toned the same light to dark gray value. In this next exercise you will choose the tonal value of each item to correspond to its home value, or local color, as it's sometimes called. A white hat, for example, will still be white under any lighting condition. Likewise, a gray shirt or black shoes will also retain their home values no matter what sort of light strikes them. A white cup, for instance, would employ a middle tone as its darkest value, gradating up to white for its lightest light. A green apple with a middle home value would be painted with a light to dark gray range of tones whereas a dark piece of cloth would be limited to middle gray in light, gradating to black in shadow.

Some students ask: "Why bother wasting time with all this rigid, technical stuff when all I want to paint is a simple cup, apple and piece of cloth?" The answer is, as a painter you are working with a handicap. The range of values available in paint is far less than the range your eyes see when looking at a real-life subject. To illustrate this handicap, gaze at the light illuminating your set-up and notice how it gives off a glare, causing your eyes to squint. Now look at the white paint on your palette. See how it not only lacks the glare of the light bulb but also appears darker in value. I'll be talking more about overcoming the limitations of values in Chapter Four.

PREPARATION — For this exercise place three objects, each with a different home value, on a table in front of you under the same diffused light as in the previous exercise. Tone your entire canvas with a thin, light gray value, washed on with a turpentine-soaked rag and a small amount of pigment. Give the wash ten or fifteen minutes to dry. Next make an evenly gradated five-step value scale from white to black. Study the various home values of the objects in your still life. Allot a limited bracket of values on the scale using each bracket to designate a place for each of the various light to dark home values. You'll then be able to simplify the dozens of values it's possible to mix from black to white. This will enable you to convincingly model the form of an object, yet still keep its home value in proper relation to the different home values of the other objects in the still life.

ASSIGNMENT — Mass-in the three objects with a middle gray tone, and establish the shapes and gestures of the forms. Remember, the direction of your hand touching the form will establish your source of light. Paint the objects using the same procedure as in the previous two exercises, relying on your sense of touch rather than sight to model the forms. Apply the paint thickly, using white rather than medium or turpentine to lighten a mixture. By using the paint opaquely and employing plenty of juicy pigment into your mixtures, you'll find value control more manageable. Although opaque mixtures take longer to prepare than transparent ones, the effect is worth the effort. Take your time, reworking the paint if need be, until the proper tone is approximated.

It's less important where you begin than how you proceed. You may, for example, start with the lightest lights of the white object, darkening values as the form recedes. Then switch to the gray and black objects, progressively darkening tones to maintain their different home values.

■ *The range of values that can be produced with paint is far less than the range visible to the eye. Therefore, in order to paint what he sees, the artist must simplify the values he uses.*

APPLICATION — When I first mastered the idea of home values I can remember going on location and painting landscapes with a whole new point of view. Buildings and trees ceased being places to live in and objects to get shade under. My eyes were opened to the wonderful world of painterly seeing, and like an important building block shifting into place, I could feel my artistic capabilities heighten.

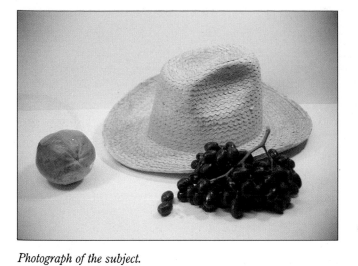

Photograph of the subject.

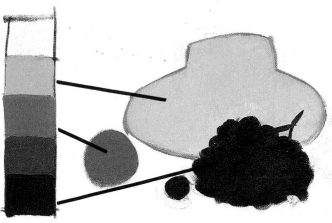

Diagram showing the home value of each of the objects.

Pale tone of burnt umber washed over canvas.

Forms modeled with thick, opaque paint.

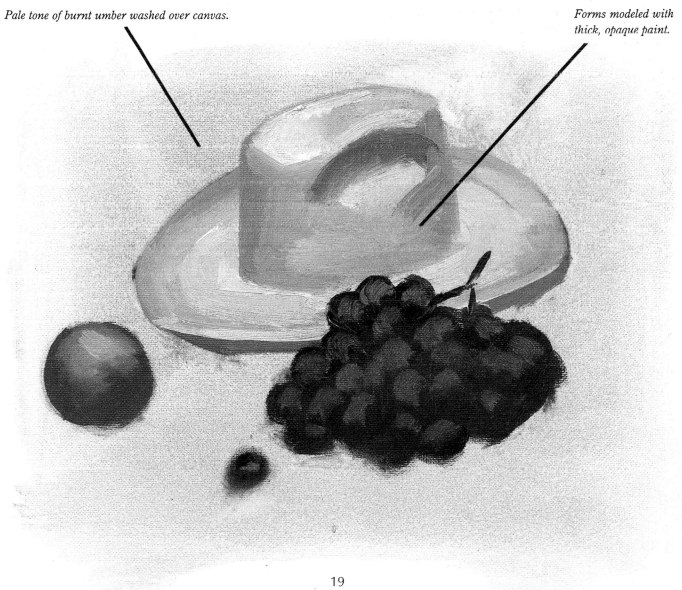

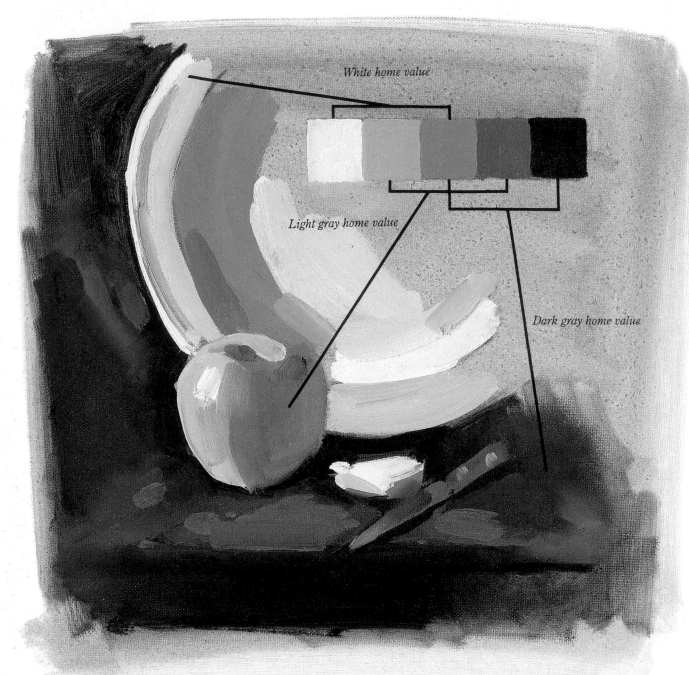

White home value

Light gray home value

Dark gray home value

USING A LIMITED VALUE RANGE TO SHOW THE HOME VALUE OF AN OBJECT.

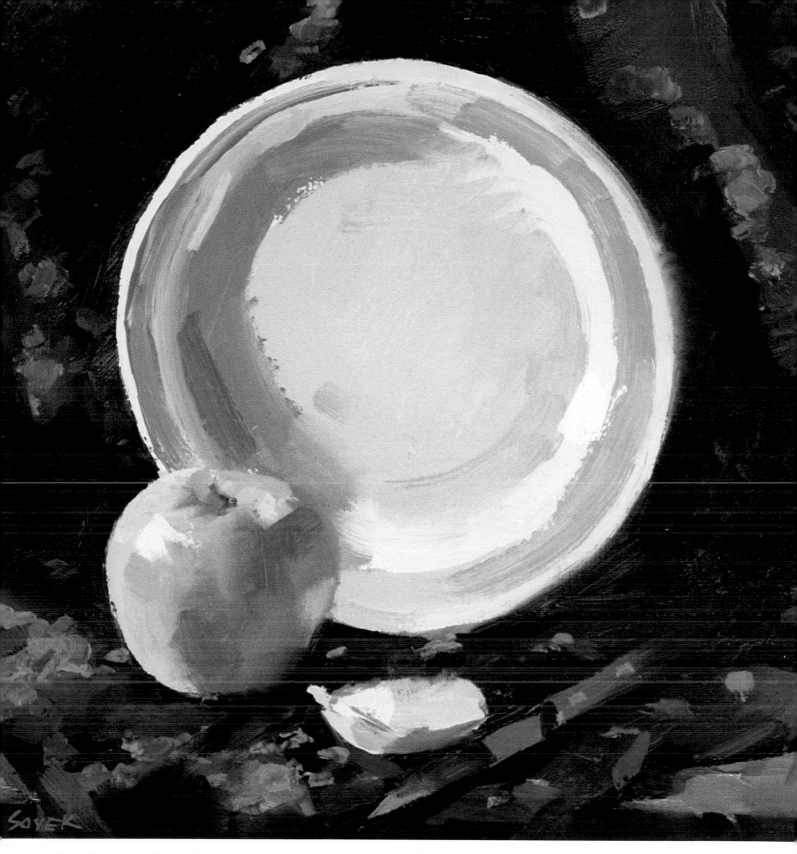

STILL LIFE WITH APPLE, PLATE AND KNIFE

9" × 9", oil on Masonite, collection of Nancy Kerr, Old Greenwich, Connecticut.

The objects in this painting present a dramatic pattern that is easy to read against the busy backdrop of the dark cloth. If the apple were red and the plate a middle brown, the result would be dull and hard to read. The lesson here is to bracket your home values accurately and choose objects that present an interesting array of shapes and patterns.

Once a mastery of shape, gesture, tactile solidity and home values is acquired, you should be more than well equipped to tackle this next, more ambitious exercise which involves the clustering of items together and painting the grouping as a unified whole. Instead of focusing on isolated objects, as in the previous lessons, your objective is to unify the various forms in your set-up into a single pictorial statement.

Getting carried away with the *parts* of a picture is a common painting error. Students and professionals alike often become engrossed in a particular object in their painting, lavishing inordinate amounts of time and loving care to render surface characteristics, only to step back and see their precious effort stick out like a Rolls Royce at a construction site. Remember, no matter how beautifully you paint an object, it remains a mere study until it is artfully incorporated into a composition. Occasionally I've seen students whose paint handling is crude, whose home values are unconvincing, and whose forms are badly proportioned, but who somehow manage to unify their paintings and end up with a stronger artistic statement than those with sophisticated skills yet no eye for the overall effect.

PREPARATION—Choose four or five objects of various shapes and sizes with different home values and arrange them in a group. Step back and study the set-up, overlapping and repositioning things until the forms appear unified. A large jug or serving tray, for example, placed beside or behind a couple of small items like a piece of fruit, a tube of paint or a can opener will give the subject scale and variety. Avoid lining up items evenly in a row like a picket fence. Overlap things, stack one object on top of another, turn a form on its side or even upside down if it makes the composition more interesting.

ASSIGNMENT—Begin painting the set-up using the same procedure as in Exercise Four, relying on touch more than sight. Try to work on all the objects simultaneously. You might start with the near edge of one form, move to the far side of another, and then jump to the middle masses of a third. Keep the background simple. Little or no background additions are needed because the canvas has already been toned a light gray.

Concentrate on getting the effect of the grouping as a *whole* rather than focusing on any one part. Think of the combination of objects in front of you as patterns on a finely crafted Oriental rug. Impart each form with a unique identity, yet make sure it contributes to the beauty of the group as a whole. Disregard any cast shadows, painting only the tones your sense of touch directs you to make. The completed painting should appear as a unified cluster of objects against a nearly neutral background.

■ *Think of the component parts of the subject in front of you as patterns on a finely crafted Oriental rug. Impart each form with a unique identity, yet make sure it contributes to the beauty of the group as a whole.*

Two painters particularly adept at artfully marrying together the objects in their paintings are Edouard Manet and Jean (Baptiste) Siméon Chardin. A study of these artists' works will show not only how interestingly a group of forms can be presented but also how individual objects can be masterfully painted yet still contribute to the integrity of the overall composition.

Whatever objects you choose to paint will appear only as a collection of parts until you compose them into an interesting arrangement.

Keep rearranging the objects until the overall shape takes on an interesting silhouette.

If you get carried away with the details, take a break and view the picture from a distance. Remember, it's the grouping as a whole that counts, not *any* one individual part.

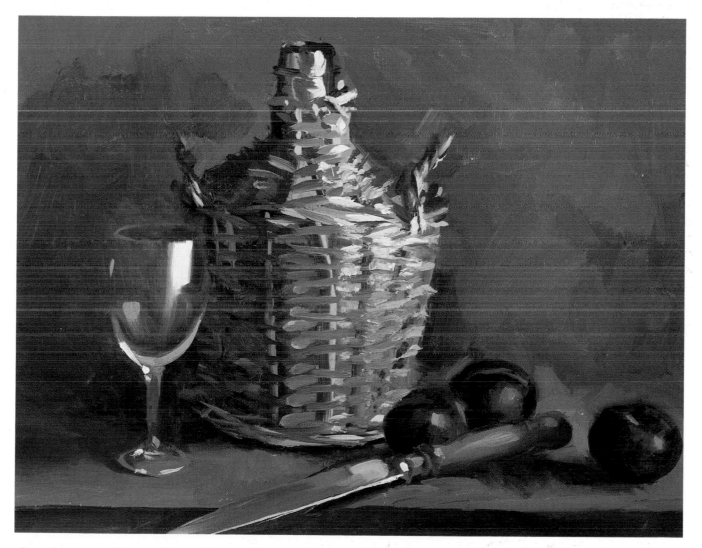

STILL LIFE WITH PLUMS, KNIFE, GLASS AND BOTTLE
12" × 16", oil on Masonite, collection of Zolton and June Henczel, Norwalk, Connecticut.

The lay-in for this work was done exactly the same way you were instructed in the exercise. I spent an hour positioning the objects until I was satisfied with the overall shape. Notice how the overlapping gives a composition interest.

PAINTING AN ENTIRE COMPOSITION

The final exercise of this chapter includes the background as part of your subject. Backgrounds tend to be the forgotten stepchild of far too many student compositions. It is easy to be so preoccupied with the more tangible qualities of the actual objects present that you treat the area surrounding the forms as an unresolved afterthought. By giving a background the same careful attention that's lavished on the objects in a painting, you'll find your picture achieves a unity that can transform an ambitious study into a far more complete artistic statement. A survey of the still-life works of such diversified artists as Edouard Vuillard, Fairfield Porter and Andrew Wyeth will reveal not only impeccable arrangements of solid forms but also backgrounds that are thoroughly integrated into the composition.

PREPARATION— For this exercise, you'll need an assortment of objects, an unpatterned piece of cloth or drapery, and an empty cardboard box into which the items will be placed. Trim off the top and two adjacent sides of the box. Secure the drape to the top edge of one of the two remaining sides, positioning the fabric down the side and across the bottom of the box. If you don't have a box, push the table your objects rested on in the previous lessons against a wall and fashion the drape in a similar position by tacking or taping it against the wall and letting it drop down and cover the table.

Ruffle the cloth a little until some interesting fold patterns break up the flat monotony of the material. The middle gray home value of the drape will provide just the right foil for showing off the lights and darks on the other various home-valued forms. Place the objects in the middle of the set-up, rearranging and overlapping them until they form a unified whole. Repeat the same painting procedure as in the two previous exercises.

ASSIGNMENT— After massing-in the shapes of the objects and a few dominant folds, begin to model and solidify the various forms. Think of your brush as a sculptor's tool incisively carving the broad planes of the subject and then

■ *Think of your brush as a sculptor's chisel incisively carving the broad planes of the subject.*

refining each item with more detail as the picture takes shape. Treat the forms of the drapery the same as the objects, using your sense of touch to show where the values lighten and darken. Reach out from either the left or right and let your fingertips describe the form's terrain which in turn will position your light source. By approaching your set-up from either side rather than the front, the play of light to dark across the forms will appear more interesting and three-dimensional. Continue painting until the objects and drapery appear convincing and the entire surface is covered.

A cardboard box trimmed of two of its sides and a piece of drapery are all that's needed to make a still-life backdrop.

A few preliminary doodles such as these can quickly reveal the best arrangement to choose from.

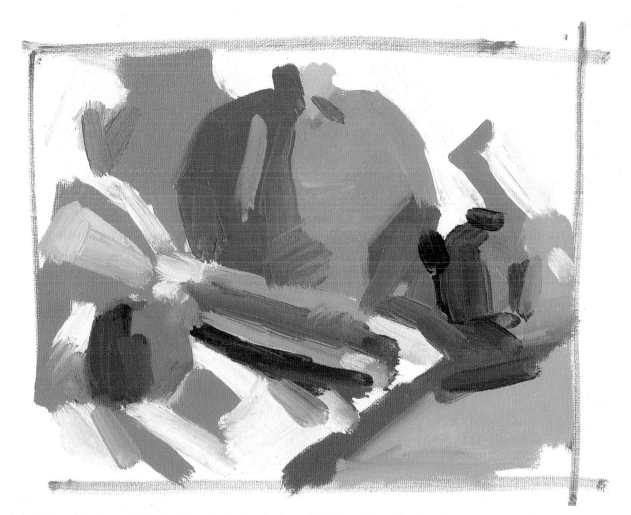

Lay in bold patterns of value until the painting begins to take shape. Working with as big a brush as you can comfortably handle, reduce the subject down to a large mosaic of shapes and values.

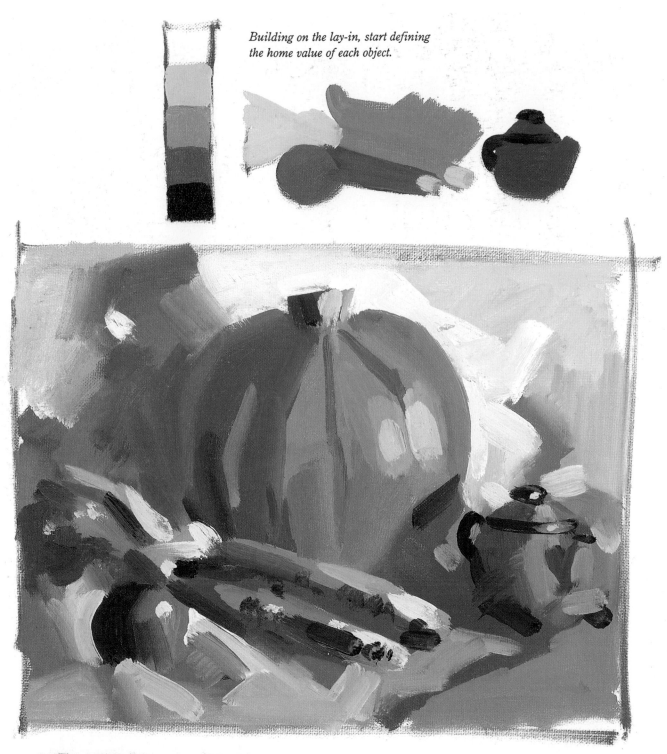

Building on the lay-in, start defining the home value of each object.

As the painting begins to take shape, start modeling each of the individual items. The painting is complete when the objects appear solid and the composition unified.

Remember, your light source will dictate how the forms are modeled.

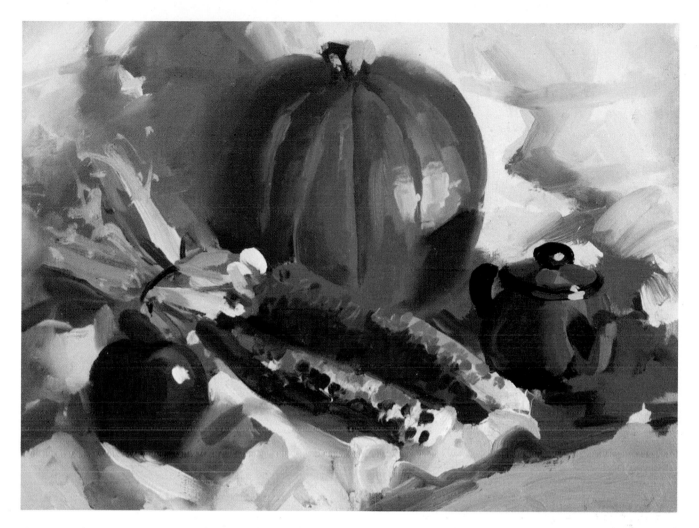

AUTUMN STILL LIFE
16" ×20", oil on canvas, collection of Armand de Grandis, Torrington, Connecticut.
A classroom demonstration that worked. Sometimes they don't! Painting an entire composition requires constant attention to the combined effect of the overall masses. What holds this busy picture together is the strong pattern of light and shadow that weaves in and out of the various forms. Notice the use of soft edges in the shadow and how they make the objects appear to melt into the background. This device helps the overall unity and defines the roundness of the forms.

REVIEWING YOUR PROGRESS

Line up all six exercises in front of you and study them to make sure you thoroughly grasp each of the principles presented. If you are working in a group, now is the time to get together with some of your classmates and constructively critique each other's work. Equally important is to congratulate yourself on finishing this first chapter, realizing that you have just solved many of the basic problems encountered by artists in still-life painting, landscape, interior and figure work as well. I'll be referring to these basic building blocks of painting again and again throughout the book so be sure each one is clear in your mind.

· C H A P T E R 2 ·

LOOKING AT THE WORLD THROUGH COLORED GLASSES

Just as you established a language of values when painting tonally, a language needs to be fashioned to enable you to get the most out of your pigments. Because it is impossible to duplicate in paint the dazzling brilliance of a pot of geraniums in full bloom or the riot of multicolored neon lights on a busy street, a suitable approach has to be formulated, taking into account the limitations of color.

Whereas tactile painting requires a great deal of intellectualizing, or left-brain thinking, color is essentially an intuitive, right-brain process. Teaching color can be likened to showing someone how to walk, talk or write. Once the basics are learned, the act becomes natural and stamped with a personal uniqueness.

Everyone agrees that the colors in a traffic light are red, green and yellow. But ask ten artists to *paint* a traffic light, and you're apt to see ten different solutions. One may use vermilion for the red, another cadmium red light, a third, alizarin crimson. The greens may range from permanent green light to Thalo green. A warm cadmium yellow medium could feel just right to one artist, whereas another may choose a cooler lemon yellow. Yet each would swear his painting was as truthful a representation as possible. So rather than attempt to impose my color taste on you, the aim of this lesson will be learning the basics and then moving on to the challenge of expressing the particular color sense each of you is gifted with.

STUDY PROGRAM Lesson 2: Looking at the World Through Colored Glasses	
TIME	**EXERCISE**
1 hour	7 Determining the home value of a color
2 hours	8 Lightening and darkening the home value of a color
2½ hours	9 Brightening or dulling the intensity of a color
2 hours	10 Identifying the temperature of a color
3 hours	11 Changing the temperature of a color
1½ hours	12 Mixing colorful grays

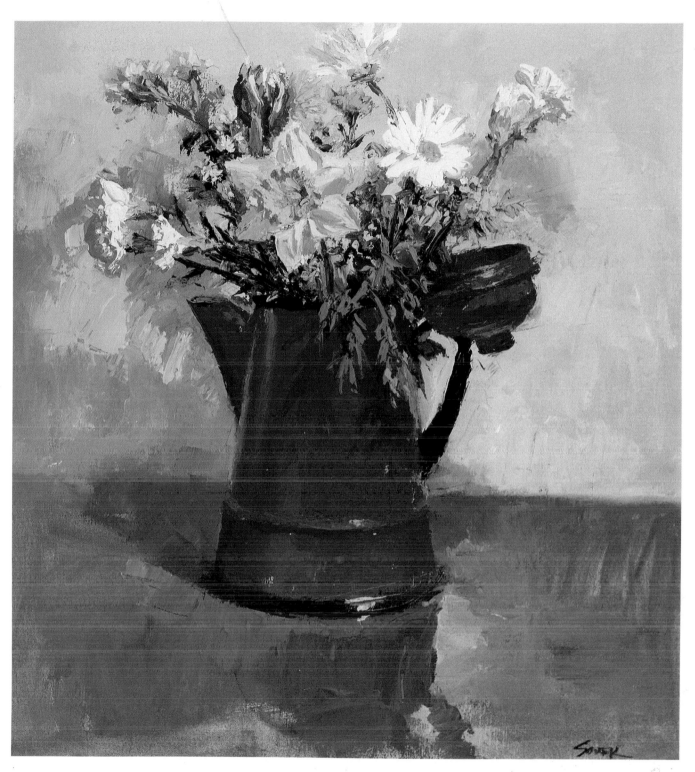

STILL LIFE WITH COFFEEPOT AND FLOWERS

24" × 20", oil on canvas, collection of the artist.
This picture was painted at night under a warm light and executed entirely with a palette knife. The wet brown base reflected the rich reds of the coffeepot and turned what was a bland piece of plywood into a colorful pictorial element. To achieve this I sprayed the setup every fifteen minutes or so with water from a plant mister. This kept the flowers from wilting during the eight hours it took to complete the picture and gave the objects a glistening sparkle of color and light.

Just as every object you observe has a particular home value, so too with colors squeezed from a paint tube. Yellow, for instance, is nearly white in value. Red and orange approximate the middle range of the tonal scale, whereas blue, green and purple tend to have dark home values. To become familiar with the various home values of your paints, you will paint a value scale consisting of five tones and use it to compare the values of each color.

PREPARATION— Begin by drawing a horizontal series of five two-inch squares at the top of your canvas. Begin painting by filling in each of the squares with a progressively lighter value. Start with black and end with white (fifth square) with three evenly gradated values in between. Keep the paint consistently opaque and remember to clean your brush thoroughly after every mixture, being careful to keep each tone free of any trace of a previously mixed value. Be sure each tone touches the next because any white space between values makes accurate judging more difficult. If in doubt about the accuracy of a value, squint your eyes and compare it with the tones above and below it. Study the contrast between each value and make sure it's consistent. Does the overall effect appear to smoothly gradate from dark to light? Is the scale free of any jumpy spots or weak contrasts? If not, repaint any problem areas until the sequence looks even.

Rather than give numbers to the different gradations, think of the tones as simply white, light gray, middle gray, dark gray and black. I prefer giving the values easily remembered names rather than still another confusing system of numbers.

You're now going to employ the complete list of colors found on page 4. When squeezing out your paint get into the habit of placing the colors in some kind of logical, prismatic order. You could start by putting cobalt violet on the edge of the near left-hand corner of your palette and working your way back through the reds, orange, the yellows, the earth colors, the greens and finally the blues. Or you might start with the yellows and progress through the earth colors, the greens, the blues, purple, the reds and orange. Whichever way you choose, keep your arrangement consistent so that, in time, dipping into your palette of colors becomes as instinctive as a practiced musician's reaching for a key on his instrument.

ASSIGNMENT— Now paint a swatch of pure pigment from each of the colors on your palette below the value on the tonal scale the color comes closest to matching. See the chart at right. If a color is halfway between two values, position it in between the two tones. Continue painting until you've placed a swatch from each of your colors under its appropriate value.

Now imagine you are looking at a black-and-white pho-

■ *Keep your arrangement of paints consistent so that, in time, dipping into your palette of colors will become as instinctive as a practiced musician's reaching for a key on his instrument.*

tograph of the completed chart. Visualize comparing such a picture with your value scale. Would the colors appear to duplicate the even gradation of tones on the scale? If not, repaint whatever colors appear false in value until the match looks accurate.

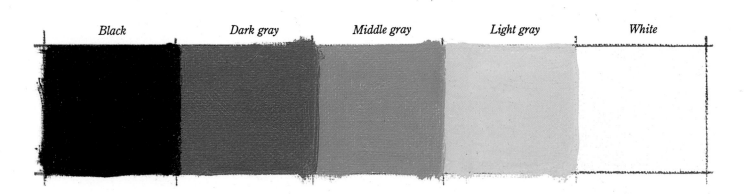

| Black | Dark gray | Middle gray | Light gray | White |

It's easier to see if your gradations are accurate if you let each value touch the next rather than leaving stripes of white canvas in between.

Identifying the Value of a Color

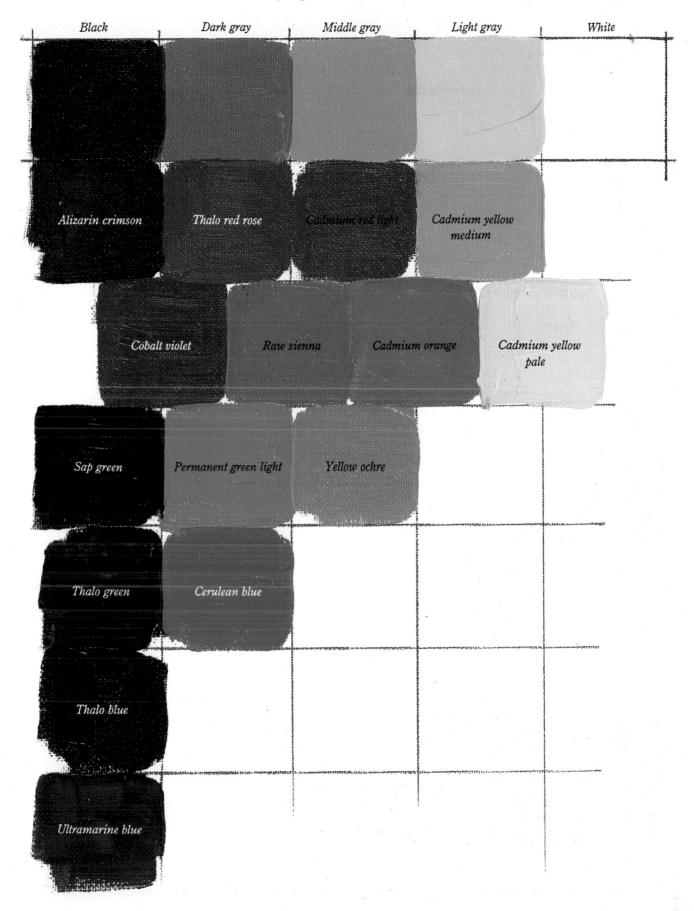

	Black	Dark gray	Middle gray	Light gray	White
	Alizarin crimson	Thalo red rose	Cadmium red light	Cadmium yellow medium	
	Cobalt violet	Raw sienna	Cadmium orange	Cadmium yellow pale	
	Sap green	Permanent green light	Yellow ochre		
	Thalo green	Cerulean blue			
	Thalo blue				
	Ultramarine blue				

Now that you know the home value of all your colors, it would seem a simple procedure to lighten or darken them. In one respect it is. All you need to do is lighten the dark ones with white and deepen the light ones with black. While there are some painters who employ this method exclusively, there are many others who avoid it for the simple reason that it's relatively easy to lighten or darken the *value* of a color with black and white but nearly impossible to retain a color's *intensity* using such mixtures. Most whites tend to cool the color they're mixed with, dissipating the original color's intensity. Black presents an even bigger challenge. Being dense and colorless, any addition of black into a mixture neutralizes the color, and the original intensity of the hue is lost. This isn't to say black and white should be banned from your palette. Manet and Velazquez were magicians when it came to using black. And without white, it would be practically impossible to paint even the simplest of pictures.

ASSIGNMENT—This exercise explores ways to lighten and darken colors of different home values. It consists of painting three sets of three identically shaped blocks that have the top and two sides visible. The first block in each set will be a light or white home value; the second will be a middle tone; and the third will be dark or near black. Set one will be painted using only black and white. Set two will use a color for each block plus white or black to lighten or darken the values. Set three will use a color for each block with the addition of other colors plus white to darken or lighten the values, using no black at all. Try to use only the five values from the scale you made in Exercise Six.

For each set, imagine light coming from the left side and falling on the top and left side of the block. The right side will be in shadow.

Set One—Using white and black only, paint the first block using pure white for the light-struck top and left side, middle gray for the shadow. Paint the second block light gray on the lighted faces and dark gray for the shadow. The third block should be middle gray for the lights and black for the shadow.

Set Two—Mix equal amounts of cadmium yellow pale and white for the light sides of the first block. For the shadowed side try to duplicate the value of the first block in set one using cadmium yellow pale with increasing amounts of black until the value reaches a middle gray. For the second block mix cadmium red light and only enough white to lighten its value to light gray; the shadow will be a dark gray made by lowering the value of cadmium red light with black. The dark block will be ultramarine

blue, lightened to a middle gray with white; the shadowed side, pure ultramarine.

Set Three—The final set of blocks will be rendered without the use of black. Begin by painting the light side of the yellow block with the same combination of cadmium yellow pale and white used in the previous set. Add just a touch of cadmium yellow medium to the mixture to balance the coolness of the white. For the shadow, add a small amount of permanent green light to yellow ochre, deepening the mixture to middle value. Green is used because it not only helps lower the value but also neutralizes some of the orange in the yellow ochre. The light side of the red block will be a mixture of cadmium red light, white and, to counteract the coolness of the white, cadmium orange. For the shadow, mix alizarin crimson with cadmium red light until the value deepens to dark gray. Finally, mix equal amounts of ultramarine with cerulean blue. Lighten the mixture to a middle value with white and paint the light side of the dark block. Because cerulean contains a bit of yellow, it's the perfect solution for balancing the cool cast of the white. For the shadow, use pure ultramarine.

The mechanics of color mixing varies with each individual and is a habit best learned from experience, so remember, while I can suggest specific colors and give tips on amounts, only practice will teach you the exact proportions needed to make a mixture work.

■ *While it's relatively easy to lighten or darken the* value *of a color with black and white, it's nearly impossible to retain a color's* intensity *using such mixtures.*

EVALUATION—Now step back and study your completed exercise. As in the previous exercise, ask yourself if a black-and-white photograph of your painting would show three identically toned sets of blocks. If not, fine-tune them until the values in the two color sets are consistent with the black-and-white group. Understanding color values is the backbone of good painting.

While not a requirement, I would like to encourage you to paint a series of blocks based on every color on your palette. You may find yourself stymied occasionally, but trial-and-error growth is what painting is all about, and the experience gained would be well worth the effort.

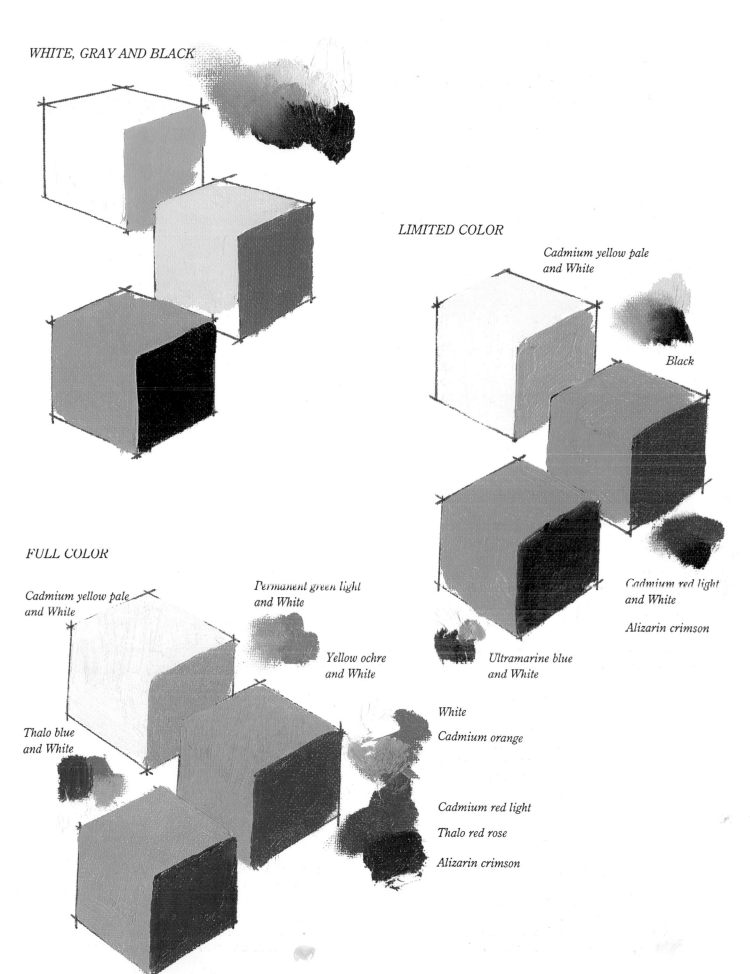

WHITE, GRAY AND BLACK

LIMITED COLOR

Cadmium yellow pale and White

Black

Cadmium red light and White

Alizarin crimson

Ultramarine blue and White

FULL COLOR

Cadmium yellow pale and White

Permanent green light and White

Yellow ochre and White

Thalo blue and White

White

Cadmium orange

Cadmium red light

Thalo red rose

Alizarin crimson

33

Armed with the knowledge of how to manipulate the value of a color, you're now going to alter its intensity. Varying a color's brightness is much akin to changing the value of a tone. The intensity of a color can range anywhere from the brilliance of a freshly squeezed dollop of red paint to the myriad of undefinable grays that barely whisper an identity. The most brilliant is called full intensity; the least brilliant is called low or dull intensity. To simplify the vast range of possible intensities inherent in any given color, think of them as belonging to one of the following three basic groups: *bright, medium* and *dull*. Some colors have a greater range of intensity than others. Cadmium red light, for example, if mixed in steps from pure hue to a barely discernible reddish gray, would include twenty or more varied progressions, whereas the weaker pigmentation of a color like viridian would be limited to a mere eight to ten steps. Don't mistake a dull color to mean a dirty or muddy color. As you'll learn in Exercise Eleven, it's impossible for a single color to appear dirty unless contrasted with other colors. With experience, you may choose to expand the three basic classifications to encompass more subtle variations. For now, however, managing such complicated variables can make painting a real chore, so keep it simple and try to bracket all your color mixtures into categories of either bright, medium or dull.

Learning to manipulate the brightness or dullness of a color is one of the cornerstones of good painting, and, when combined with a sound understanding of how to control a color's value, should raise your skills to a new plateau.

PREPARATION — This next exercise deals with observing and painting the various range of intensities found in a simple still-life arrangement. Set up four or five objects that range in intensity from bright to dull. Kitchen bric-a-brac works well for this project. The bright objects could include a red ketchup bottle or some brilliantly colored fruit or vegetables. Wooden stirring spoons, pastel colored dishes, a bread board, or perhaps a handful of nuts could be ideal for medium intensity subjects. Low intensity items could include white or neutral cans or boxes, a can opener, pasta colander, dishtowel or tablecloth.

Illuminate your set-up with a warm light. A 100 or 150-watt household light bulb is ideal. Avoid any natural source of illumination from the sun because its constant movement alters effects from hour to hour and makes interpretation of the subject confusing.

Follow the same painting procedure used in Exercise Five. Remember, you are not painting a picture but learning about color. Try to focus all your attention on categorizing each object into either bright, medium or dull. Don't forget the options learned in the last lesson. Black dulls a color but saps the mixture of vitality. Color combinations take longer but yield more exciting results. Both can be useful tools, so experiment with each—or combinations of both—and you'll soon discover which does the best job at solving a particular problem.

Lay out your entire palette for this exercise. Tone your canvas with cerulean blue or viridian to provide a cool complement for warmer colors. Try to limit each mixture to combinations of no more than two or three colors. With experience, you may choose to employ more, but for the next few projects keep it simple. Now is a good time to get into the habit of having your complete line of colors available for even the most seemingly colorless subjects. A limited palette certainly has its place in painting, but until you develop a well-rounded sense of color, stay with the full list of hues. It may seem like a waste of money to squeeze out eighteen or twenty colors when all you're going to paint is a red apple. Imagine, however, if Monet or Cezanne had decided to scrimp on paint how mediocre the resulting work might have been. So right from the start, allot a plentiful supply of every color needed.

ASSIGNMENT — Begin by massing-in large shapes with a brush. You may want to sketch in a few preliminary guidelines or simply plunge right into the big masses. Think of your lay-in as a large mosaic of simple color

■ *The intensity of a color can range anywhere from the brilliance of a freshly squeezed dollop of red paint to the myriad of undefinable grays that barely whisper an identity.*

notes. Work over the entire picture area rather than refining, developing and completing single passages one at a time. Disregard any reflected lights and focus instead on establishing the form of the objects with the same kind of tactile solidity and home value identity used in Exercises Two and Four. Continue painting until all the objects are completed.

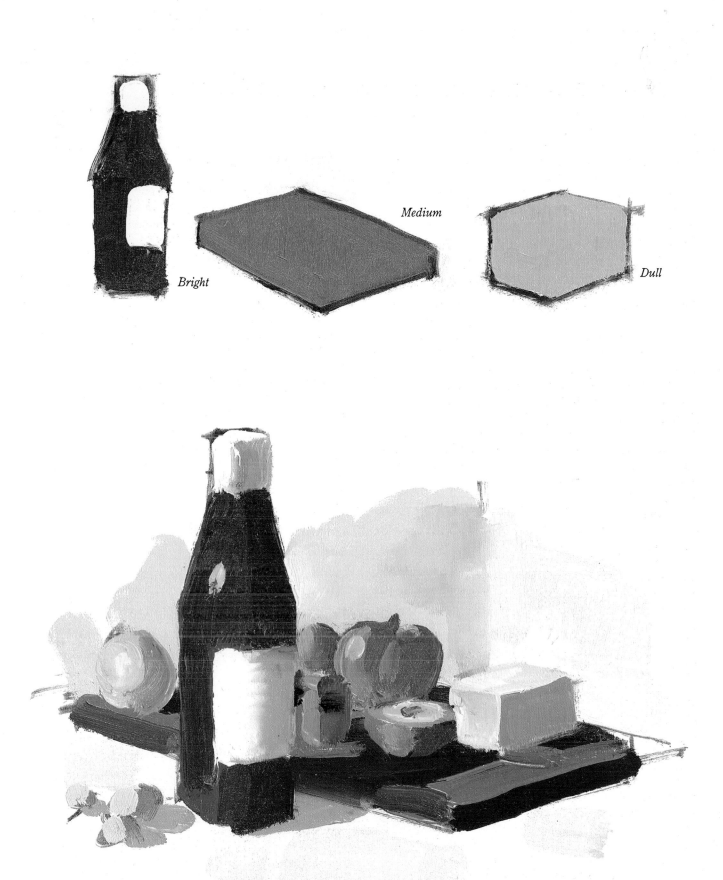

Bright

Medium

Dull

Once your eye becomes sensitive to variations in intensity, color takes on a new dimension. The challenge is to keep your approach simple and brushwork clean. It's nearly impossible to judge a color's intensity without comparing it to another, so don't hesitate to scrape off a color if it's not right. Remember, the aim of this exercise is to see and record different intensity changes, not to paint a finished picture.

COLUMBUS CIRCLE

18" × 24", oil on canvas, collection of Daphne Cochran, New Canaan, Connecticut.

I spent three days in my studio painting this picture from location sketches and photographs. Busy subjects such as this demand a simple palette and careful organization of intensity changes or else the unrelated parts will undermine the composition as a whole. Working on a thin underpainting of raw sienna, I used a limited palette made up of alizarin crimson, cadmium red light, cadmium yellow pale and Thalo blue. All the greens were made from mixtures of blue and yellow. The blacks were mixed from various combinations of Thalo blue and alizarin crimson. The subject also required a tight organization of light and shadow masses. Observe how the vendor and surrounding figures are essentially dark shapes against a light background, with the other elements of the composition subordinated to this important passage.

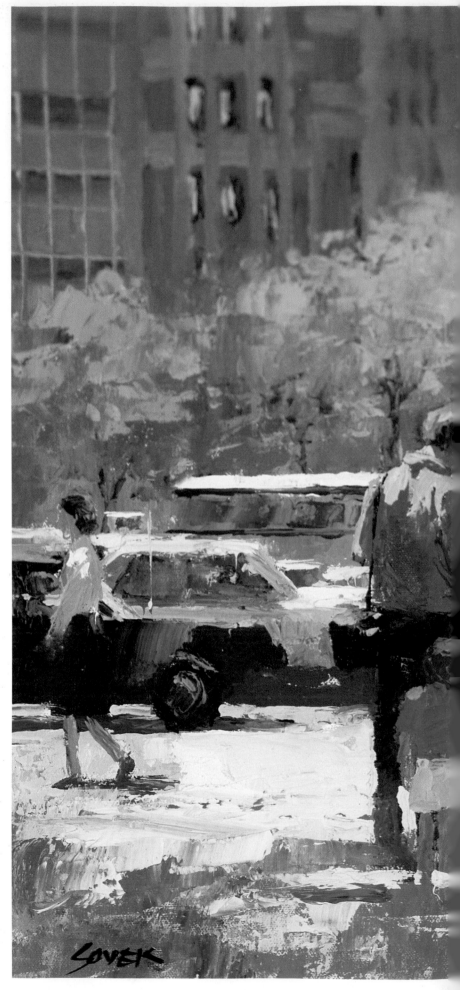

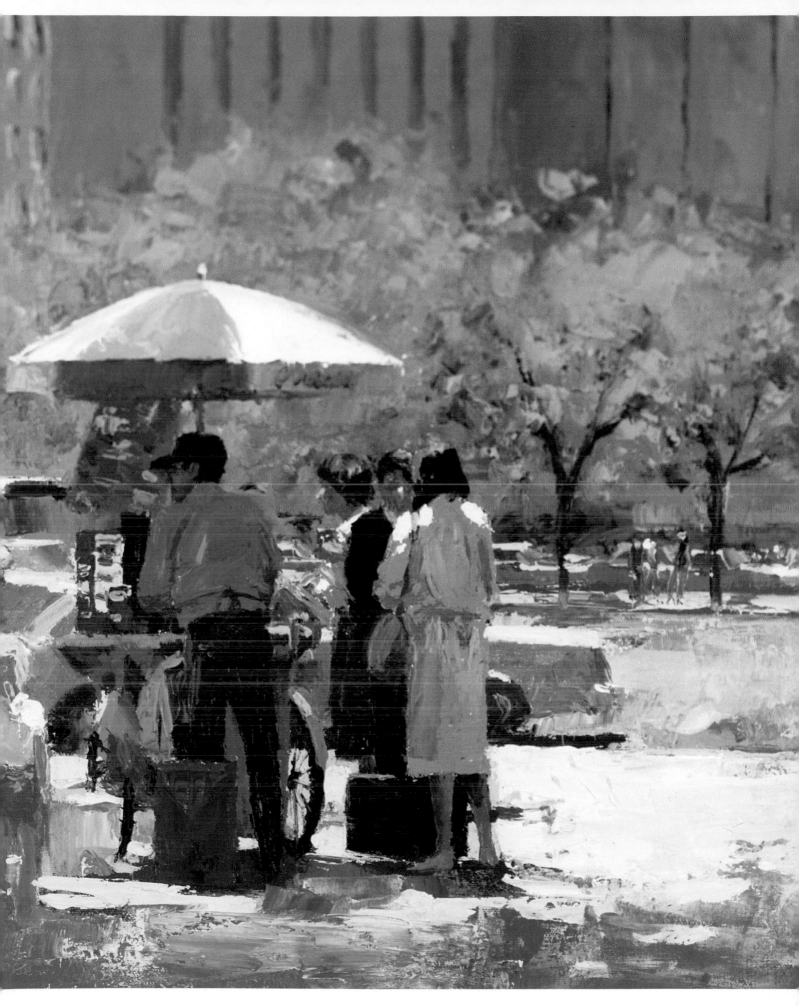

Colors are commonly used to express emotional states as in the expressions, "he has the blues," or "she saw red." Everyone also has an intuitive awareness that all colors have a particular temperature identity.

ASSIGNMENT—You are now going to make a color wheel and position each palette color into either a warm or cool category. Begin by lightly sketching a large circle on your canvas. Thinking of the circle as a clock, make a small mark at 12:00, 2:00, 4:00, 6:00, 8:00, and 10:00. Paint a generous swatch of pure cadmium red light in the 12:00 position. Next, paint a similar daub of cadmium orange at 2:00. Keep moving clockwise around the circle and place the following colors in their respective positions: cadmium yellow light at 4:00, permanent green light at 6:00, cobalt blue at 8:00, and cobalt violet at 10:00. Be sure to use the color directly from the tube rather than altering it with black or white and don't forget to clean your brushes thoroughly after each mixture. Now draw a vertical line down the center of the wheel beginning at the red swatch and ending at the green swatch. In the open half circle on the right of the wheel write the word *WARM*. In the left space write *COOL*.

Before filling up the circle with the rest of your colors, notice how the three primary colors of red, yellow and

■ *Theoretically, every color under the sun can be painted from six colors. In actual application, however, a pigmentary paint falls far short of being able to accomplish this.*

blue and the three secondaries of orange, green and violet appear orderly and unified, like a rounded spectrum.

Theoretically, every color under the sun can be painted from these six colors. In actual application, however, pigmentary paint falls far short of being able to accomplish this. The reason is that true spectrum colors are made up of light and, like the projected beams of color shining on a movie screen, are mixed optically. Tube paints, on the other hand, are composed of powdered pigments, filler and binders, not to mention impurities and fluctuation in

WINTER IN SOUTHPORT
11" × 14", oil on Masonite, private collection.
After I had laid in and begun to develop this picture, the sun came out for about five minutes and turned what had started out as a drab, gray day into a lively lesson in warm and cool color.

the quality of colors. Because of this the artist needs to employ a far greater range of tube colors than the six basic colors.

Having established the warm and cool perimeters of the color wheel, you are now going to fill in the spaces with all the colors on your palette. Begin with the reds. If you're tempted to replace cadmium red light with a medium or deep version of the color, remember that cadmium red light is the most brilliant of the oil reds. Position the rest of the colors as shown below.

Now study the wheel and notice how each color not only reveals itself as either warm or cool but occupies its rightful position on the spectrum.

Earth colors also have a place on the wheel, but rather than treating them as spectrum colors—which they're not—consider them instead as *shades* of the spectrum colors they most closely resemble.

Yellow ochre, burnt sienna, raw sienna and burnt umber are the only earth colors needed on most palettes. Occasionally you may want to experiment with Naples yellow, raw umber or the iron oxides (Indian, Venetian or red oxide, chrome oxide green and Mars violet), but with practice I think you'll find it easy to duplicate these colors with mixtures of spectrum colors. Such combinations will not only yield more harmonious results but also will eliminate the inherent muddiness raw umber and the oxides seem to impart to mixtures.

Beginning with yellow ochre, study its hue and ask yourself which color it most closely resembles. It's obviously not blue or purple. Instead it appears more yellowish. But which yellow? Cadmium yellow medium is too orange, cadmium yellow pale or aureolin too cool and greenish. The answer is cadmium yellow light. Raw sienna, which contains a touch more orange, is the perfect shade for cadmium yellow medium. Burnt sienna, on the other hand, is very orangeish and matches perfectly as a darker shade of cadmium orange. Although burnt umber appears brown, it's really a deep, dull shade of cadmium red light. If there are other earth colors you would like to place on the wheel, use the same comparisons and place them accordingly. Complete the wheel by placing each swatch of earth color beside its parent color, positioning it on the outside of the wheel rather than wedging it into the circle of spectrum colors. If you happen to favor a color that isn't listed here, paint a swatch of it on a sheet of scrap paper or canvas and lay it beside whatever spectrum or earth color it comes closest to matching. Scrutinize the warm and cool variations of the comparison, trusting your intuition along with your intellect, and repaint the swatch into the position it seems to fit best.

Be sure to paint all the swatches with thick, opaque paint straight from the tube. If you find it difficult to remember the names, positions and temperatures of the colors, write descriptions beside each of the swatches.

Identifying the Temperature of a Color

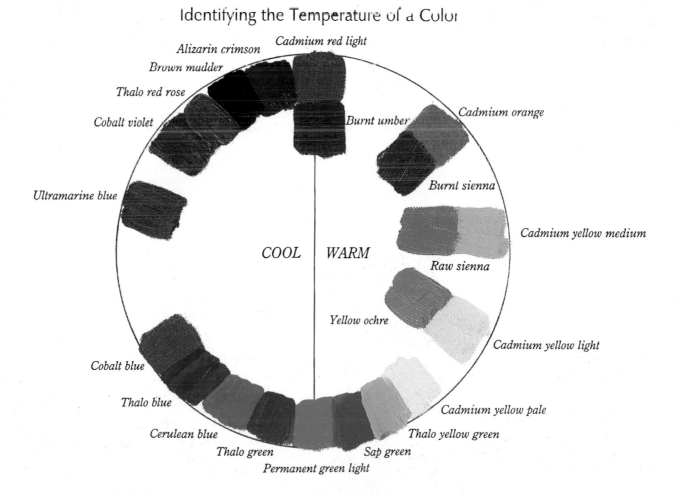

COOL | WARM

Cadmium red light
Alizarin crimson
Brown madder
Thalo red rose
Cobalt violet
Burnt umber
Cadmium orange
Burnt sienna
Cadmium yellow medium
Raw sienna
Yellow ochre
Cadmium yellow light
Ultramarine blue
Cadmium yellow pale
Cobalt blue
Thalo yellow green
Thalo blue
Sap green
Cerulean blue
Thalo green
Permanent green light

Dividing your palette into warm and cool segments was the first step in understanding color temperature. You're now going to learn how to identify and paint warm and cool combinations *within* a particular bracket of color. At first glance all the blues on the wheel appear to be consistently cool. However, between the various blues lies still another series of warm and cool temperature changes. So, too, with all the other primary and secondary colors. For example, cerulean blue appears cool next to cadmium orange. But, put a swatch of ultramarine beside cerulean blue, and the color takes on a warmth and also, because of the contrast, brings out the cool, purple cast unique to ultramarine. This is because cerulean blue contains a small amount of yellow whereas ultramarine is tinged with violet. There are similar effects with the juxtaposition of each set of analogous colors on the wheel. Permanent green light appears cool beside cadmium yellow pale yet warm compared to Thalo green or viridian. Alizarin crimson looks warm beside cobalt violet, yet cool next to cadmium red. Compound this with value and intensity changes, and the number of possible color mixtures obtainable becomes nearly endless.

The first rule to learn in altering a color's temperature is: *No single color has a specific temperature identity until compared with another color.* This means that cadmium red light or vermilion is simply a red until a cooler hue like alizarin crimson or Thalo red rose or a warmer hue like cadmium orange is placed beside it, activating, by comparison, the color's temperature. The same holds true with each color on the wheel.

The next rule is: *A color appears most intense when placed beside its complement.* Paint a swatch of cadmium yellow light and notice how much more brilliant it appears when foiled by a daub of cobalt violet. If identifying a color's complement still seems confusing, try taping a sheet of clear plastic or kitchen wrap over the entire color wheel. Draw a line, using a china marker, from each color to the color directly opposite on the other side of the circle. When completed, your overlay should look like a wagon wheel of lines with each line connecting a different pair of complements.

The third rule is: *Avoid placing two equally intense primary or secondary colors beside each other.* Unless done intentionally, the clash set up by the juxtaposition of these colors can undermine the harmony of a painting. Think how startling a person appears dressed in a pair of bright, electric blue pants and blazing orange shirt. Lower the

intensity of the pants to the duller, blue-gray of a pair of jeans however, and the ensemble becomes harmonious.

The fourth rule is: *Every object in light should appear consistent with the color temperature of the source of illumination.* What this means is that if an apple, pear and white piece of drapery are lit with a yellow light, *all* the light-struck planes of those objects will contain some yellow.

The fifth rule is: *Every object in shadow should contain some color complementary to the temperature of the light.* This means the shadows of the apple, pear and drapery mentioned in the previous rule would have small amounts of purple, the complement of yellow, mixed into them.

The sixth rule is: *Not only does a color appear brighter when illuminated by the light of a similar color but also duller when illuminated by the light of a complementary color.* While sounding complex, the principle is easily demonstrated. Imagine a green houseplant resting on a blue piece of cloth, flanked by a red and yellow apple. Now visualize a yellow light illuminating the subject. The light-struck side of the apples would appear brighter in intensity than similarly lit passages of the plant and cloth, because the light source is analogous to the colors of those

■ *Think how startling a person appears dressed in a pair of bright, electric blue pants and blazing orange shirt. Lower the intensity of the pants to the duller, blue-gray of a pair of old jeans however, and the ensemble becomes harmonious.*

objects. Because the cooler items are made up of more complementary hues, they would appear less intense. If the principle still seems unclear, make a small color sketch to help crystallize the idea.

The final rule is: *The color of a light will intensify those colors analogous to it and neutralize those which are complementary.* This means simply taking the third rule a step further. If the light-struck side of the red and yellow apple described in the previous rule is more intense under a warm light, the shadow would appear less intense. Likewise, because the intensity is lower on the light side of the plant and cloth, the shadows will take on more brilliance. The reason is that if both the light and dark sides of the forms are painted with equally high intensity, they

BALSTON BEACH, CAPE COD

16" × 16", oil on canvas, private collection.

It pleased me to read that some of Claude Monet's beach paintings had actual grains of sand mixed in with the paint. This location piece was done while crouched under an umbrella, using one hand to defend myself against some children throwing sand, and the other to put paint on the canvas. The subject, however, was magical. Light, color and a carnival array of shapes provided me with a ready-made composition. Pay particular attention to how the cool, deep color of the water sets up a contrast to the warmer hues of the sand, figures and umbrellas.

41

would not only dissipate each other's effectiveness but also disrupt the consistency of the single source of colored light. On the other hand, if less intense colors are used throughout, the color identity of the objects becomes lost. Remember, just as every form needs a home value, it also needs a home color and, whether in light or shadow, that home color must be identified.

ASSIGNMENT — The exercise consists of painting two sets of colored blocks and will demonstrate how the color of a light source affects the temperature of a color. Both sets will be made up of three blocks, horizontally striped with yellow, red and blue. In each set one block will be bright, one medium, and one dull in intensity. Set one will be illuminated with an orange light, set two with a blue light. The light will hit the blocks on the top and left side, as in the previous exercise.

Start by sketching in the forms and clustering them into two separate groupings. To indicate the color temperature of the light source, daub a swatch of cadmium orange above and to the left of the first group and a note of ultramarine in the same place above the second group.

Some mental juggling may be needed here because you're going to show the effects of a warm and a cool light on each of the blocks which range in intensity from bright to medium to dull. You're also going to maintain the proper home *value* of each band of color on the forms. This will give you a chance to apply the principles learned in Exercises Seven and Eight. If all this sounds like a tall order, remember that painting is simply a matter of taking one step at a time, giving it your best shot, and moving on to the next step.

Begin with whatever block you feel most confident with. Keeping the temperature of the light source in mind, start laying in the different stripes of color. Try not to be fussy. Use a big brush, clean it thoroughly after each mixture, and don't worry if the forms look a little lopsided or out of perspective. Your chief concerns here are accurate color, values, intensity and temperature changes, not perfection of form. Begin with the shadow, laying in all three of the colors in each block before moving on to the lights. Apply the same visualizing method described in Exercise Eight and imagine a black-and-white photo taken of the completed exercise. If all six blocks appear to be identical in value distribution, you've succeeded. If not, repaint the problem area until it appears consistent with the others.

APPLICATION — Don't forget that the color temperature of light varies not only from the orange and blue examples given in this exercise but also from every color on the wheel. This, in turn, opens up a myriad of possibilities for interpreting sunlight, moonlight, artificial light or whatever source of illumination an artist's imagination can conjure up.

WARM LIGHT MAKES SHADOWS APPEAR COOLER

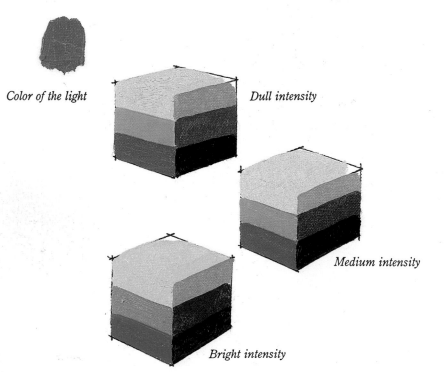

Color of the light

Dull intensity

Medium intensity

Bright intensity

42

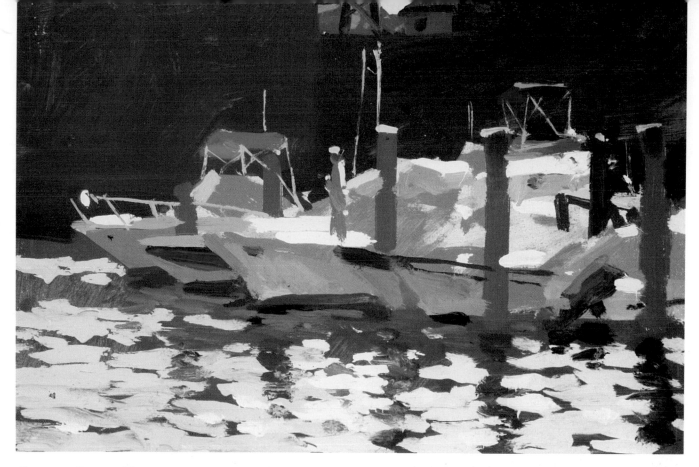

SUMMER, SOUTH NORWALK HARBOR

9" × 12", oil on Masonite, collection of Shirley Lewis, Bath, Maine.

This small painting is deceptively simple. Aside from the busy reflections on the water and a few calligraphic strokes defining the masts and rigging, the composition is composed of no more than broad passages of warm lights and cool shadows. The warm sky is established by the use of the reflections on the water, with only a hint of the actual sky showing.

COOL LIGHT MAKES SHADOWS APPEAR WARMER

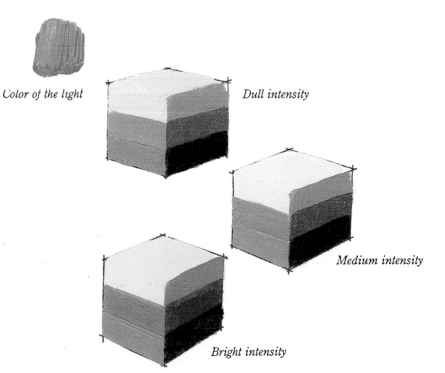

Color of the light

Dull intensity

Medium intensity

Bright intensity

This final exercise in seeing the world through colored glasses will explore the various tints and shades of gray available through combinations of complements, earth colors, black and white. Like a fine gourmet chef basting a carefully prepared dish with his own unique brand of sauce, the grays in your painting should also smack of individuality. Exactly what is the difference between a gray and a color reduced to a dull intensity? A gray lacks an obvious color identity whereas a low intensity color still retains a recognizable cast of its original hue.

Seeing color in gray subjects takes practice and an open mind. At this very moment there are probably numerous examples of gray all around you, many of them pulsating with color. Opening your eyes to these possibilities is simply a matter of becoming aware of what you see. Study the shadows of a white kitchen sink or bathtub, for example, and see if you can identify any hints of color. At first your vision, conditioned by a lifetime of habit, will probably take in nothing more than lackluster variations of light and dark. Now take a second look and this time try to shake off any preconceived ideas that gray is gray and that's all there is to it. Let your eyes meander over the subject. Trust your impulses, trying to monitor even the slightest hint of a color as your eyes roam over the forms. Perhaps an orange scouring pad or brightly colored shampoo bottle is lying near at hand. Dismiss the objects for what they are and see them instead as reflectors of color, imparting subtle auras of warm and cool hues onto the

■ *Like a fine gourmet chef basting a carefully prepared dish with his own unique brand of sauce, the grays in your painting should also smack of individuality.*

surrounding surfaces. I think you'll soon discover that any seemingly gray item can be a treasure-house of subdued color.

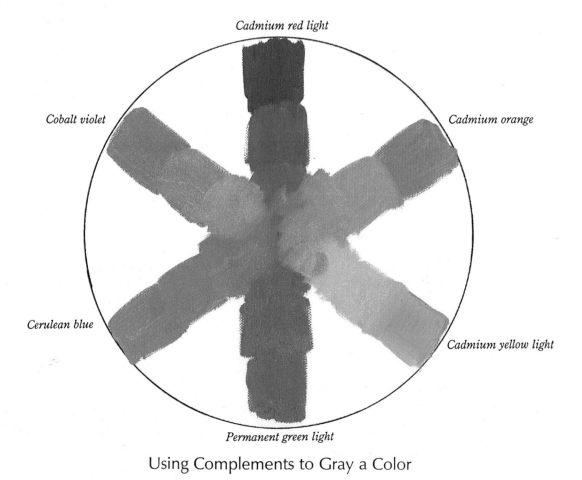

Cadmium red light

Cobalt violet

Cadmium orange

Cerulean blue

Cadmium yellow light

Permanent green light

Using Complements to Gray a Color

The easiest way to make gray with an opaque medium is to mix black and white. Remember, black is colorless and white has only a marginal cast of hue, making an unexciting gray. One workable option is to vary the black-and-white mixture with other colors. This alternative is practiced by many tonal painters who are less concerned with "colorful" grays than with adhering to a particular tonal system. The richest grays, however, are made by mixing complementary colors. Theoretically, mixed complements will form a perfect gray. In practice, they don't because pigmentary hues are not as pure as optically mixed spectrum colors. This limitation is actually an asset because it gives the artist a rich choice of colorful muted grays to choose from.

ASSIGNMENT—Keep your color wheel handy for this project as well as a full palette including black and white. Sketch six blocks on your canvas. Paint the shadow of the first block a middle gray value made from a mixture of black and white. Next, adding just enough black into a generous portion of white to form a very pale gray, mass-in the two light-struck sides of the form. Repeat the procedure with the second block except this time include a small daub of cerulean blue into the shadow mixture and a touch of cadmium orange into the light gray. Each of the next three blocks will be made up of complementary mixtures. To identify these, place a daub of the following pairs of complements above each of the blocks: cadmium red light and permanent green light; cadmium orange and cobalt blue; and cadmium yellow light and cobalt violet. Beginning with red and green, mix up equal amounts of color and paint the shadow side of the block. Add some white if necessary to lighten the mixture to a middle gray value. When painting this or any other combination of colors, try to begin each mixing procedure by starting with the warmer of the two colors—in this case, red. This is because *it's far easier to cool a color than to warm one,* since cool colors tend to overpower warm ones. Also avoid

overmixing the paint. You're not after a flat, house-painter's gray here but a muted yet colorful neutral; so keep the mixtures loose and don't be afraid to leave a few of the accidental bits of purer paint intact. Moving on to the light side of the block, add the smallest amounts of the red and green mixture to white and paint the two light-struck sides of the form. Repeat the same procedure with the next two blocks, using the complements above the forms as the basis for your mixture. The final block of the set will be painted with a mixture of burnt sienna and ultramarine. Remember, burnt sienna is a shade of orange, so you're still working with essentially a complementary blend. Don't forget that the home value of most of the colors used here is darker than the tones required, so be sure to lighten the above mixtures to a consistent middle gray in shadow and near white in light.

EVALUATION—Now study the completed exercise and notice how varied the blocks are. Observe that while all the mixtures result in gray, each combination appears colorfully unique. Also notice how each of the grays made from complements is not only in perfect harmony with the others but also renders the black-and-white block lifeless by comparison.

APPLICATION—The six mixtures you've just completed are only a small number of the many possibilities your palette offers. If you have time, sample the various blends possible with other complementary mixtures. Or you might stray slightly from the complements and explore combinations like viridian and alizarin crimson, cerulean blue and cadmium red light, or ultramarine and burnt umber. Then there are the numerous possibilities of adding various colors to black and white. Eventually you'll find yourself developing favorites. This is natural. The important thing, however, is to know your options, build a base of mixtures you can rely upon, yet never be afraid to risk experimenting with new possibilities.

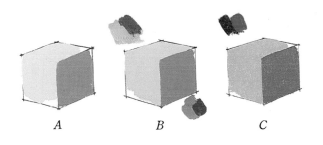

A *B* *C*

A. Black and white. The cube appears colorless.
B. Cadmium orange and light gray with cerulean blue and dark gray gives a luminosity absent in the first cube.
C. Cadmium red light and permanent green light. Without black, the gray has a warmth absent in the first two cubes.

D. Cadmium orange and ultramarine offer a wide range of brownish grays.
E. Cadmium yellow pale and cobalt violet. The golden lights are heightened by the violet shadows.
F. Burnt sienna and ultramarine can capture the grays of rocks and weathered wood.

D *E* *F*

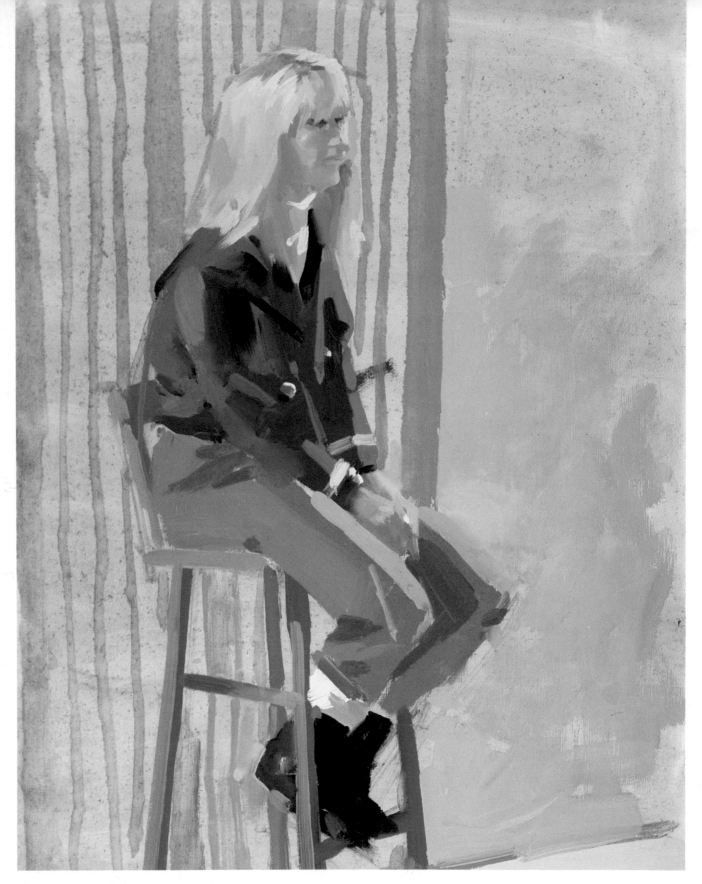

ROBIN

24" × 18", oil on Masonite, collection of the artist.

Whenever I see a friend or acquaintance wearing an interesting outfit I'll frequently ask them to pose. My interest was in the interplay of patterns in Robin's ensemble. I lit the model with a rim light from the right and a weaker, secondary light from the left. This broke up the figure into three broad planes of light, shadow and reflected light, which gave me the opportunity to exploit the various color changes while still maintaining a solid tonal structure. To add to the provocative array of shapes and patterns, I reduced what was an elaborately designed background drape to a series of flat orange and tan stripes.

SKIPPER'S MARINA
12" × 12", oil on canvas, collection of Barbara
Dachowski, Dunellen, New Jersey.
Sargent once said "The best way to get clean
color in oil is to use a lot of paint." Following
his advice, I used more than a quarter pound
of white as well as equally generous amounts
of various colors to capture the striking juxta-
position of luminous grays and intense pri-
maries in this busy subject. The shadows here
are predominantly cool, but I've charged them
with colorful notes of warm reflected light ema-
nating from the bright, noonday sun. To foil
these muted tones I painted the light side of the
blue boat trim and red trash can with pure color
directly from the tube. "Skipper's Marina" took
one three-hour location session to complete.

THE EYES HAVE IT

The six exercises you've just completed could be likened to a pair of magic glasses that let you see the visual world in a way you may not have before considered. The more you apply these principles to your painting the greater your powers of observation will become. But rather than thinking a day will arrive when you know all there is to know about color, consider instead the completion of each project as the expanding of an everwidening spiral of skills which will continually add to your powers of personal expression. As you begin to trust your visual sensations your eyes will meet the challenge and start presenting you with increasingly more sophisticated problems to solve.

Just as there are those who can play a piano without ever having taken a lesson, some painters seem to be more naturally gifted colorists than others. Most painters, however, need some sort of guidance to steer them in the right direction. Whatever your natural abilities may be, know that it's within your grasp to develop a solid and mature color sense. If you're frustrated by any of the problems, review the completed exercises and ask yourself where the weak points lie. Perhaps your mixtures end up too raw or muddy, or you just can't seem to get the various intensities to appear convincing. No matter what, accept your shortcomings, work at improving them, but try not to let the challenge dissipate your worth as a painter.

Don't forget that you probably have an equal number of strong points and it's these that keep painting a pleasurable experience.

Color is never completely mastered. Like the infinite variations of snowflakes, leaves or breaking waves, its appeal lies in an enigmatic diversity that has preoccupied thousands of painters for hundreds of years yet still defies any limitation imposed upon it. There really are no rules for using color. Granted, it's helpful to understand the basics presented here, but these are merely touchstones designed more as a guide to your intuition than any sort of firm dogma. As stated earlier, we all respond to color a little differently. And whether you follow my suggestions to the letter, choose other alternatives, or initiate some new ones of your own, if the desired effects are achieved, consider your efforts successful.

Finally, try not to take the whole thing too seriously. Color is meant to be a spontaneous reaction, not a chore. Watch a child with some poster paints jabbing on some outrageous color combination and simply letting the picture paint itself. He's not preoccupied with what anyone thinks or how his work compares to Monet's water lilies. He's simply enjoying himself. So trust your vision, have some fun, and let your color sense evolve at its own pace.

· CHAPTER 3 ·

THE DRAMA OF LIGHT AND SHADOW

Have you ever sat in a darkened theater and gotten so caught up in a performance that the play seemed like a real life experience? This ability to mesmerize is in no small part the creative work of the lighting designer. When employed with purpose and imagination, light and shadow are capable of an infinite variety of effects and can alter not only the ambience of a theater stage or movie screen but also the mood of a painting.

The best way to approach light and shadow is to consider their effects as temporary illusions. Temporary because even the slightest repositioning of a lamp or movement of the sun instantaneously alters one effect and replaces it with another. An illusion because, being strictly a visual phenomenon, a light or a shadow is impossible to touch. To illustrate this try the following experiment: Study a subject lit with a single light source — a cluttered desk or tabletop illuminated by a single lamp, for example — and notice how each object is clearly broken up into segments of light and shade. Disregard the intermediate halftone values on rounded forms, and focus solely on the sharply defined light and dark aspects of the subject. Notice how immovable each passage appears. Observe how the portion of the object exposed to light looks crisp and well defined while the shadow side takes on a softer, more amorphous quality. Now reach your hand into the shadow and touch one of the objects, run-

ning your fingers over its surface. While your *sense of touch* tells you the form feels solid, your *sense of sight* will see the shaded portion of the same item as soft and intangible. Now change the position of the light a few inches and notice the corresponding change in the shape of the shadow pattern. Observe that although the shadows are now altered, the forms remain the same. Consider that while light and shade can change the *appearance* of a subject by altering home values and colors and camouflaging tactile solidity, they cannot alter the *structure* of a form.

You're now confronted with a paradox. If shadows are nonexistent in the world of tactile solidity, how should they be treated in a painting? What considerations should an artist make in distinguishing these illusive elements from the primary forms beneath them and transferring them into the language of paint?

The answer is to think of light and shadow as a tool capable of heightening the quality of a painting in a number of ways. To begin with, light and shade have the magical power to imply. They can also set a mood, help define the distance between things, and unify a complex subject. A tactilely painted object reveals a form's solidity, but it's the effects of light and shadow that give it immediacy, character, a sense of place and time of day. A landscape seen under early morning light contains essentially the

STUDY PROGRAM
Lesson 3: The Drama of Light and Shadow

TIME	EXERCISE
1 hour	**13** Determining the light and shadow pattern of a subject
1 hour	**14** Using a cast shadow to describe the form of an object
2 hours	**15** Designing the light and shadow pattern of a subject using black, white and limited color
2½ hours	**16** Using full color to show the various home values of objects within the light and shadow patterns of a composition
2½ hours	**17** Defining the form of a figure within the light and shadow patterns of a composition
3 hours	**18** Using light and shadow to unify a composition

same forms in the evening when the sun is setting. Even under moonlight, the effect may be different, but the forms remain constant. Tactile painting, home values, and careful color application can give a painting a high degree of believability, but the effects of light and shade bring the scene to life by blanketing it with a consistent source of illumination. Light and shade are also useful for defining textures, weaving interesting tonal patterns, washing over forms like water, and revealing the roughness or smoothness of a surface.

Of all the many ways light and shadow can serve the artist, one of the most useful is their ability to unify a painting. The following exercises will demonstrate that even the most complex subjects can be reduced to an easily readable pictorial statement.

PROVINCETOWN SKYLINE

12" × 12", oil on Masonite, collection of the artist.
Edward Hopper and Charles Demuth were among the many artists who painted this familiar Cape Cod landmark. Determined to make a contemporary statement of my own, I blanked my mind of the memory of any past masterpieces and tried to determine what made the subject special to me. The first thing I was struck with was how the television aerial not only made the church tower appear even larger and more regal but also how it gave a contemporary stamp to the subject. It's easy to be intimidated when you've seen a success-ful version of a subject you want to paint. The best way around this is to jump right into the picture and get so caught up in what you're doing that little else matters.

DETERMINING THE LIGHT AND SHADOW PATTERN OF A SUBJECT

Seeing and painting a subject with sophisticated simplicity is a hallmark of good picture making. The prime requisite for this skill is the ability to visualize the broad masses of light and shadow in a composition.

PREPARATION — Your first exercise will be to isolate the shadows of a strongly lit subject and render them in hard-edged, poster-like tones of black. Begin by placing four or five objects on a table in front of you. Studio items such as brushes in a container, paint tubes, an assortment of small art supply boxes, medium bottles, books, or a roll of paper towels are all perfectly suitable. Other options could include workshop tools, sewing paraphernalia or sporting equipment. Whatever your choice, try to pick material with a variety of interesting shapes and forms.

Arrange the objects in a cluster and position a table lamp or spot light with a bright 100-watt bulb to the left or right of the setup. Turn off or subdue any conflicting light sources that would cast a second set of shadows. Move the lamp around until there is a definite pattern of strong light and shadow dividing the objects and also some substantial shadow spilling into the background. The closer the light is to the setup the stronger the shadows, so the position of the lamp should be no further than a foot or two from the objects.

ASSIGNMENT — Using black paint, thinned enough to permit easy handling, copy the pattern of the shadows, ignoring any background material not related to the subject. Leave the light-struck areas untouched.

Block in the most obvious shadows. Disregarding any change in the home values of the objects, complete the picture by indicating both the shadows and cast shadows of the forms with the same consistently flat black tone. Square forms such as books or boxes have sharp corners, making the boundary between light and dark easily observable. Rounded items like paint tubes or bottles demand more scrutiny because the edges are softer and less defined. Rather than trying to duplicate the tonal gradations of these soft edges, paint a *sharp line* where you think light ends and shadow begins. At this point decisiveness is more important than accuracy. With experience, you'll soon be able to discern exactly where this border lies. The Spartan selectiveness of this exercise will go a long way in helping to lay the foundation for a strong and incisive painting approach. One simple way to find the boundary line on smoothly rounded forms is to cast a shadow onto the form by holding your pencil or brush between the light and the object. Follow the shadow cast from the instrument until it disappears into the shadow of the object. The point at which the shadow disappears is where light ends and shadow begins. Another method which works particularly well at night is to turn off all

■ *The Spartan selectiveness of painting shadow patterns in black forms a major building block in the foundation of a strong and incisive painting approach.*

the lights in your studio except the one illuminating the subject. This reduces the objects to stark contrasts of light and dark.

EVALUATION — Now study your picture and notice how the single value of black shadow not only implies the existence of the forms beneath it but also acts as a unifying agent for the entire composition.

Sidelighting is one of the best ways to unify the lights and darks in a composition. Observe how the shadows on the objects merge with the cast shadows and together turn what could have been a fragmented composition into a single, cohesive whole. See page 145 for a full-color version of the subject.

Light and shadow diagram of the subject.

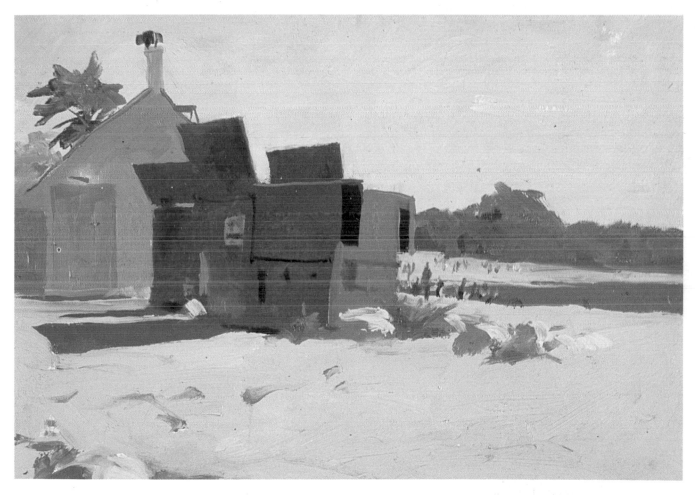

DUMPSTERS
9" × 12", oil on Masonite, private collection.
For years I had seen these threatening-looking receptacles lurking around back streets and thought they might make an interesting subject. When I saw this one beside a bathhouse at a private beach I couldn't resist the incongruity of the two images. Aside from the beach, a few small portions of the grass, and the right side of the Dumpster, everything is in shadow. The result is a strong breakup of light and dark patterns. Remember, you need very little modeling to define an object if the shapes of the shadow patterns are interesting and revealing.

Cast shadows were generally ignored by painters until around the seventeenth century. Rembrandt, Caravaggio and El Greco are credited as being among the first artists to heighten the feeling of realism in their paintings with this useful spatial device. Another example of a pictorial innovator utilizing shadow to convey mood is Degas who dramatically lit his renditions of ballet dancers and interiors. Today, Andrew Wyeth and Robert Vickrey, among others, have taken this tradition a step further by basing the foundation of their compositions on strong patterns of cast shadows.

■ *A cast shadow can literally diagram a form's circumference.*

To understand the full range of descriptive possibilities cast shadows offer, I suggest you do the following exercise outdoors under direct sunlight. Cast shadows are best observed in the morning or late afternoon when the sun is low in the sky, so avoid any midday sessions. If you find this impractical, either set up an arrangement indoors, near a window illuminated by direct sunlight, or work at a table using the same strong lamp or spotlight employed in the last exercise.

PREPARATION—You'll need a three or four-foot length of thin wood or metal such as a planter pole, yardstick, broom or shovel. Find a sunny patch of earth and position the upright into the ground so it stands vertically. Next, arrange four or five objects of your choice directly into the shadow the pole is casting. Keep rearranging things until the shadow cast from the pole is visible on every object. If working indoors, use a smaller pole and position the items in a similar manner.

Now study the setup and notice how the cast shadow rolls over each object, describing the roundness or squareness of the forms. The success of this exercise depends upon the positioning of the objects in relation to the light source. Be imaginative. Move the objects around, overlapping a few or turning some on their sides. Explore the possibilities. Also keep an eye out for any interesting shapes the shadows may form, trusting your intuition as a guide.

ASSIGNMENT—Place your easel in front of the subject and paint the entire arrangement, including the pole, using the same approach as in the previous lesson. Observe and paint the cast shadow from where it begins its roller coaster journey at the base of the pole, as it meanders over each of the objects in its path until it ends. Some of the areas crossed will already be in shadow. If this happens disregard the gulf of darkness and pick up your journey on the other side. Think of the pole's shadow as encircling a particular surface the same way a hoop is wrapped around a barrel. This can be a very useful device for a painter, especially when showing foreshortened objects, because a cast shadow can literally diagram a form's circumference.

Casting a shadow over an object not only helps describe its form but can also be a useful design element.

Complete the exercise by painting the shadows of each object. Rather than keeping every edge hard, as in Exercise Thirteen, try softening the shadow lines on the rounded forms by smearing the paint into the canvas with a paper towel wrapped around your finger. Don't soften any of the edges of the cast shadow from the pole. Disregard any background material such as buildings, foliage or windows.

Cast shadows have numerous pictorial possibilities in helping to describe the character and dimension of an object. Learning to use them will add another avenue of expression to your repertoire and act as a creative exercise to help expand your artistic inventiveness.

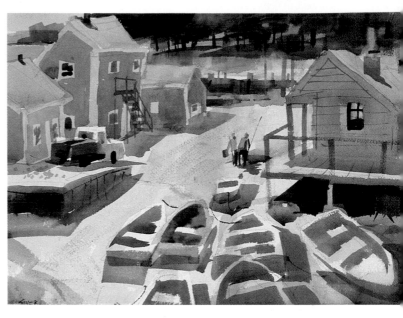

OYSTER HARBOR
15" × 24", watercolor on cold press paper, collection of the artist.

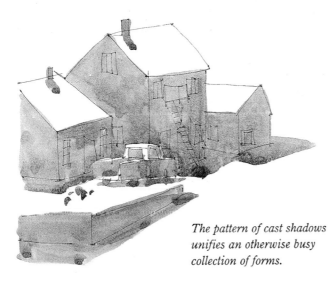

The pattern of cast shadows unifies an otherwise busy collection of forms.

When done prior to a painting, diagrams such as this are an excellent way to work out the tonal foundation of a picture.

KITCHEN AT NIGHT
8" × 8", watercolor on hot press paper, collection of the artist.

Notice how much more intimate the subject appears when cropped. Like most busy scenes, it's better to focus on a single, vital area rather than fragment a composition into a series of unrelated parts.

The light and shadow pattern is established on the sign. Surface texture and lettering are added later.

Using shadows to define a subject.

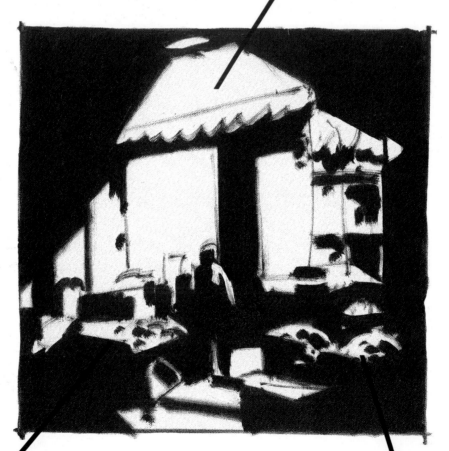

The various light and shadow tones of home values are diminished to black and white.

Texture is reduced to posterlike shapes of light and shadow.

54

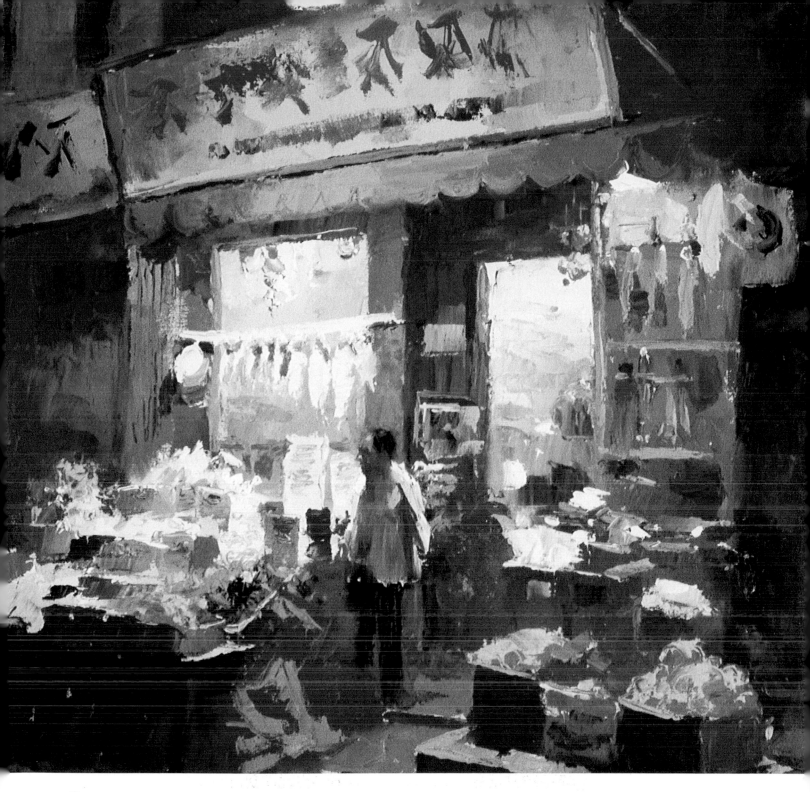

CHINATOWN
20"×20", oil on canvas, private collection.
Equipped with a small, battery-operated fluorescent light taped to my painting box, I often paint night scenes directly on location. This one, however, is a composite of sketches and photographs. To capture the mysterious ambience of the subject, I eliminated the dozen or so people standing around the entrance-way and focused on the proprietor. This lets the viewer's eye wander around the exotic array of fruit, vegetables, signs and other bric-a-brac that makes this kind of subject so interesting. I limited my palette to brown madder, cadmium red light, cadmium yellow pale and Thalo blue, which enabled me to harmonize the wide array of colors by reducing them to a manageable range of lights and shadows, permitting me to focus on the dramatic effect of the lighting.

Artistic taste varies with each individual. What may appear a perfect lighting arrangement to one painter may seem discordant and uninspiring to another. The aim of this next exercise is for you to learn to find the best lighting situation for a painting.

PREPARATION—Working either indoors or out, set up four or five objects that look interesting to paint. These could be some of the same items used in previous exercises or new ones such as flowers, fruit, a statue or piece of driftwood. Divide your canvas into four equal sections with a light pencil or brush line. You'll be painting four different versions of the same subject, so decide now whether your working surface will accommodate the compositions better in a vertical or horizontal position.

The first three studies will each be lit from a different angle. The fourth will duplicate the lighting condition of one of the first three. If working outdoors or by a sunlit window, you can change the angle of light by moving your easel to another position. If painting indoors, simply rearrange your lamp or spotlight each time you paint a new sketch.

ASSIGNMENT—Start by choosing a lighting effect you find attractive. Employing the same stark patterning of black shadows used in Exercises Thirteen and Fourteen, paint the shaded areas. Be sure to keep the shadow edges firm, softening only those found on rounded objects. Use cast shadows whenever possible, taking advantage of their unique ability to map the geography of a form. Avoid any indication of background material. After completing the first painting, reposition your light source or easel and begin the second. If your first sketch was lit from the left, try lighting this next one from the right. It's not so important where you place the light as long as it's decidedly different from the first effect. Repeat the massing-in of black shadow patterns. Although lit from yet another angle, the third sketch should be painted with the same consistently black shadows of the two previous ones. As you learned in Exercise Fourteen, it's your imaginative use of lighting that makes these studies successful. So try to be inventive. Explore different angles of back, front, side and edge lighting. If working indoors, you might even investigate the possibilities of light from beneath, behind and above your still life. As you experiment, observe the various patterns each effect makes. Some studies may be

mostly composed of shadow and conjure up an entirely different mood than one in which the lights dominate. Try to avoid an equal distribution of light and shade. Usually a predominance of one or the other makes a more interesting composition.

Now step back and study your three sketches. Which one best captures the essence of the subject? Which one

■ *Try to be inventive, exploring different angles of back, front, side and edge lighting. If working indoors, you might even investigate the possibilities of light from beneath, behind or above your still life.*

utilizes cast shadows to their best advantage? And which study has the most interesting abstract arrangement of light and dark shapes? What counts here is your individuality so trust your first gut reaction rather than trying to get too analytical.

Your fourth and last study will be painted in limited color. Using your most successful sketch as a basis, reposition the lamp or easel, if need be, to duplicate the lighting in that sketch. With the subject before you and your painting as a guide, replace the black shadows of the original painting with pure cerulean blue. Next, lay in the previously unpainted areas of light with a mixture of equal amounts of cadmium orange and white. Use the paint opaquely and duplicate the light and shadow patterns you see with the same crisp technique employed in the three black-and-white studies. Be sure to butt the light tones right up against the shadows so no distracting areas of white show through.

Making the transition from black and white into color should be an easy one. Difficulties arise only when light and shadow are thought of as unrelated to color. Remember (see Exercise Eight) that color is capable of the same range of value contrasts as black and white. *Any* subject executed in black and white can be duplicated in color.

This is where you can start to incorporate what you've already learned about color and tactile solidity into your approach to strong tonal contrasts, using them both to paint your subject as a unified whole.

Light from the right

Light from the left

Light from the top right

Color lay-in based on light from the right

57

To successfully depict the colors and tones of a landscape or cityscape—or any subject for that matter—follow exactly the same procedure used in painting the various colored blocks in Chapter Two. The only difference is that the subject appears more complex.

PREPARATION—Choose an outdoor subject. Cars, houses, telephone poles, mailboxes and even trashcans could all be possible material for this next exercise. If you're unable to work outdoors, set your easel up by a window and choose an interesting view. As a last resort, you could work from a colored photograph, but use one you took yourself so there's at least some kind of recall of the light, color, time of day and general mood of the scene. Don't get overly ambitious. Keep your motif limited to a building or two, some trees, a few rocks or a fence and leave it at that. It's important that direct sunlight strikes your subject, so avoid working on a cloudy or overcast day.

ASSIGNMENT—Lay out the full palette of colors listed on page 4. Utilizing the same eye for inventiveness you exercised in the previous project, sketch in a composition that has an interesting pattern of lights and shadows. Follow the same procedure used when painting the limited color sketch in Exercise Fifteen, laying in opaque passages of cerulean blue for the shadows and a mixture of equal amounts of cadmium orange and white for the lights.

Your next step will be to start developing the shadow areas of the underpainting, showing the color and tonal changes of the various home values of the subject. Since it's difficult to rework wet paint into an already wet underpainting, take your palette knife and scrape off any excess pigment that's built up on your canvas. This will not only keep your initial color notes intact but also provide a conducive surface upon which to overpaint. Try not to get too much contrast into these changes. A good rule of thumb is to go *no lighter than a middle gray value* in any area of shadow. In other words, your tonal range of shadow will be limited to the span between middle gray and black. Any shadow tone painted lighter than a middle gray usually breaks up the unity of the overall shadow pattern. A good test of your tonal accuracy is to step back a few feet every once in a while and look at your painting through half-closed eyes. This reduces the details and forces you to see how the subject appears as a unified composition. If the variations of color and tone seem to merge into the overall shadow pattern, your values are accurate. If, instead, the effect seems jumpy and confetti-like, tone down any bothersome areas until each passage appears unified.

Keep painting the various home values and color changes you see until the shadow area appears convincing. Repeat the procedure with the lights. Again, keep all color and

■ *With patient and careful analysis you'll soon begin to see that beneath every gingerbread-laden Victorian house, fire hydrant or eucalyptus tree lies a fundamental form just as easily translated into the language of value, intensity and temperature as a basic block.*

value changes in the light area within the confines of the general pattern of light, going *no darker than a middle gray value* in any area, and limiting the tonal range from middle gray to white.

EVALUATION—Now step back and study your finished picture. If executed correctly, the painting should appear to pulsate with warm and cool color yet still hold together as a light and dark unit. The variety of home values and colors should not only define the character of the forms in the composition but also set up a music-like cadence of varied shapes and tonalities which playfully interact with one another.

APPLICATION—A word about detail. Resist the temptation to develop this, or any other of the exercises, any further than a generalized sketch until instructed to do so. Once a painting begins to look convincing, it's natural to want to keep working until you've included every last detail. A story about John Singer Sargent best describes my feelings about this. A student once had the good fortune to study with Sargent and upon arriving at the master's studio asked where he should begin. After posing a model, Sargent said, "Paint the masses, but no more." The student obliged, and for the next few weeks worked doggedly at following Sargent's instructions to the letter. After a few more weeks the student grew frustrated and asked Sargent when he could go on to the details and try to capture a likeness of the model. Sargent looked at the young student's work and after nodding his head in approval said "No more than a year." So be patient and try not to include any more than the simplest details. If you haven't yet noticed, you're already juggling quite a few sophisticated principles and in time you'll be manipulating a lot more.

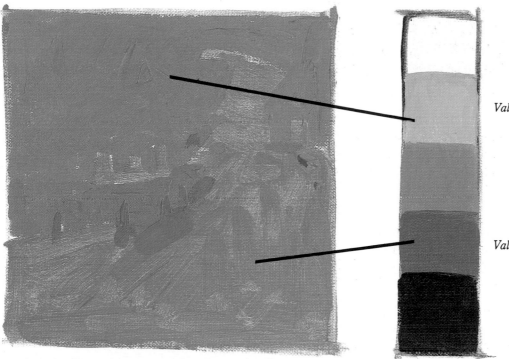

Value of color in light

Value of color in shadow

Orange light and blue shadow lay-in of the subject.

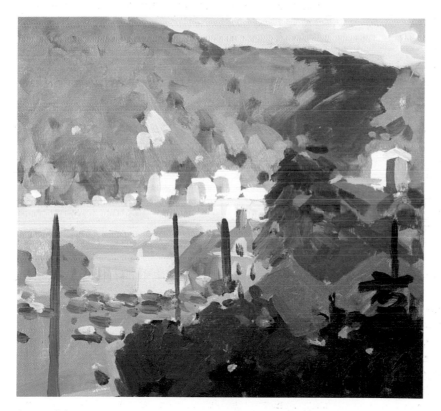

LUKE, MARYLAND
16" × 16", oil on canvas, collection of the artist.
An hour's study of an effect that lasted only minutes. On the day that I passed this industrial area, the setting sun had transformed the scene into a wonderland of shapes and hues. After massing-in a broad pattern of light and shadow, I painted the various home value and color changes, added a few details, and called it a day. Effects such as these change so quickly that an artist has to rely far more on instinct than rules.

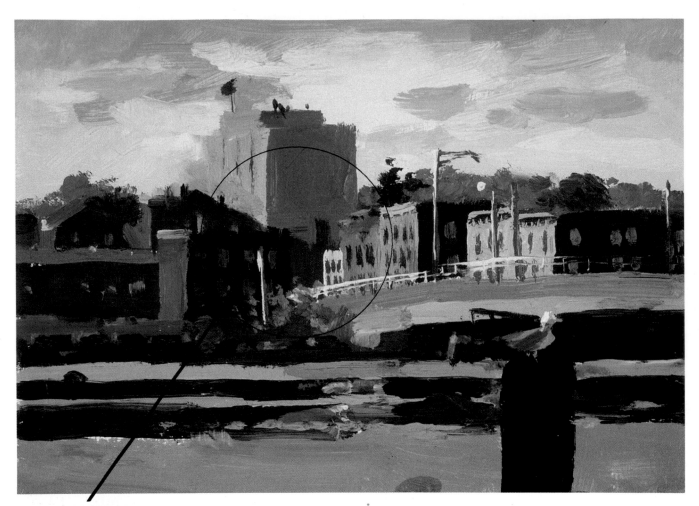

**WARM LIGHT—
COOL SHADOWS**

VIEW OF SOUTH NORWALK
9″×12″, oil on Masonite, private collection.
I worked in my van painting this sunny view of my hometown. The temperature was in the twenties but the color of the light was warm. Light and shadow on architecture have always intrigued me and, when combined with interesting color, make a challenge I can't resist. While loose in technique, I was very careful in this painting to keep the tonal brackets of light and shadow consistent on all the various home values of objects.

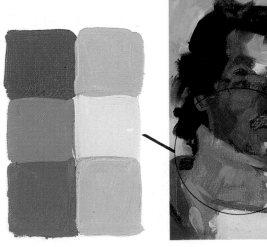

SELF-PORTRAIT
7″×5″, oil on Masonite, collection of the artist.
This self-portrait was painted under cool light, which gave me a chance to inject some rich, warm color into the shadows. While both the lights and shadows are full of various colors, each area maintains a separate tonal identity.

**COOL LIGHT—
WARM SHADOWS**

No matter what colors you use, everything you paint in light should be a middle gray value or above and everything in shadow a middle gray value or below.

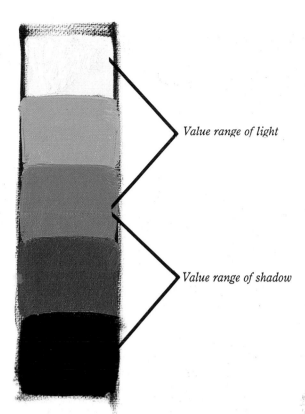

Value range of light

Value range of shadow

AUTUMN ON THE RIVER

12" × 16", oil on canvas, collection of the artist.
One of the bonuses of living near the water is the myriad of changes the tide causes on the various inlets which flow into the ocean. What captivated me about this subject were the nearly black passages of mud that skirted the thin stream of water. The dramatic effect was further heightened by the warm, light-struck grass and trees as they displayed their autumn colors.

DEFINING THE FORM OF A FIGURE WITHIN THE LIGHT AND SHADOW PATTERNS OF A COMPOSITION

The thought of putting any sort of human element into a painting often causes a student to ignore useful skills and tighten up his technique. This need not be the case. People are just as subject to the principles thus far presented as buildings or bottles are.

The reason many beginners shy away from figure work is that rather than sensibly approaching the painting as a problem in form and color, they reach for their small brushes, devote a few laborious hours to the eyes, nose and mouth, become discouraged because it doesn't look like the person, and walk away feeling like a failure. I feel that painting people is no more out of the reach of a beginning student than still-life or landscape subjects. Painting a sketch of a single figure should prove no more difficult than painting anything else.

One reason for this dilemma is the great emphasis put on capturing an exact likeness. The best way around this problem is to disregard, for now, any attempt to do a portrait. Try to visualize the person you're painting with the same detached objectivity used in the earlier exercises. It's only when you become self-conscious of who you're painting that a picture tends to get out of hand. I know it's hard to imagine a husband, friend or fellow student as no more important than a wine bottle or side of cheese, but for the time being this is exactly what I am asking you to do.

PREPARATION— Even if you've never before painted a figure, try to complete this next exercise. Have a friend or classmate pose for you. No fancy props or elaborate costumes are necessary, just a standing or seated figure in everyday dress. Position a light above and either to the left or right of the model. Keep rearranging the lighting until the shadows form an interesting pattern. Don't let the light divide the figure down the middle. Instead, let the shadow predominate so only a third or a quarter of the figure is in light.

ASSIGNMENT— Begin by covering your entire canvas with a thin wash of cadmium orange using a turpentine-soaked rag and a small amount of pigment. The wash takes about ten minutes to dry, so you may want to tend to this first, then pose the model, squeeze out your other colors, and get your painting gear all set to go.

Begin by drawing in a few casual guidelines to show the gesture and basic proportions of the figure. Using a *thin*, middle-valued wash of cerulean blue, paint an even tone over the entire area of shadow. Work boldly, disregarding any of the smaller forms on the figure such as eyeglasses, buttons or shoelaces. Concentrate on the large masses of head, upper and lower torso, arms and legs. Keep the hands and feet simple, like mittens and boots. Try not to focus on the features. Instead, think of

■ *Painting people is no more out of the reach of a beginning student than still-life or landscape subjects.*

the head as a rounded, egg-shaped form and the hair as a helmet placed on top. Eliminate any background material except the shadows cast on the floor by the figure and chair. You may want to put a few darks beside the edges of some of the light-struck areas to show contrast, but this is optional. This stage of your picture should resemble a thinned-down equivalent of the limited color sketch you painted in Exercise Fifteen because if the pigment is applied too thick, the overpainting that follows will smear and your colors will be distorted.

Now begin working into the shadow areas with thicker, more opaque pigment. Recalling the method used in Exercise Two, imagine your hand skimming over the surface of the figure, moving downward over the hair and face, tucking under the chin, jutting out over the chest and in and around each arm. If the person is sitting, visualize the lap as a cloth-covered tabletop with folds radiating down the sides, describing the sturdy forms beneath as they cascade towards the floor. As you paint these forms, rely more on the tactile information your sense of touch gives you than the visual facts your eyes perceive. Start with any area that looks obtainable, an elbow, for example, or the hair. Just as in Exercise Sixteen, try to keep all the shadow values within a middle gray to black range.

Treat the lights in the same manner, this time bracketing your values between middle gray and white. Disregard

any tonal changes that conflict with the overall light and shadow pattern, squinting your eyes occasionally to check out any questionable areas.

Don't try to cram everything you've learned so far into this one exercise. Ease up and try to work in the same relaxed manner as when painting the earlier lessons. Trust that your new-found sense of color will intuitively guide you into making the right choices. Your only concern here should be painting the tactile solidity of the figure and making appropriate home value changes. If laid

in accurately, the light and shadow pattern will take care of itself. The important thing is not to put any undue pressure on yourself.

If for some reason you choose not to paint a figure, set up a still life and follow the same procedure. Cezanne made masterpieces out of a few pieces of fruit. And while he also painted superb landscapes and portraits, it was his artistic vision that made his paintings great and not the subjects he chose.

THE THREE GRACES
18" × 24", oil on canvas, private collection.

Aside from the red and blue dresses, hats and fleshtones, this painting is essentially a variation of different shades of green. This gives the picture unity. Another important device I utilized was to keep all the subtle modeling tones in the shadow of the faces subordinate to the overall home value of the flesh. The same is true with the lights. Simplicity is the key to successfully painting a subject like this. While the eyes, fingernails and other fine details are lacking, the picture still appears complete. This is because the relationship between light and shadow and warm and cool color is carefully worked and painted with conviction.

Laying In and Developing the Figure

A thin wash of orange and blue is used to mass-in the broad light and shadow patterns of the figure.

Working on top of the underpainting, the subject's true home values and colors are defined.

However much or little modeling you choose to do, keep all the tones subordinate to the original light and shadow pattern.

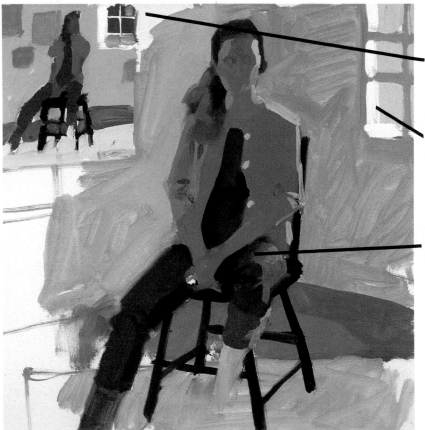

A small preliminary sketch can be useful to help clarify the subject's home values and colors.

The cool light from the window makes the lights on the figure appear bluish. To heighten this effect the shadows are painted warmer.

The entire painting is laid in and developed before any details are added.

FREDDIE
16″×12″, oil on canvas, collection of Stella Thompson, Richmond, Virginia.
A class demonstration of one of those characters that most artists just love to paint. Although Freddie moved around a lot, he had a twinkle in his eye that many professional models lack. Before focusing on Freddie's singular demeanor and colorful dress, I carefully established a strong pattern of light and shadow on the hat, face and shirt. I then developed the individual forms, not taking any one part too far until all the areas were equally developed. To emphasize the light on the figure I minimized the clutter of the foliage in back of the subject.

Imagine a crowd of bathers whose upper bodies are clearly visible but whose lower limbs appear camouflaged by colorful ripples and reflections. Envision the unifying effect the water would have in such a scene and how a similar group of people would appear visually unrelated if seen on an open beach, field or sidewalk. In many ways, the water line which separates a partially submerged form could be likened to the line of demarcation between light and shadow. Taking the beach analogy a step further, simply because the bathers' lower bodies are veiled by the color and movement of the water doesn't mean they're nonexistent. In such a case the *appearance* of the submerged limbs may alter, but their solidity remains intact.

The delicate balance between blanketing a subject with a particular lighting effect and still maintaining the inherent tone, color and solidity of the forms beneath demands skill and inventiveness. The aim of this lesson is to give you a procedure for keeping that balance.

Looking over your previous exercises from this chapter, observe that in most cases the patterns of light and shade give the paintings their initial impact. Form, color changes, and variations in home value generally appear secondary by comparison. So remember that by basing your composition on a pattern of light and dark you give your picture a solid foundation.

■ *Work simply and go for the big effect.*

PREPARATION — This final exercise in light and shadow has two steps. The first will be to paint two small, black-shadowed studies similar to the three you did in Exercise Fifteen. These should be no larger than a postcard and should take only a few minutes to complete. The second step will be to choose the best of the two sketches and enlarge it into a full-size format, incorporating what you've learned about form, home values and color.

Choose any subject but make sure to work under either strong sunlight or substantial artificial light. Your choice could include either a landscape, figure or still-life arrangement. It might be fun to try combining different subjects, setting up a still life outdoors, for example, or combining a small figure with either a landscape or some interesting props. The choice is yours. It can be as simple as a few nuts and a slice of watermelon or as complex as a busy street, but keep the complexity of the subject relative to your degree of proficiency.

ASSIGNMENT — Complete two or more preliminary sketches. Then, lay in the picture applying the same procedure used in Exercise Seventeen. Develop the painting the same way you did in the previous two exercises. Work simply and go for the big effect. State the broad shadow forms, taking your time to analyze the subject with a penetrating eye rather than just painting what you see. Remember to keep the shadow tones limited to a span between middle gray and black.

For example, say you've chosen a small figure surrounded by a cluster of red buildings. In this case the range of home values might include the *white* shirt the figure is wearing, the *light* value of the flesh and sky, the *middle* value of the figure's pants, the cluster of buildings, and the surrounding grounds, the *dark* of some window trim, and the *black* of the figure's hair and shoes. Now move on to the color aspects of the subject. If the source of illumination is warm, the lights will pick up the color of the light source while the shadows will probably contain some hints of cool blue, purple or green. For now, disregard any reflected lights like shiny windows or puddles as they will only add a burden to an already involved problem.

As you paint, try to visualize the subject tactilely, using the tones and colors to describe the solidity of each form. Don't be discouraged if you feel all thumbs. In time, the whole procedure will become a smooth-running operation with all the principles working together.

Try to complete the sketch in the three hours allotted for this exercise. By going too far over the limit you'll undermine the aim of the lesson.

Light and shadow diagram of the subject.

KITCHEN INTERIOR WITH FLOWERS
24" × 30", oil on canvas, collection of Lori Cutler-Goodrich, Rowayton, Connecticut.
What holds this picture together is the predominance of shadow. Study the painting and observe how, aside from the windows, sinktop and a few slivers of light on the orange, plant leaves and windowsill, the subject is essentially in shadow. Within those shadows, however, are numerous passages of reflected light from the window on the other side of the room. Be on the lookout for ordinary subjects like this because they can give you an opportunity to personalize a painting with material uniquely your own.

KITCHEN STUDY
10" × 6", oil on Masonite, collection of the artist.
A color sketch exploring the possibilities of direct lighting. This time the emphasis is on the sink. This and the watercolor study on page 53 gave me the idea for the larger painting shown above.

Photograph of the subject.

While both of these black-and-white studies capture the vitality of the subject, the second one is more successful than the first because the patterns are simpler to read. Remember to keep these sketches loose so you can find how the lights and shadows best display the subject.

Adding full color to the composition is far easier now that the light and shadow patterns are resolved. Consistent to the light source, all the modeling in the light is bracketed between middle gray and white while the shadows are painted in a range between middle gray and black. Adding color is simply a matter of determining the temperature of the light and subordinating the hues to match the values of the lights and shadows.

NAPLES, FLORIDA
12" × 16", oil on canvas, collection of the artist.
If you look out the palm trees this painting would still look like Florida. The reason is the color. Having painted similar subjects all around the country, I find it fascinating how each locale has its own unique color ambience. In this case, the blues and greens lean towards sap green, cerulean and Thalo blue rather than the ultramarine and viridian more common in colder climates. This is because the light appears more yellow-orange, which in turn makes the sky appear warmer. Because photographs seldom are accurate in portraying these regional differences, the painter is forced to do some location work in order to build up a visual vocabulary as to just what these differences are.

MORE THAN A SHADE OF TRUTH

Like a maestro directing his baton at the various sections of an orchestra, as a painter you too are responsible for conducting your own compositions. Unlike the immediacy a musical conductor is faced with, however, the artist has the luxury of building his work up in progressive stages.

Experimenting with various effects of light and shadow enables an artist to preview the overall impression of a painting. Staying within this light and dark pattern allows for sustained work on the various pieces of a picture while still being able to keep an eye on the total effect.

This and the other skills you have exercised during these first three chapters should equip you to handle most of the basic mechanics of painting. While the material that follows is equally important, it's the use of the primary building blocks covered in these early lessons that will form the bulwark of your technique.

Integrating these skills takes practice. Part of the pro-

cess is that *you* assume the responsibility for what and how you paint. Whatever working procedure you choose, learn to see the total effect you're creating. There are infinite variations within the techniques taught here, allowing each subject you paint to be a unique statement. A brilliant autumn landscape, for example, might be better expressed with a rich tapestry of color woven into a strong pattern of light and shadow with a minimum of form and solid definition. A pair of weathered boots could be primarily an exercise in tactile modeling, underplaying color, light, and shade. To heighten the mood and add more of a feeling of mysterious suggestion, a dramatic night scene may demand emphasis on interesting shapes of lights and darks, minimizing color and any tactile feeling for the subject, letting the viewer's imagination solidify the forms. Whatever your choice of focus, light and shadow can always play at least a small part in helping you express your point of view.

· C H A P T E R 4 ·

A PAINTERLY SENSE OF VALUES

I've always been amazed how certain paintings, when viewed from a distance, appear to be loaded with a wealth of detail. Surfaces like water, wood and stone take on a richness of texture and sheen. Faces come alive with expressive character and trees have the appearance of sprouting thousands of leaves. Stepping closer, however, an entirely different visual character reveals itself. What was once a rich tapestry of lifelike effects now appears as no more than crude slashes, dashes and daubs of thick paint positioned in seemingly formless patches of tone and color. Where before stood a majestic oak in full leaf now emerges a mad quiltwork of unrecognizable swatches and dots lying on top of washes dripping with reckless abandon. This visual sleight of hand, though appearing difficult, is essentially no harder to execute than painting the illusion of colored light or indicating a descriptive cast shadow rolling over a tree trunk. And just as Rembrandt, Monet and Sargent all had their own ways of exercising this magic, the principle is ready and waiting for your unique interpretation.

The power of suggestion has long been an ally to the artist, and, with experience, you will be able to reduce most any subject into strong, simple statements of hue and value. Zigzags of green paint will transform themselves into acres of forest, confetti-like flicks of pink, blue and orange will become crowded streets, and bold strokes of light and dark will metamorphose into intricate architectural details.

Most pictures are based on the power to suggest rather than define. By limiting the tones and colors used in painting an apple, for example, to eight or ten accurately placed strokes, the rendition becomes far more lifelike than if an unlimited palette were used and the form rendered with photographic accuracy. Because it's impossible to duplicate in paint the succulent juiciness of a ripe apple the painter is forced to call upon the viewer to participate in the interpretation. For this reason, a painterly translation of a subject will go much further in conveying a sense of realism than a literal copy.

Edouard Manet's interpretive depictions of life in eighteenth-century France were among the first canvases to be coined "painterly." The term was meant to describe the artist's deliberate paint application and purposeful use of broad tonal patterns. What Manet hoped to accomplish—and succeeded splendidly in doing—was to make the *painting* the work of art rather than relying on the charm of the subject to give the picture worth. This was quite a departure from the more traditional approach of thinking of paintings as windows through which to depict lifelike illusions of three-dimensional forms receding in space. Manet minimized the feeling of space and dimension in favor of interesting two-dimensional patterns, discarding the smooth modeling techniques employed by academy painters. Working with a loaded brush and refusing to alter the freshness of his strokes, the artist called upon the viewer to visualize the details.

STUDY PROGRAM Lesson 4: A Painterly Sense of Values	
TIME	**EXERCISE**
1½ hours	**19** Extracting the tonal essence of a subject
3 hours	**20** Combining tone, light and shadow to duplicate the surface appearance of a subject
2 hours	**21** Using tone to create a center of interest
2 hours	**22** Combining tone and limited color to key a painting
1½ hours	**23** Combining tone and full color to show atmosphere in a painting
2 hours	**24** Emphasizing either tone or color in a painting

The light and dark gradations of a subject's value range often appear to be as many and varied as the myriad of hues on a color wheel. And just as some basic guidelines were needed to reduce the complexity of color into workable terms, so too with value. Because your tonal interpretation should be as personal as your sense of color, the following exercises are designed to allow for a wide range of flexibility. You'll find there's no one way to solve these problems, so think of the lessons more as a guide to push you in the right direction than a set of predetermined rules to follow. The important thing is to let your intuition guide your brush, apply the paint confidently, and trust in the knowledge you've already acquired.

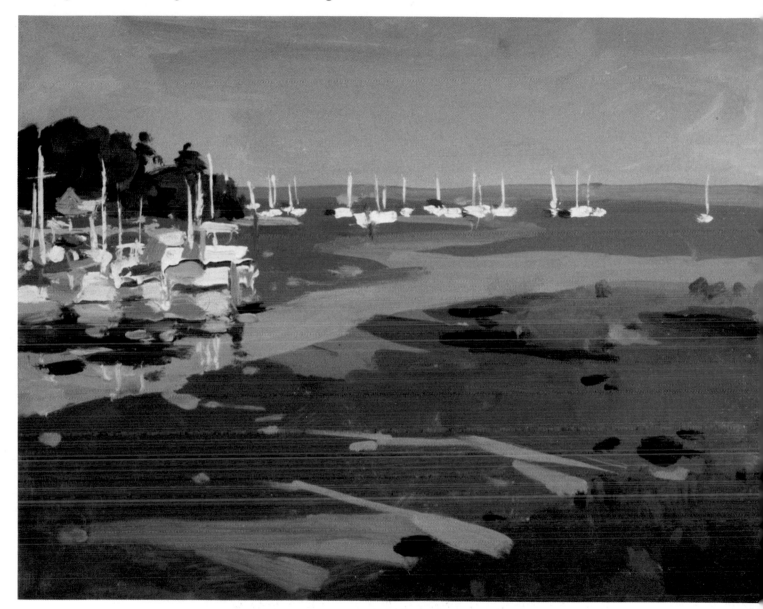

WILSON POINT
12" × 16", oil on Masonite, collection of Edith McClean, Rowayton, Connecticut.
This may be the fastest picture I ever painted. I had about twenty minutes before the sun set. Determined to catch the effect, I began painting with no drawing whatsoever, piling on thick paint as quickly as I was able. Paintings done at such a feverish pitch by necessity must minimize or eliminate detail, focusing on value and color. If these essentials are right, the viewer's imagination will fill in the details. Aside from white, the entire painting was done with ultramarine blue, alizarin crimson, cadmium yellow pale and sap green.

The temptation to plunge headlong into copying a subject tone-for-tone is a natural inclination common to most beginning painters. It would seem logical that if a subject were painted exactly as it appeared the result would be a close facsimile of the original theme. Two factors, however, prevent this from happening. First, the range of values between black and white paint is far narrower than the considerably wider scale visible to the eye. Looking into the sun or at a bright light, for example, causes a painful glare that even the whitest of white pigments can't even begin to match. The second factor is that nature rarely provides us with ready-made compositions. We're seldom aware of this because our eyes focus instantaneously and set up a composition of sorts out of whatever we concentrate on by softening the forms in our peripheral vision. So when we gaze at something, our eyes are really using a type of tunnel vision akin to a riveting spotlight illuminating a stage performer. Focus on a finger held ten or twelve inches in front of your face and everything else in your line of sight appears softer by contrast. Owing to this fact, it is impossible to paint a subject exactly as you see it merely by focusing on one item at a time. The following exercise will demonstrate that the way around this dilemma is to visualize the entire subject as a single, unified whole.

Most painters employ a gradated value scale similar to the one used in Exercise Seven. This helps to visualize the allotment and distribution of tones needed for a given subject, and prevents the various light and dark home values of objects from becoming muddled into one repetitious range of tones. Using a value scale also helps separate the foreground, middleground and background values, which is essential for showing distance. Just as tactile modeling, light and shadow, and color are thought of as the building blocks to good painting, values can be said to make up the bedrock on which these are laid.

PREPARATION—Using either burnt umber, Payne's gray or black mixed with white, paint a scale of five values on a corner of your canvas. Remember to keep the gradated tones evenly bracketed to include white, light gray, middle gray, dark gray and black. Your choice of subject can include anything from a still life to a landscape or interior. The exercise involves three different sketches, so you may want to try one of each. If at all possible, work from live subjects. Working from photographs or magazine clippings could do in a pinch but you'll gain a lot more from the lesson if you stick with the real thing.

Whatever you work from, try to choose the material for its interesting tonal qualities rather than the narrative it depicts.

ASSIGNMENT—Begin by squinting your eyes until the subject you've chosen is reduced to a blur of abstract shapes. Study the shapes until you see large tonal masses. Start painting, choosing any one of the five values on the scale that comes closest to matching one of the tonal masses observed in the subject. Working with crisp incisiveness, translate the various tones you see using any one of the five values at your disposal. *Avoid intermixing any of the five values to match a particular tone of the subject.* This will mean some ruthless discrimination on your part because many of the values will appear as jumpy combinations or bewildering gradations. A stadium full of spectators, for example, could be reduced to a middle gray. A cloud-filled sky at sunset might be generalized to a single light gray or a littered dresser bureau an uncompromising dark gray, and so on. Try to work quickly so your intellect doesn't intervene and dictate that the subject be recognizable. There's no need to feel an obligation to copy the values exactly as they appear. If the dark shape of a foreground tree provides a good centerpiece for a composition, don't hesitate to change a similar dark value on a nearby rooftop to a lighter value. Close up, your sketches may appear nonobjective but don't let that stop you from fashioning them into sturdy arrangements of interesting lights and darks.

■ *If the dark shape of a foreground tree provides a good centerpiece for a composition, don't hesitate to change a similar dark value on a nearby roof to a lighter value.*

OBJECTIVE—If executed successfully your studies should not only crackle with abstract interest but, when viewed at a distance, take on a suggestive realism that, unlike the subject, smacks of pictorial completeness. I encourage you to get into the habit of painting many such sketches not only to sensitize your eye into seeing the big picture but also to help nurture your compositional skills.

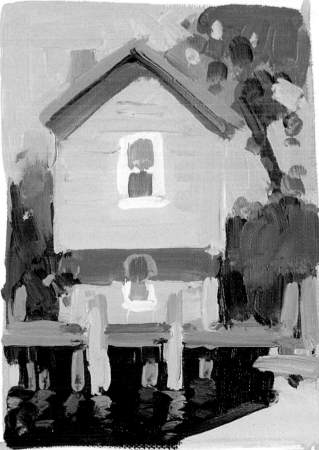

Working from the three subjects shown, each of the accompanying sketches reduces the countless value changes seen in the photographs down to five. Notice the crispness and vitality the sketches display. Now visualize how busy they would appear if the photographs were copied tone for tone.

COMBINING TONE, LIGHT AND SHADOW TO DUPLICATE THE SURFACE APPEARANCE OF A SUBJECT

Cover a light and you create a shadow. Seems obvious, yet many students lose sight of this basic fact and try to substitute meticulous rendering for discriminating tonal judgment. No matter what you paint, light is the dictating influence on the distribution of shadows as well as the particular value scheme that will clothe the subject.

In many ways painting a visual representation of a subject is akin to photography. Both are concerned with appearance and either can find anything under the sun a possible theme. Like a snapshot, the visual painter's composition can be either casual or formal. A patch of dabbled sunlight against the side of a building is just as suitable a motif as the darkened interior of a medieval church or a wispy formation of clouds. The prime focus is the interesting tonal effects and patterns that stir the eye.

PREPARATION— This next exercise involves painting a single composition. The emphasis is on capturing the *appearance* of the subject. The selection of material to paint and how to light it is your choice so long as the setup remains unchanged during the three-hour exercise. Because of the lesson's critical emphasis on subtle tonal juxtapositions, work from life if at all possible. Your palette will again consist of either burnt umber, Payne's gray or black, and a generous amount of white.

ASSIGNMENT— Working with the same limited scale of five values used earlier, mass-in broad patterns of tone similar to the approach used in the previous lesson. Because your composition now fills the whole canvas, you may be tempted to refine objects or get more fussy with detail. Avoid this by working with a larger brush and standing as far back from your easel as possible so you're forced to work broadly. I once had a teacher who would place a stool between a student and his easel if a painting began to look too picky.

Once the composition is laid in, stand back and see if it has the same strong mosaic of patterns as the sketches from the previous lesson. If not, now's the time to restate any bothersome areas.

So far, you've been limited to five values. To develop the intermediate and finishing stages of the painting, expand the value range of the scale by adding four additional tones. Think of these as half-steps. Mix up a light gray and add equal amounts of white. This will give you a value halfway between white and light gray. To mix the three other half steps combine equal amounts of light and middle gray, middle and dark gray, and dark gray and black, or whatever dark color you're using. The expanded range should now include nine evenly gradated tones. After the

Spartan discipline of working with only five values, you should be able to interpret any tonal arrangement your subject displays.

■ *In many ways painting a visual representation of a subject is akin to photography. Both are concerned with appearance and either can find anything under the sun a possible theme.*

ESTABLISH ANCHORS— Continue painting by establishing what I call "anchors." These are value notes daubed in with a small swatch of paint to show which areas of the composition approximate middle gray, white and black. Position the anchor notes after the lay-in is completed. Once these tonal guides are established, your next aim is to subordinate the other values accordingly.

EVALUATION— After completing this intermediate stage, again step back and evaluate what you've done. Ask yourself if the picture still retains the strong pattern it had in the initial lay-in. Are the tones crisp, yet subordinate to the overall effect? Do the values capture the character of the particular lighting condition? Adjust any problem areas, then begin finishing the picture. It's at this point that many student paintings begin to deteriorate rather than improve. Like delicately positioning a few remaining playing cards atop a fragile framework, it takes very little to topple over a painting's underpinnings. So take your time and paint the finishing layers of strokes with care and sensitivity. This doesn't mean focusing all your attention on minute passages and rendering them with a small brush. It does mean taking care not to undermine or dissipate the impact of the whole composition. It also means retaining your painterly approach down to the final finishing touches. Remember, your eyes focus on what you are looking at, while your peripheral vision remains softer. If you give equal attention to each and every item, the unity of the combined effect is going to suffer. Squint your eyes every so often to make sure you're reducing every form to its very essence. Some painters look at their subject through a dark piece of colored glass or plastic. To summarize, painting a bottle, for example, may require but one flat value during the lay-in. The intermediate step may divide the tone into two or three variations while the finishing stage may need no more than one or two additional strokes to render the form complete.

APPLICATION—As you study your finished painting, it may come as a revelation to see that many of the principles from previous chapters have unknowingly worked their way into the picture despite the fact that you were only concerned with painting what you saw. If so, be pleased that your mind has subconsciously assisted in the work and realize that as you continue to grow this will happen more frequently. On the other hand, if your painting falls short of your expectations, trust that it's only a matter of time before your brush will begin to respond automatically to help provide surprisingly effective pictorial bonuses.

Degas said of Monet that "He's only an eye, but what an eye." What Degas meant was that the artist intentionally tried to block out any preconceived ideas about what he was painting and simply worked at reproducing what was in front of him. Because of Monet's lifelong dedication to picture making, however, his mind had long since digested the very principles you may now be struggling with.

Photograph of the subject.

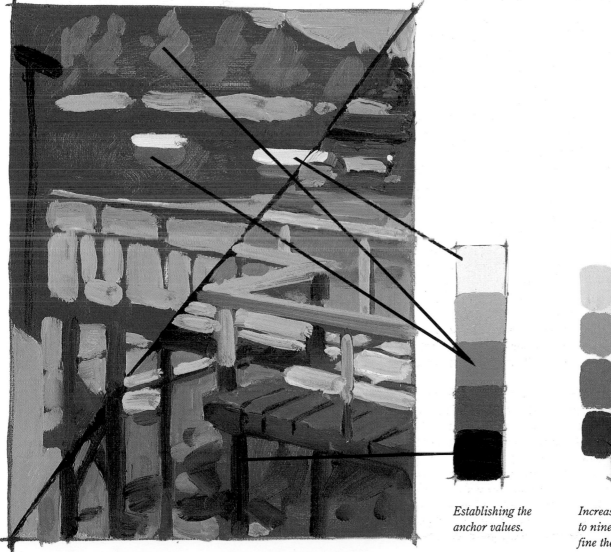

Establishing the anchor values.

Increasing the scale to nine values to refine the painting.

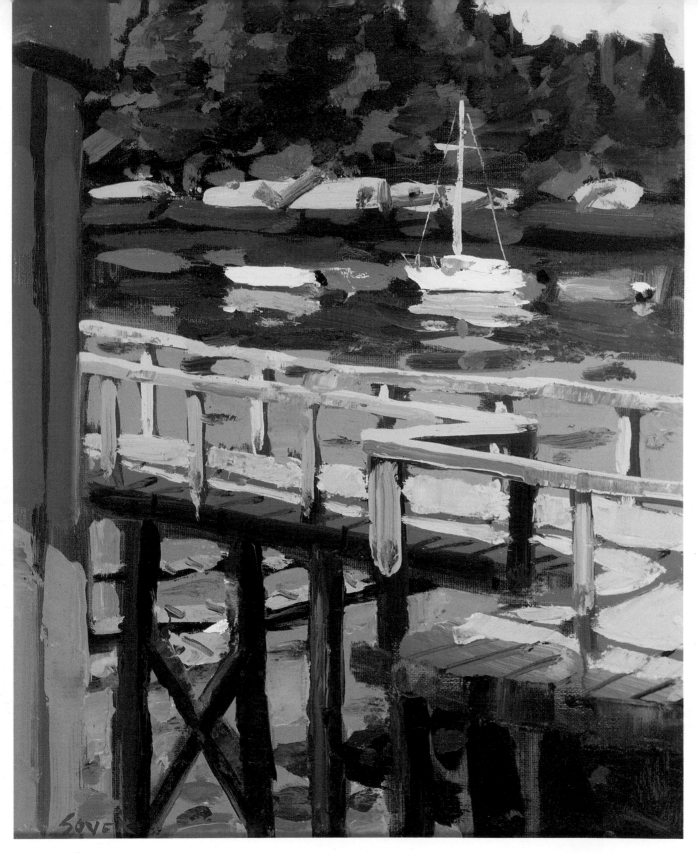

HARBOR, SEBASCO, MAINE
14" × 11", oil on canvas, collection of Martha Ann Taylor, Gainesville, Georgia.
The tonal organization of this painting is built on the foreground, which not only takes your eye into the composition but also forms an eye-catching center of interest. The line of light-struck lobster traps seen through the dark pilings of the walkway give depth by giving the viewer something to see after looking through the pilings. "Harbor, Sebasco, Maine" took three hours to complete.

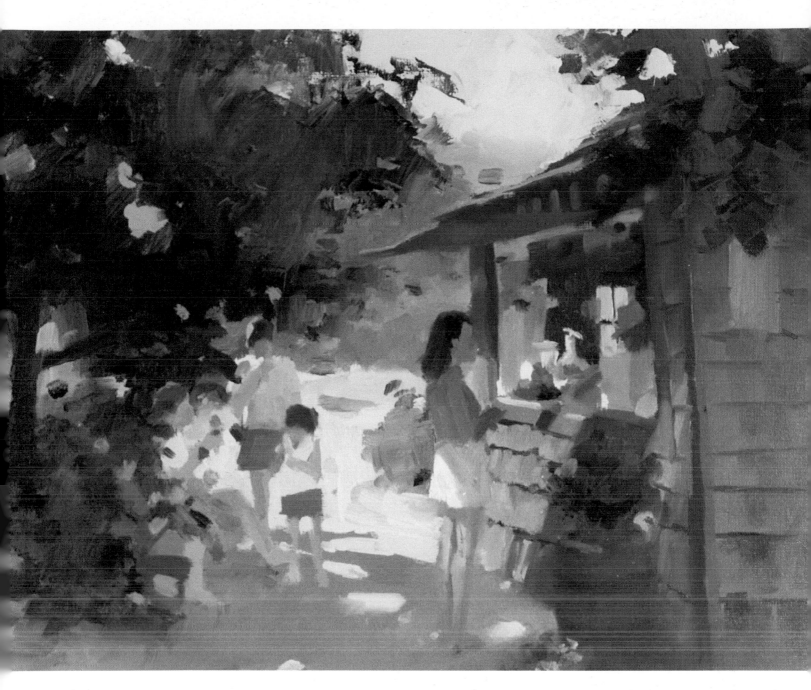

JULY

16" × 20", oil on canvas, collection of Armand de Grandis, Torrington, Connecticut.

Aside from the girl in front of the stand, notice how the figures here have no faces, fingers or toes but are made up of blobs of various light and dark colors. This enables the viewer to fill in his own details and in turn keeps the picture from becoming a narrative illustration. I used a lot of atmospheric perspective to create depth. Notice how the overhanging branch, building and foreground figure are darker than the middleground figures and trees while the background is painted even lighter in tone. I did three or four color sketches before painting "July" and although the execution appears spontaneous, the painting took three days to complete.

Drop an orange jersey onto the dark green grass of a playing field and even from a considerable distance the garment will attract attention. On the other hand, throw a worn, leather baseball mitt onto the same field and from just a few yards away the object appears to melt into its surroundings. So too with the major or minor elements of a painting. Once skill is acquired in objectively capturing the appearance of a subject, the artist is free to focus on the more illusive qualities of picture making. Shifting your quest from visual accuracy to the intangibles of selectiveness, embellishment and accentuation is a sign of growth and artistic maturity. Doing so will give your imagery a more personal stamp of expression. Subduing a secondary segment of a composition by framing it with a patch of similar values or accenting a focal point by surrounding it with contrasting tones is a device painters have used for centuries. The principle is easily understood and, once learned, can be a mainstay in your tonal repertoire.

PREPARATION — The following exercise uses this device to help you have control over the focus, pattern and mood of your composition. Using the same limited palette and expanded range of values as in the previous lesson, set up a still life composed of half a dozen pieces of fruit or vegetables ranging in value from middle gray to white. As a centerpiece, choose anything from a blackened cooking pot or frying pan, to a wine jug or any other large, dark form that tonally contrasts with the lighter items. You'll also need a piece of light-, middle- and dark-toned cloth or drapery for the different backgrounds employed. These could be random pieces of fabric, old shirts and dresses, bath towels, or even sheets of paper or cardboard.

Begin by draping the lightest of the three backdrops over the base and up the vertical wall of the empty stage in which the objects will be placed. Illuminate the area with a strong light from either the left or right. Next, arrange the items so *one light-* and *one middle*-toned piece of fruit or vegetable overlaps the shadow side of the larger, dark-toned centerpiece. The four remaining pieces should be within close proximity but not overlap the two that will eventually form a focal point. The aim of this lesson is to feature a different segment of the still life in each of the three sketches *without* repositioning any of the items, so take your time until the arrangement is set up according to plan.

ASSIGNMENT — Divide your painting surface into three equal sections. Sketch three identical compositions of the subject before you begin painting. For your first painting sketch, paint the subject as it appears because the strong contrast between the dark centerpiece and

light background is all that's needed to form a center of interest. For the second sketch, however, feature one light- and one middle-toned piece of fruit instead of the large dark pot. Set against the same light background, the task proves difficult because of the overpowering presence the pot assumes against the background. Replace the light background drape with the middle-toned fabric. The pot then recedes in importance and the fruit assumes more dominance. There still remains one last hindrance, because all of the pieces of fruit assume equal importance. The way around this is to slightly darken all the values on the light side of the fruit *except the two featured pieces*. Likewise, you'll need to slightly lighten all the tones on the shadow side of the secondary items. One final adjustment. Assuming the dark side of the pot appears black in shadow, lighten all the values in that area to a half-step between black and dark gray *leaving a soft halo of black around the two featured pieces of fruit*. This takes attention away from the overpowering mass of the pot and focuses attention on the fruit. I call this the "spotlight" effect because it directs the strongest value contrasts around the center of interest.

■ *Shifting your quest from visual accuracy to the intangibles of selectiveness, embellishment and accentuation is a sign of growth and artistic maturity. Doing so will give your imagery a more personal stamp of expression.*

In your final sketch, focus on two *light* home-valued pieces of fruit. Replace the middle-toned background drape with the dark one. With both pot and background now dark, the problem changes. The various light and middle-toned items are clearly seen and the two featured pieces of fruit can be featured using the same spotlight effect used previously. The new problem is to get the pot to still appear defined yet keep its proper secondary position in the composition. The solution is to employ what artists call a "passage." This means *darkening* the values beside the light side of the object and *lightening* the values beside the dark side of the form. In the case of the pot, the device not only helps define the form of the object but also gives added dimension to the area. This light against dark, dark against light principle can be used again and again in your pictures to emphasize a form and add to the illusion of space.

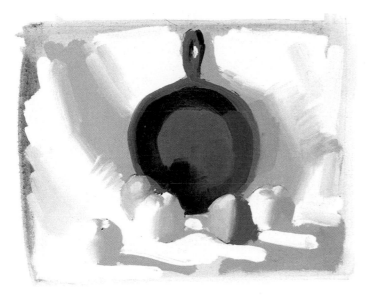

The white background emphasizes the dark of the pan and minimizes the lighter-home-valued pieces of fruit.

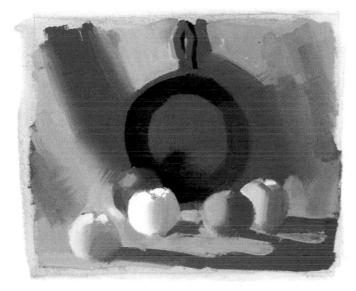

The middle-toned background subdues the importance of the pan and places emphasis on the two light-home-valued pieces of fruit.

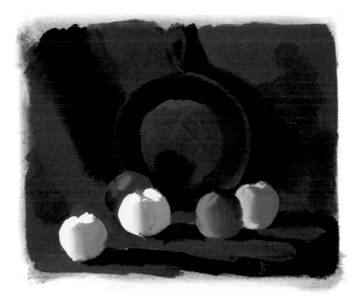

The dark background places even more emphasis on the light home values of the two apples while making the darker pieces of fruit and pan appear to merge into the background.

Light against dark

Dark against light

Designing lights against darks and darks against lights sets up an interesting tonal rhythm throughout a picture and enables you to place emphasis on what's important in the composition.

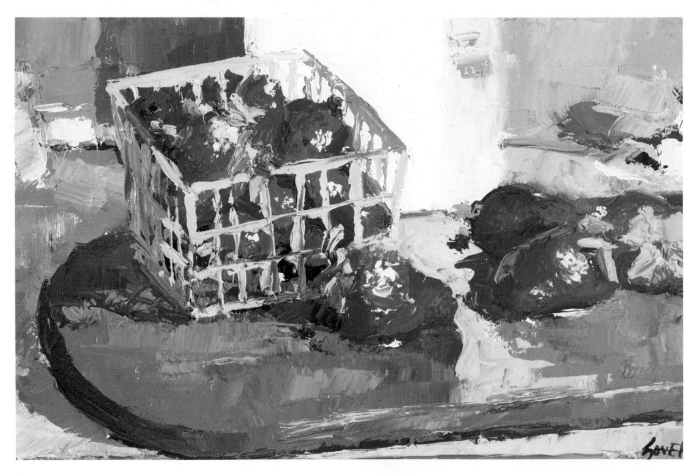

STRAWBERRIES

7″ × 13″, oil on canvas, collection of Jeannie and Eric Pierce, Annapolis, Maryland.

Fresh fruit and vegetables are always interesting to paint because of their fresh color and interesting shapes. Rather than contrive an arrangement I usually prefer to paint such items as I happen upon them. What intrigued me about this subject was how the green plastic container formed a complement to the fruit and by doing so, heightened the intensity of the reds. Observe how I've underplayed the background by reducing it to a near abstraction with only the merest suggestion of recognizable forms. Executed in one three-hour session, "Strawberries" was painted entirely with a palette knife.

APPLICATION— A study of the three sketches on page 79 should clearly reveal a dominant center of interest in each, with all the other items tangible yet playing subordinate roles. It's surprising how much flexibility you have in emphasizing or subduing the forms in a composition. All that's needed is careful consideration of the arrangement, lighting and background material, and a clear idea of what's to be featured. Once mastered, these principles can easily be applied to painting any subject under whatever lighting condition you choose.

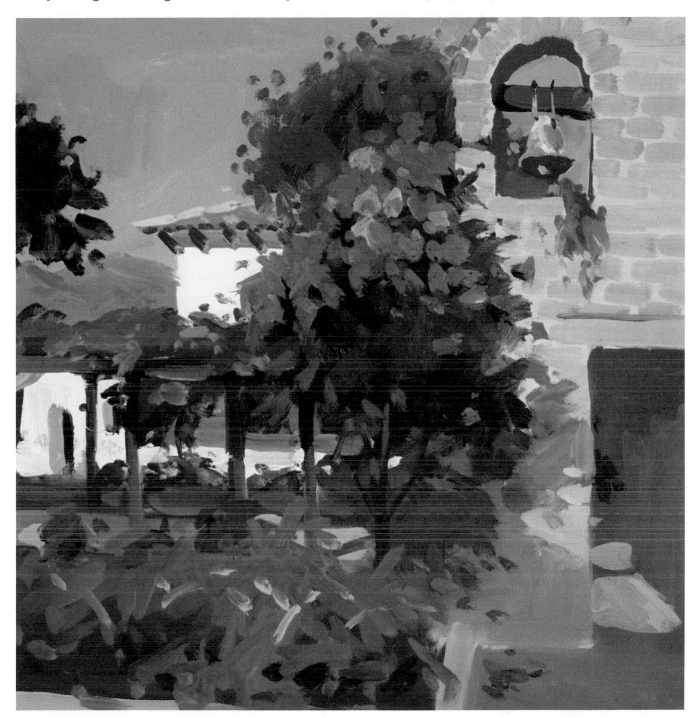

MISSION AT SAN LUIS OBISPO
16" × 16", oil on canvas, private collection.
As I painted this location piece a warm, balmy breeze was blowing, the smell of bougainvillea was in the air, and a choir blended with the warble of some distant mockingbirds. These ideal conditions played a part in helping to convey the serenity of the subject—especially when contrasted with the clatter of big city street traffic and noisy boat yards that I'm accustomed to hearing. To capture the warm light of Southern California I used a predominately warm palette consisting of brown madder, alizarin crimson, cadmium red light, cadmium orange, cadmium yellow pale, yellow ochre, sap green, Thalo blue and cerulean blue.

EXERCISE

22 COMBINING TONE AND LIMITED COLOR TO KEY A PAINTING

Imagine the following three subjects for a painting: a cluster of pastel-colored bathing towels lying on the white sand of a sun-filled beach, a vendor selling his wares on a busy city street, and the dark outline of a weather vane silhouetted against a night sky. Each evokes a different mood. To capture the spirit of such subjects a painter is often required to exercise some artistic license and overstate the tonal makeup or "key" of what he's painting. Keying a picture means emphasizing the particular range of values prevalent in a subject and, when combined with color, presents the viewer with a heightened sense of mood. Keying also enables the artist to share with the viewer the same kernels of pictorial uniqueness that moved him to paint the picture. Almost any subject can be reduced to one of three different tonal plans. These include high key (the beach towels), middle key (the street vendor) and low key (the weather vane). Many students, in their eagerness to catch all the nuances of a particular effect, tend to constantly compare their picture to the subject, forgetting that when hung on a wall, a picture's impact relies solely on what is within the frame and not on how closely it simulated what was observed.

The following lesson concentrates on limiting the values used in each key to intentionally exaggerate a particular mood. While the emphasis will be on value, limited color is employed to help dramatize the effect and to get you into the swing of juggling both hue and value.

PREPARATION—Working either from life or photographs, pick three subjects that incorporate each of the three different tonal keys. Your choice for a low-key scheme could be an interior illuminated with a dim light, a group of buildings or boats positioned against a darkened section of trees, sky or water or a figure dressed in dark clothing in front of a dark backdrop. As long as the values range from black to white, middle-key material can be anything from landscapes, seascapes and street scenes to well-lit interiors, figures or still-life arrangements. High-key subjects mostly occur outdoors under bright sunlight although you could use a figure dressed in light-valued clothing, a still life composed of light-toned objects, or an interior illuminated with bright fluorescent light. If unsure about the key of a subject, hold a small mirror under your eyes and look at the scene upside down. This turns an otherwise recognizable subject into an abstract arrangement of tones, colors and shapes.

After dividing your canvas or paper into three equal sections, wash in a light gray tone over the middle-key format and a middle gray over the dark-key format. To help keep each key separate and distinct, daub in—either above or beside each of the sketches—the same kind of five-toned value scale used in Exercise Nineteen. Starting with the high-key sketch, draw a line beside the scale and bracket the range from middle gray to white. Since the middle-key sketch encompasses the entire range, no bracketing is necessary. For the low-key sketch, bracket a line that includes middle gray through black.

Now choose three colors whose home value approximates each of the three tonal keys. To help determine your choices, refer to the color chart completed in Exercise Seven. Cadmium yellow medium, for example, could be one of a number of choices for the high-key sketch. Cadmium red light or permanent green light could each work well in the middle-keyed scheme, with Thalo blue or ultramarine being possible options for the low-key sketch.

ASSIGNMENT—Beginning with the high-key subject, start massing-in the large shapes of tone and color using the same procedure employed in Exercise Nineteen. Using any of the hundreds of combinations possible with black, white and the single color you've chosen, try to approximate the tonal pattern and mood of the subject. Remember, any values or colors you choose could be pos-

■ *To capture the spirit of a subject a painter is often required to exercise some artistic license and overstate the tonal makeup or "key" of what he's painting.*

sible solutions for a particular effect *so long as they keep within the allotted tonal bracket.* If in doubt, paint a test swatch directly on top of the value scale beside the sketch. Repeat the procedure with the middle and low-key studies, developing each sketch until you feel it's complete.

Because the entire range of values was used on the middle-key sketch, it will probably appear more tonally satisfying than the other two. To remedy this you're now going to accent the high and low-key sketches with two or three small garnishes of contrasting value. In the case of the high-key painting, a few small swatches of dark accents around the focal point will do wonders in setting up a pleasing balance. These may take the form of a dark

stripe on an awning or sign, a bathing suit, or a fence post. In the low-key sketch, a couple of bright highlights such as a streetlamp, window or puddle reflection, or light-toned piece of clothing should set up just the right amount of contrast to foil the otherwise dark tonality of the painting. Don't overdo these accents and highlights because any more than a few will dissipate the unique effect of the key.

EVALUATION—Now study your sketches and see if each maintains its proper place in the series. When viewed collectively, the sketches should appear to pulsate with rich yet varied tones and colors. Yet when looked at individually, each should reveal a pictorial completeness uniquely its own. In time, this will all become second nature, and keying a subject will demand no more effort than matching a tone or mixing a color.

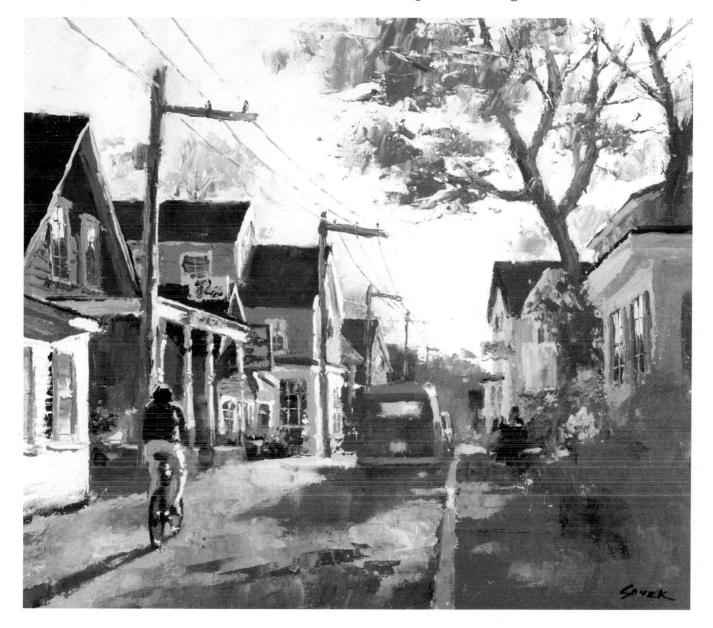

PROVINCETOWN
20″×24″, oil on canvas, collection of Judy Kerr, Rowayton, Connecticut. To capture the feeling of the sun as it began to descend toward the horizon I painted the right area of the sky slightly lighter and more yellow. I then subtly cooled the color and deepened the value as it moved from the center of the painting to the left. I also capitalized on the mirrorlike quality in the windows by reflecting some warm yellow into those facing the sun and cooler blue into those facing the opposite direction. I keyed the picture in the middle range to be able to include the rich array of tones needed to capture the effect.

While the photographs shown here imply different value keys, it's up to the artist to clarify the effect he wishes to emphasize. Study the three demonstration sketches painted from the photographs and notice how, by bracketing a different range of values for each of the subjects, the key of the painting appears more obvious.

High Key

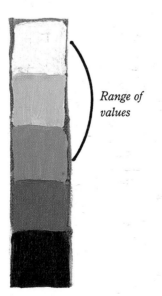

Range of values

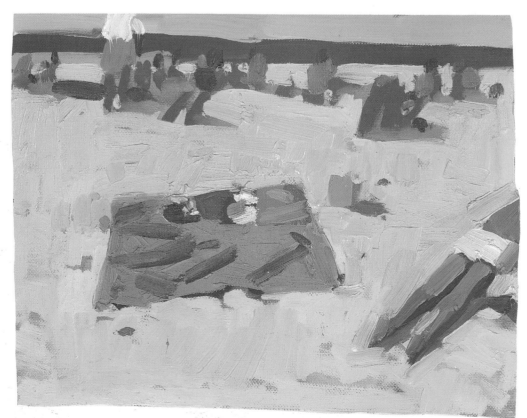

Middle Key

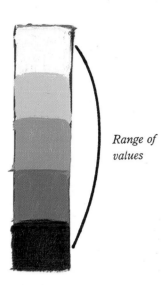

Range of values

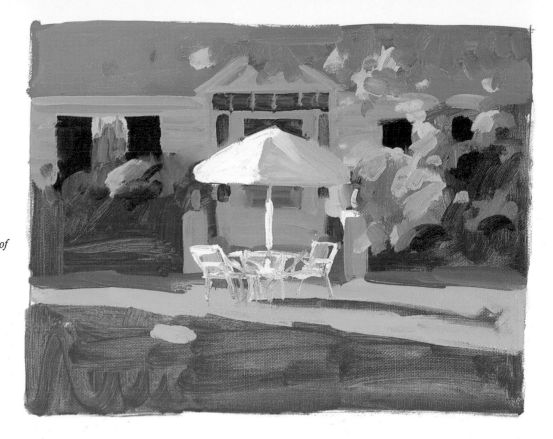

Low Key

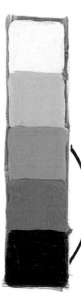

Range of values

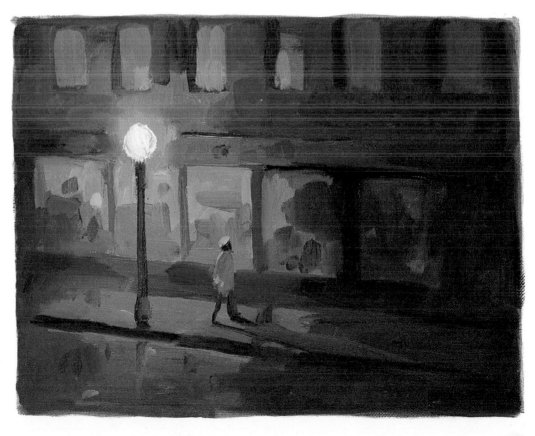

COMBINING TONE AND FULL COLOR TO SHOW ATMOSPHERE IN A PAINTING

To understand how atmosphere affects a subject, gaze across any local panorama and notice that the more distant a building, growth of trees or range of hills appears, the lighter in tone and more muted in color it becomes. This effect is especially noticeable when the weather is humid and you can literally feel the moisture in the air. So, too, with interiors. A large cathedral after a candlelight ritual, a dusty library hall illuminated by a few shafts of sunlight, or a crowd-filled gymnasium can all take on a vast dimension when bathed in atmosphere. The reason for this is that the dust, smoke and condensation in the air, particularly at the end of the day, form an increasingly dense veil over distant objects and in so doing, alter their home value and color.

Capturing the feeling of atmosphere is most easily accomplished by reducing the number of clusters of objects that recede into space to a manageable few. Most painters find success by limiting the planes in their pictures to the three broad categories of foreground, middleground and background. By doing so, what previously appeared as an endless array of unmanageable and often cluttered material now becomes a clear visual pathway that not only helps lead the viewer's eye back into the picture but also gives clarity to the composition's tonal makeup.

Atmospheric perspective first came into use during the Renaissance when analytical realists such as Leonardo da Vinci began thinking of their pictures as "windows into space." Turner and Constable further exploited the device, but it wasn't until French impressionism that the full pictorial possibilities of atmosphere and space were explored.

PREPARATION—This next exercise is broken down into two parts. First, draw a postcard-sized black-and-white sketch of any panorama of your choice. This could be a city, suburban or country landscape, street scene, or even seascape. Beside the sketch, paint a small, five-toned value scale similar to the one used in past lessons. Alongside the scale draw a line that brackets all the tones from black to white. Now draw a second line which brackets only the tones from dark gray to white. Finally draw a third line bracketing only the values between middle gray and white. The aim of this diagram is to isolate the various tonal ranges of the foreground, middleground and background of your sketch.

Now, study your subject and pinpoint the near, middle and far areas of distance. Doing this will require some decisiveness on your part because most subjects include many more degrees of distance than the three mentioned. A nearby barn, silo and house surrounded by trees, ma-

chinery and a haystack, for instance, should all be thought of as part of the foreground plane. The middleground may be a hodgepodge of more trees, some outbuildings, fences and a stream but still considered as one collective element. And although the background might appear to be broken up with fields, hills or even a distant mountain range, the items should be bunched into a single component.

Using the three brackets on your value scale as a guide, paint in the foreground of your sketch with the complete range of values. Next, move to the middleground, decreasing the range to a dark gray to white bracket. Then paint the background in the middle gray to white range. Paint the sketch as simply as possible using only the five tones of the scale, referring to the different value brackets as often as needed. Remember, the aim here is only to diagram the three planes of distance as they recede in space. Your completed study should provide enough data to give you a foothold in painting the larger, more finished rendition.

ASSIGNMENT—Now sketch a full-sized version of the same subject. Once drawn, paint a daub of cadmium yellow light, cadmium red light and ultramarine blue on the side of the drawing beside the foreground section of the composition. Beside the middleground, paint a daub of cadmium red light and ultramarine blue. Alongside the background, paint a single daub of ultramarine blue. The

■ *Capturing the feeling of atmosphere in a painting is most easily accomplished by limiting the planes in your picture to three broad categories: foreground, middleground and background.*

color notes are to remind you that the more distant a subject, the cooler the colors become. This isn't to say you can't show a yellow house in the background or a blue-shirted figure in the foreground. But, if you do paint a yellow building in the background, be sure it's a *cool* yellow. And if a figure in a blue shirt does appear in the foreground, make sure the blue is a *warm* blue.

Working with a full palette of colors and employing the complete range of nine tones—the five basic values plus the four half steps—begin massing in the composition the same way as in Exercise Twenty. If in doubt about a particular tone, make a test swatch on the value scale in the appropriate bracket. If the subject is strongly lit, try to

exercise some of the same kind of design and inventiveness with the light and shadow patterns you did in Chapter Three. If you see colorful temperature changes between the lights and darks, show them. Remember, on a sunny day the lights will appear warmer and the shadows cooler, while on an overcast day just the reverse happens. Likewise, if the forms lend themselves to a more tactile approach, adapt your painting plan accordingly. Your prime focus, however, should be on capturing the atmosphere and depth of the subject.

While the bracketing formula given earlier will convincingly show an atmospheric effect, remember that each subject presents a different challenge. A foggy day, for example, will sometimes turn even the middleground of a scene into a high-keyed study in close values, whereas the near and far distance of some mountains viewed from a high altitude on a clear day could appear equally strong in tonal contrast. So instead of treating the bracketing recipe given here as a hard and fast rule, think of it as a point of departure. The best way to learn about atmosphere is to paint dozens of small location studies from life in all kinds of weather, seasons and times of day. This will enable you to build up a visual vocabulary so when working in your studio or from photographs you'll have the necessary skills to create a convincing illusion of atmosphere and space.

Using Atmosphere to Show Distance

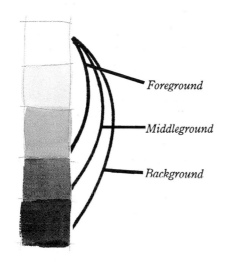

Foreground

Middleground

Background

Don't overwork this preliminary sketch. Keep the treatment poster-like and restrict yourself to only the values indicated.

Skies can also be instrumental in showing atmosphere. Notice how even a clear day can be made to appear dimensional by cooling the color of the sky as it recedes. By adding some clouds, the effect not only becomes more atmospheric, but also gives the painter an interesting series of light and shadow patches to further heighten the feeling of distance.

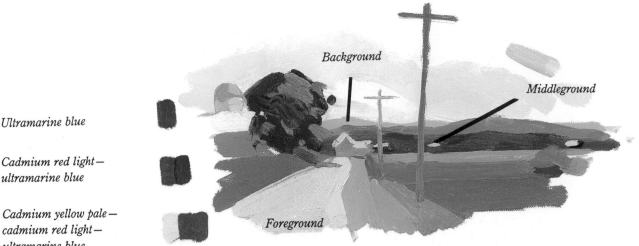

Ultramarine blue

Cadmium red light—
ultramarine blue

Cadmium yellow pale—
cadmium red light—
ultramarine blue

Background

Middleground

Foreground

PENNSYLVANIA DUTCH COUNTRY
12"×16", oil on canvas, collection of the artist.
To add to the rural ambience of the locale, every twenty minutes or so I would hear the sound of a horse-drawn wagon approaching and an Amish family would pass by, wave and disappear down the road. This kind of thing gives location work an immediacy seldom found in studio projects. I worked from back to front in this painting, laying in the sky, clouds and distant mountains with thick opaque paint, moving onto the middleground field, buildings and road and ending up by painting the telephone poles directly into the wet underpainting. To make the background recede I added a lot of ultramarine to the greens, lessening the amount toward the foreground. I used the shiny metal roofs of the buildings as focal points, reserving my only touch of pure white for the top of the silo.

Big Sur

12" × 16", oil on canvas, collection of the artist.

On rare occasions an artist will come across a subject so perfectly composed that all that's required is to paint what you see. Bir Sur was such a subject. A fog shrouded the background just enough to reduce the hazy masses into a cluster of revealing silhouettes, the middleground showed definition yet still revealed enough atmosphere to make it recede, while the foreground rocks and waves loomed majestically, providing an ideal center of interest.

EMPHASIZING EITHER TONE OR COLOR IN A PAINTING

Camille Corot was essentially a tonalist. Claude Monet was known for his color. Renoir and Degas often chose to combine both, while Pissarro started out a tonalist, explored the various combinations of the two, and ended up a colorist. All of these great artists were true to their instincts, yet each had a different set of priorities. While it's impossible to completely separate tone from color, a distinction does exist; it's up to each painter to find his own unique place in the scheme of things.

PREPARATION — This next exercise is designed both to develop your sensitivity to the enormous range of possibilities tone and color offer and to help reveal your personal preference for either of the two. To get the full benefit of the lesson, work from life rather than photographs. Since some very individual choices are involved, your artistic growth will be greater by responding to your subject directly, rather than getting a secondhand version from a photograph. A still life is probably the best choice for a motif although you could work from a landscape or interior providing the lighting remains consistent throughout the duration of the project.

ASSIGNMENT — For this lesson use a separate canvas for each of the three exercises. Draw the subject on your first one, then write the word *TONE* above the sketch in easily read block letters. Begin painting with a full palette and whatever combination of procedures feels most comfortable. Imagine you are relieved of any pictorial responsibilities except to depict as truthfully as possible a tonal representation of the subject before you. Just before beginning work, concentrate on the word *TONE* written above your composition, letting the word roll around in your mind until all your attention is focused on it. As you paint, repeat the word over and over until it preoccupies your thoughts like an old song that pops into your mind that you can't help humming again and again. Use whatever combinations of black, white, prismatic colors or earth tones necessary to capture the tonal makeup of your subject. Don't worry about home colors, temperature changes, intensity variations or colorful grays. Simply try to duplicate the tonal integrity of what you see. When finished, put the picture face against a wall or in another room so you can't see it until the other two paintings in the exercise are completed.

Sketch an identical version of your first composition

onto your second canvas. This time write the word *COLOR* above the drawing. Now take a few moments to clear your mind of anything to do with tone and begin concentrating on the word *COLOR*, repeating it over and over until the image of the word is firmly implanted in your thoughts. Begin painting, this time using any means at your disposal to capture the unique color qualities of

■ *As you are painting, think of tone and color as deep wells of knowledge from which to draw.*

your subject. Scrutinize each shadow, duplicating whatever subtle hues each passage might yield. Scour the lights and halftones for temperature changes and clues as to how the source of illumination influences home colors. Play warm against cool, bright against dull, and complement against primary until you get the desired effect, all the while letting the word *COLOR* dominate your thoughts. Complete the painting and, like the first, put it somewhere it can't be seen.

To complete the exercise, again duplicate the composition of the first two studies. Above the third sketch write the words *TONE AND COLOR MY WAY*. With your senses now finely tuned to both tone and color, free your mind of either aspect and paint the subject exactly as *you* see it. Before starting, close your eyes and visualize the phrase *TONE AND COLOR MY WAY*. Think of the words *TONE* and *COLOR* as deep wells of knowledge from which to draw. Then ponder the words *MY WAY*, letting the phrase comfortably sift through your consciousness until it becomes a personal affirmation that it's okay to be yourself. Begin painting, confident that no matter what direction your impulses take you, you are equipped with all the inner resources needed to accomplish the task. As you paint, resist any feelings of obligation to side with either tone or color, shrugging off any purist attitudes and letting the subject dictate your approach. Side with your intuition rather than your intellect. All during the painting session, keep the words *TONE AND COLOR MY WAY* circulating through your thoughts and know that so long as you paint naturally, it's impossible to do anything wrong.

EVALUATION—Now place your two previous studies beside the one you've just completed. Look at the paintings and ask yourself the following questions: Which one do I like best? Which one has the most vitality, best captures the particular subject, or has the most penetrating mood? Finally, which one looks most like me? Share your ideas with other students or friends, asking them how they interpret what you've done. Remember, there's no one way to do this assignment, and the only kind of success that can be measured here is the degree of personality each study evokes. If ten students come up with ten different solutions, the exercise is still a success.

APPLICATION—Whether you know it or not, each of you has a preference towards either color or tone. As a student, this will most likely alter from time to time. Even as you mature, different subjects, places or even moods may call up a different responses. The important thing is to go with the flow of your strongest interest, shore up any weaknesses you feel need strengthening and realize you have the option of making both tone *and* color an integral part of your artistic makeup.

Three Different Palettes

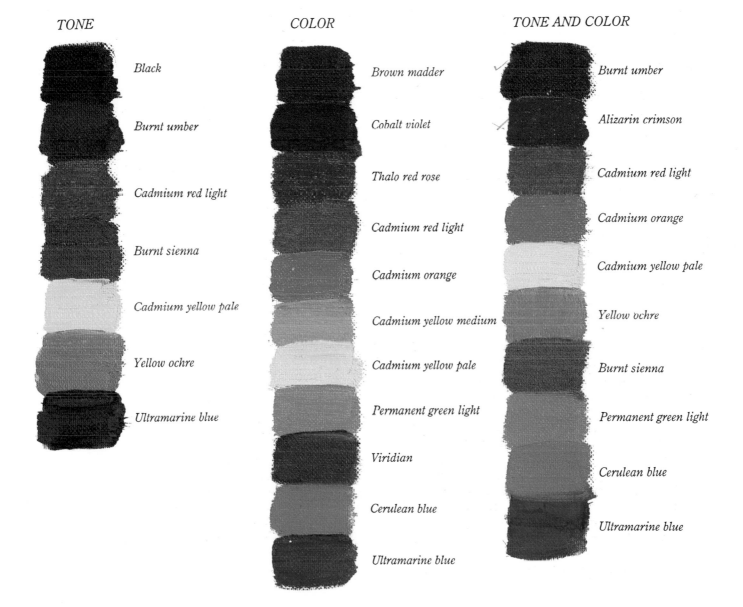

TONE	*COLOR*	*TONE AND COLOR*
Black	Brown madder	Burnt umber
Burnt umber	Cobalt violet	Alizarin crimson
Cadmium red light	Thalo red rose	Cadmium red light
Burnt sienna	Cadmium red light	Cadmium orange
Cadmium yellow pale	Cadmium orange	Cadmium yellow pale
Yellow ochre	Cadmium yellow medium	Yellow ochre
Ultramarine blue	Cadmium yellow pale	Burnt sienna
	Permanent green light	Permanent green light
	Viridian	Cerulean blue
	Cerulean blue	Ultramarine blue
	Ultramarine blue	

TONE

Notice how somber this sketch appears when compared with the two variations below. Many painters more interested in tone than color often employ a limited palette such as this because it gives them a rich array of values to work with yet still provides enough color to breathe life into a subject.

COLOR

Impressionists enjoy this kind of colorfully robust palette because it gives them an opportunity to set aside the more traditional tonal approach and focus entirely on exploiting the hues of a motif to their fullest. Observe the pulsating effect this sketch has when compared to the others.

TONE AND COLOR

Combining both tone and color is probably the most popular approach of the three because it enables a painter both to richly model the forms in his composition and also to capture any unique characteristics the colors might display.

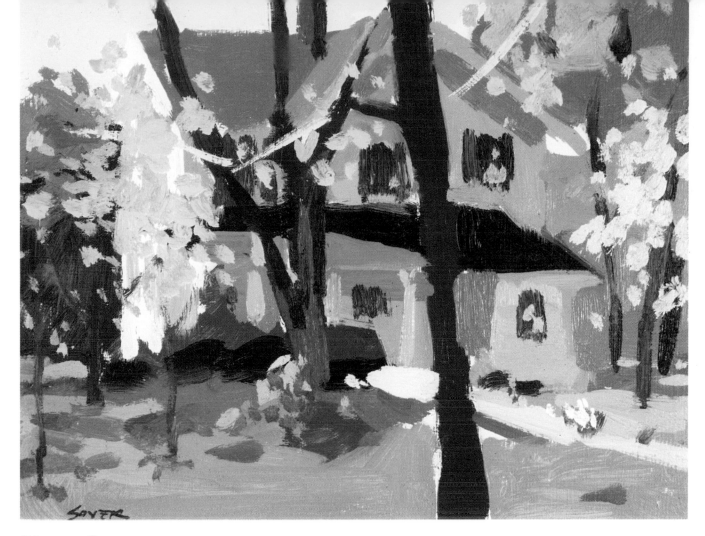

WESTPORT SPRING
9" × 12", oil on Masonite, collection of the artist.
This on-site painting started out as a crude sketch to help clarify some ideas I had about using a limited palette. After juxtaposing the warm and cool gray tones of the roof and siding, I saw some interesting shapes begin to emerge and based the rest of the composition on those two promising tonal notes. The bright yellow in the light areas of trees adds a color emphasis to an otherwise tonally oriented painting. I was pleased with the results of my experiment. A picture will frequently evolve with little conscious effort when you are busy trying to solve a problem. On the other hand, if you go out to paint a masterpiece, the free flow of spontaneity can often get bogged down in self-consciousness. The limited palette I was experimenting with was alizarin crimson, cadmium yellow pale and ultramarine blue.

VISUAL GUIDEPOSTS

Just as any good map can show a traveler the clearest way through a particular locale, the tonal layout of your pictures will guide the viewer. I remember viewing an exhibition of work by the Spanish impressionist Joaquin Sorolla and, being especially enamored with an unusually large and ambitious scene of some fishermen and their wives mending a sail, returned a few days later. Looking at the light-filled piece a second time, I noticed that as I gazed past the lush foreground props which gave way to a group of colorful middleground characters, I had retraced exactly the same path as when looking at the picture the first time. It probably took Sorolla considerable effort to stage such a complex production, yet when studying the composition it was as easy to read as a road sign.

Every artist at one time or another has found himself so immersed in a painting that he loses sight of the fact that the viewer is able to penetrate the composition only by following the visual trails and markers the artist lays out. And no matter how beautifully rendered a particular passage may be, unless it works in concert with the other parts of the composition, the picture could turn into an unrelated collection of parts. As any good cinematographer, interior decorator or conscientious dinner host arranging a table setting knows, it's sometimes not what you show but how it's displayed.

As you've probably already discovered, many of the same basic truths have determined the success or failure of the twenty-four exercises you've completed so far. However difficult some of the remaining six exercises appear, it's the fundamentals like clarity, unity and simplicity that will carry you on to a successful completion of the program.

· C H A P T E R 5 ·
SEEING THE BIG PICTURE

This chapter will deal with fine-tuning many of the principles covered so far and will demonstrate how these devices can be used to tie a picture together. With a solid grasp of the fundamentals now at your disposal, laying in and developing a painting should present no major problem. Taking a picture to completion, however, can involve an entirely new set of challenges. These might include orchestrating the glistening highlights of a puddle-filled street, knowing when and where to soften the edges of a cloud so it helps accentuate the sharpness of a foreground tree, giving different kinds of texture to the various surfaces of a rock-filled shoreline, or learning how to compress the vastness of a desert panorama into the comparatively small format of a canvas. However, unless these devices are knowledgeably applied, they can just as easily clutter up a picture as unify it.

One of the pitfalls all artists occasionally fall into is becoming so fascinated with the rendering of the various forms that they lose sight of the fact that it's the total impact of a picture that makes it a work of art and not the facility with which its parts are executed. And while many of the following principles can help impart a high degree of realism to a composition, it's far more important that these skills be used as a means to an end rather than a way to dazzle the viewer with a few brilliantly rendered yet unrelated parts.

Although the next six exercises may seem more sophisticated than the earlier lessons, try to relax and go with the ebb and flow of each individual problem. Many students at this stage feel an obligation to cram everything they've learned into a single painting and apply themselves with forced determination. Surprisingly, it works better the other way around. By blanking your thoughts to everything but the work at hand and approaching the project with childlike playfulness, your odds are far better for ending up with an exciting solution. So relax, and let the joy of self-expression guide your brush.

STUDY PROGRAM
Lesson 5: Seeing the Big Picture

TIME	EXERCISE
2 hours	**25** Unifying the surface and edges of the forms in a painting
2 hours	**26** Altering the tonal range of the various forms in a subject to unify a composition
2 hours	**27** Using halftone and reflected light to solidify forms and unify color and texture
2 hours	**28** Using color to unify a subject
2 hours	**29** Unifying a subject under different lighting conditions
2 hours	**30** Compressing the expansiveness of a subject into the restrictive dimensions of a painting

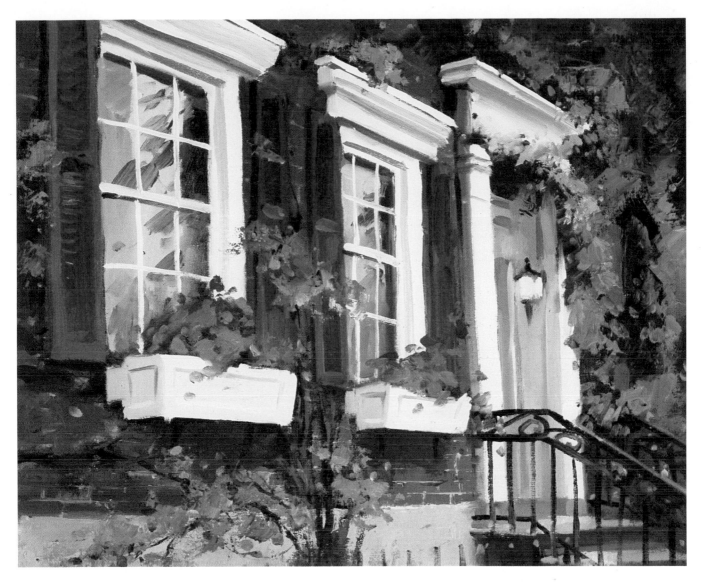

GREENWICH VILLAGE BROWNSTONE

18" × 24", oil on canvas, private collection.

*The overcast light that illuminates this subject instills a mood completely
different from that of sunlight. I don't paint under this kind of light very
often, but for the depiction of this stately old brownstone, it proved the
right choice. Observe the dramatic patterns set up with the white window
and door trim silhouetting the deep red brickwork and green foliage.
Each part relates to the whole, no matter how colorful or dramatic. To
vitalize the more muted reds of the building, I intensified the color of the
geraniums. I also painted the doorlamp lit, which gives a contrasting
note of warmth to the otherwise cool scheme. My palette was made up of
cadmium red deep, Thalo red rose, cadmium yellow pale and viridian.
"Greenwich Village Brownstone" took two days to complete.*

Glass is shiny. Bark is rough. Hair is soft. Steel is hard. A painter could probably fill up pages describing the various surfaces and textures of subjects. Confronted with such an array, it would seem quite a feat to organize everything into a cohesive whole. Add to this the limitations of paint in duplicating the range of tones and colors in real life and the challenge appears insurmountable. By working within these limitations, however, and developing a consistent language of images, it's possible to duplicate a surprisingly wide range of surface effects.

Just as the dozen or so intensity changes inherent in a color were abbreviated to include only bright, medium and dull, the types of reflective surfaces can be reduced to a manageable few. While there are probably hundreds of subtle variations between the shimmer of a polished mirror and the dull opaqueness of a piece of black coal, the entire range can be effectively summed up in four different degrees: mirrorlike, glossy, dull and flat. A chrome bumper, silver serving dish or calm stretch of water could all fit into the mirrorlike category. Glossy surfaces include a damp stretch of beach, pavement or street, varnished wood or a freshly shined pair of shoes. Dull objects, though still slightly reflective, appear far more subdued than mirrorlike or glossy surfaces and can range from a bunch of carrots to the tanned body of a sunbather. Flat surfaces are usually dark in tone and could include anything from a piece of velvet to a rock, old board or shovel full of dirt.

To varying degrees, a reflective surface can deceptively alter the home value and color of an object. A dry umbrella, for instance, may be red in home color and middle gray in home value, but when wet, its shiny surface could easily lighten in tone and take on the pale gray cast of a stormy sky, whereas a flat piece of brown construction paper hanging near a sun-filled window would show little, if any, evidence of a color or value change.

Edges work hand in hand with surface treatment in a painting. They can be reduced to four varieties: hard, firm, soft and lost. Hard edges are most often used in the foreground of a picture. The side of a building, fence or strongly lit figure, for example, could all be treated with hard edges as could the areas in, or around, the center of interest. Firm edges occur mostly on rounded forms like mountains and hills, the crest of a wave or parts of the human figure. Firm edges are also useful in place of hard edges for making a foreground or middleground object less important than the focal point of a composition. Soft edges can include the leaves on a clump of secondary trees or bushes, certain types of soft fabrics or fur, hair, or the background in a hazy landscape. Lost edges are most useful in capturing atmospheric effects such as clouds, fog, moving water or falling snow. Aside from these practical applications, various kinds of edges can be woven intuitively throughout a painting to balance a composition, play down an imposing form, or heighten the effect of a particular mood.

PREPARATION—This exercise involves painting a single picture of any subject of your choice. The aim of the lesson is to depict and unify the four different kinds of reflective surfaces using the four different edge treatments described. When picking a subject, make sure it includes a wide variety of surfaces. A street scene, more complex still life or interior could all be suitable choices. If painting outdoors, work under direct sunlight. Indoor painters should illuminate the setup with light from either the left or right.

ASSIGNMENT—Using a full palette of colors, lay in and develop the painting using the same procedure as in Exercise Twenty. *Avoid painting any surface reflections or edge variations until the painting is first laid in and then taken to the intermediate stage.* This is to prevent getting bogged down in surface detail before the masses of tones and colors are established and the forms solidified.

Now begin indicating the various degrees of reflectiveness. As you work, try to fashion a new combination of edges for each of the different surfaces. Generally, hard edges appear more often on highly reflective forms, and duller objects seem to be made up of softer contours. The snappy highlight of a wine bottle, for example, could be contrasted with the glossy skin of a pear, while the crisp, mirrorlike finish of a silver tea pot could act as a foil to the softness of a piece of drapery. Remember, there's no single solution to this problem. Be guided by the principles, but let your intuition make the final decisions.

■ *Various kinds of edges can be woven intuitively throughout a painting to balance a composition, play down an imposing form, or heighten the effect of a particular mood.*

EVALUATION—Once the painting is completed, step back and see if the whole ensemble appears unified. While the emphasis of this exercise is on reflective surfaces and edges, remember that you have a whole arsenal of color, light and shadow, values, and form at your disposal. So if you get bogged down, don't be afraid to ask yourself for help.

Reflections are usually duller in intensity than the objects that are reflected. In this case, the calm water causes an almost mirrorlike image. If the water was choppy, the reflection would become more fragmented.

BOATS IN SUNLIGHT
14" × 11", oil on Masonite, collection of Charles Movalli, Gloucester, Massachusetts.
I usually paint an object first and then add the reflection, which is the most logical approach. But, I won't hesitate to redesign a reflection if it's not contributing to the composition of the painting. I've probably done hundreds of studies like this yet never tire of the endless effects of this kind of motif.

Notice how the reflections of the light boats and dock appear darker whereas the darker objects are reflected slightly lighter in value. This principle can vary depending upon the color and depth of the water but in most cases it's an observable fact.

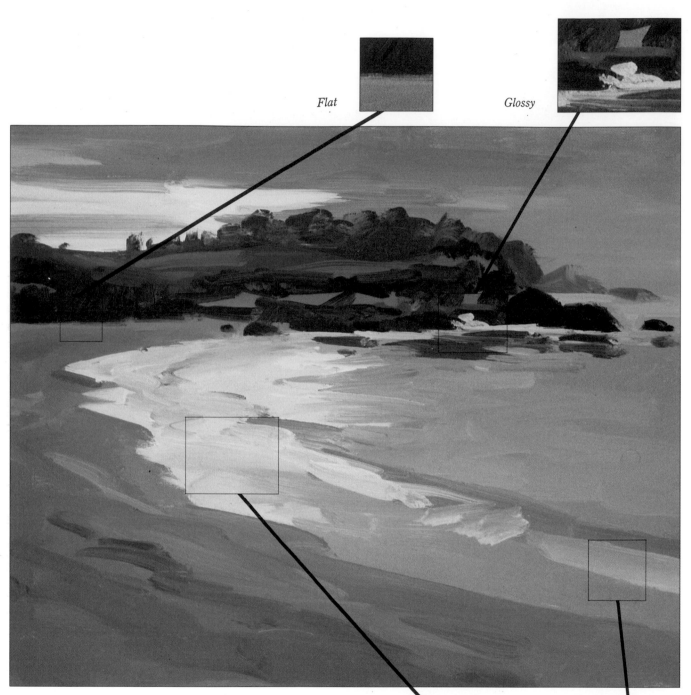

Flat

Glossy

Mirrorlike

Dull

CARMEL BAY

12" × 16", oil on canvas, collection of the artist.

In this painting, the setting sun reflecting into the water forms the focal point for the composition. See how the middleground rocks and expanse of sand beside the water have none of the reflective qualities of the water. Playing dull forms against reflective ones can relieve the monotony of a uniform expanse of land or water by providing a colorful change of pace. Notice how the white surf caused by the incoming wave lacks the gloss of the unbroken water.

Four Different Kinds of Edges

Lost edge

MOUNTAIN STREAM

11" × 14", oil on Masonite, collection of the artist.

This painting was done on gesso-primed Masonite because I wanted a hard surface that would show off the jaggedness of the rocks. To complement the predominance of hard-edged strokes I treated the middleground water softer, letting the different color and value changes melt into the background shadows. I used a lot of tactile painting in this picture to help give integrity to the solidity of the rocks as they recede steplike into the distance. Jack Pellew, a friend and fellow painter, is a master at this kind of subject and I'm sure his influence can be seen in my painting.

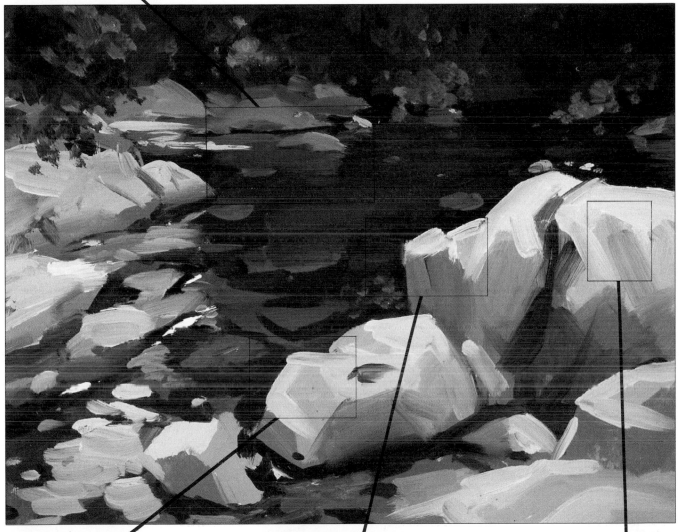

Hard edge

Firm edge

Soft edge

ALTERING THE TONAL RANGE OF THE VARIOUS FORMS IN A SUBJECT TO UNIFY A COMPOSITION

Each painter develops his own "feel" for a tonal range. Some prefer a minimalist treatment, reducing modeling values down to nearly posterlike simplicity. Others favor the richness of a more baroque style and employ a vast battery of modeling tones. Many let the subject dictate their technique, painting the easily read shape of a bicycle, for example, with only two or three values while devoting as many as a dozen tones to sculpt the nondescript character of a single egg, the premise being the more interesting a shape, the less modeling it requires. Altering the tonal range of the various forms within a subject provides the painter with an additional compositional tool to give the viewer a vision of reality.

PREPARATION—This exercise involves breaking a composition into three distinct areas, featuring one and downplaying the others. Because the emphasis will be more on modeling than depth or atmosphere, a still life or figure arrangement would probably be the best choice of subject. If you do choose an outdoor scene, pick something meaty like an interesting row of buildings, some boats tied up at a dock, or a grouping of figures instead of a placid field or stream. If painting indoors, illuminate the setup with a strong light source. If outdoors, choose a sunny day to work. Since the three-dimensional aspect of the subject is key to the success of the project, avoid working from any kind of photographic reference. The aim of the lesson will be to fully develop one of the passages as a focal point, subordinate the others, yet still convey the effect of a complete and unified composition.

ASSIGNMENT—Lay in your picture using the same full palette of colors and approach as in the previous exercise. Once the canvas is covered, get your sketchbook or a piece of paper and make the following diagram. First, sketch in an outline of the entire composition. Next, choose an area you wish to feature and beside it write the words *HIGHLIGHT, LIGHT, HALFTONE, SHADOW, DARK SHADOW* and *ACCENT*. Now move to an area you feel is of secondary importance and write *LIGHT, HALFTONE, SHADOW* and *DARK SHADOW*. Finally, choose the passage of least significance and write *LIGHT* and *SHADOW*. Unlike Exercise Twenty-three, which progressively lightened the values as they receded through

the atmospheric veils of middleground and background, this lesson will give you the option of patterning your tones in whatever place they best suit the composition. Tack the diagram to your easel and resume painting.

Start finishing the picture, resisting any temptation to use more than the number of tones allotted for each area. As you work, study how the light makes its revealing journey around each form. When developing the focal point, show how the highlight gives way to a deeper light before edging through the halftone and finally losing itself in the three values of shadow. Disregard for now any indication of reflected light, approaching the subject more tactilely than visually. The six tones required to paint this crucial area are all you'll ever need to model any form. When combined with a strong light and shadow pattern, proper edge and surface treatment, and the appropriate color intensity and temperature changes, this should fully equip you to solidify any object you ever choose to paint. Moving on to the other areas, reduce the number of modeling values to four when handling the items that are second in importance, saving the two-value range for those passages of least importance. As you work, continue to trace the path of light as it weaves over the forms, juxtaposing different edge treatments as the need arises.

■ *Many students have the mistaken impression that everything they paint should be modeled with equal importance. While the idea seems logical in theory, the results tell another story.*

EVALUATION—Now study your finished painting from a distance. Notice the impact of the center of interest and also the way the secondary areas form the perfect support patterns for unifying the whole arrangement. Since no two artists see a subject exactly the same way, your solution to the exercise will probably be different from that of other students you may be working with. Happily, this is what gives variety to painting. So get risky, trust your instincts, and feel confident that your choice of approach is the right one for you.

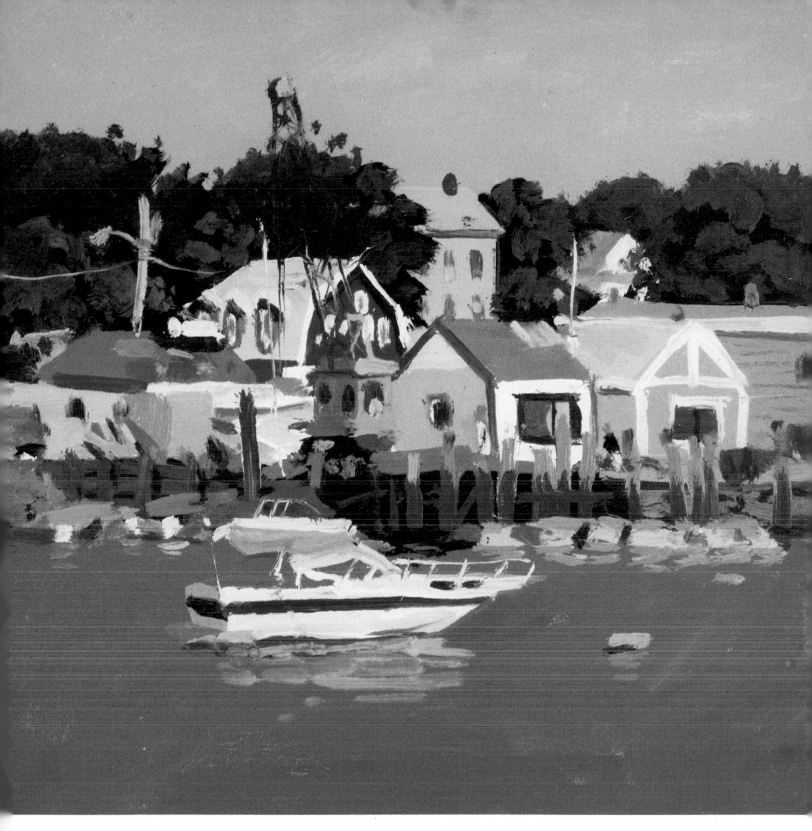

EAST NORWALK HARBOR
16" × 16", oil on canvas, private collection.
I painted this picture like I was doing a patchwork quilt. Beginning with the barn-shaped red building, I placed one note of color beside another until the entire canvas was covered. I don't usually recommend this procedure, but occasionally it's a good way to get out of the rut of using the same approach for every picture. I focused on the interesting breakup of patterns the motif conveyed. Aside from a few reflections, I've minimized any color or tonal changes in the water. This balances the staccatolike patterns of buildings and boats. I painted this entirely on location, spending only a few minutes in my studio touching up some areas that needed refining.

101

Photograph of the subject.

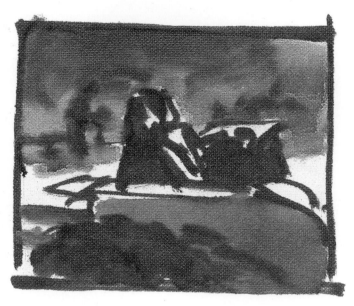

The composition is rearranged to give more intimacy to the scene. The addition of the foreground bushes adds a dimension lacking in the photograph.

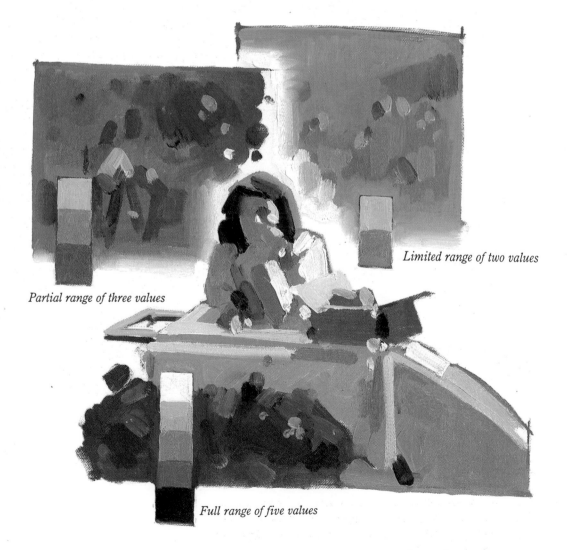

Limited range of two values

Partial range of three values

Full range of five values

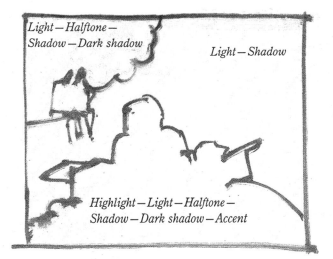

Light — Halftone —
Shadow — Dark shadow

Light — Shadow

Highlight — Light — Halftone —
Shadow — Dark shadow — Accent

Diagram showing components of the composition

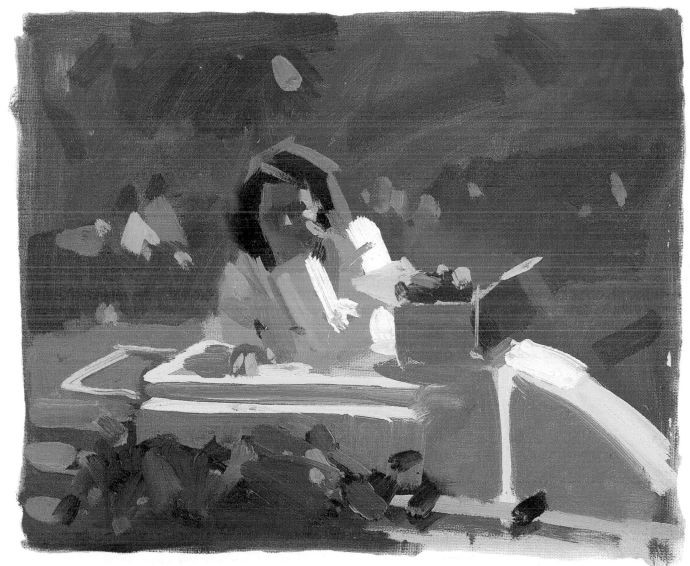

*Now that a tonal plan has been worked out, color can be added. I've further empha-
sized the focal point by intensifying the colors of the ice cream stand, milk cartons
and foreground bush. I've also played down the brightness of the two middleground
figures on the left and neutralized the colors in the background.*

I often tell my students, "If you can handle halftones and reflected lights, you can paint," because it's primarily in the halftone and reflected light that the color and texture of a form are strongest. To illustrate the point, set an orange or lemon under a strong light. Squint your eyes and notice how the light side of the object retains a high degree of home color while the highlight is composed mostly of the color of the source of illumination. Now study the halftone and observe how the hue and texture take on even stronger definition. The shadows and accent, by comparison, appear softer and more neutral. Finally, scrutinize the reflected light and notice how the object's true color and texture again begin to quietly emerge.

Halftones and reflected lights also add a third dimension to light and shadow. While light and shadow are indispensable tools for massing-in a picture, it's with the addition of a halftone or reflected light that the form becomes solidly convincing and dimensional.

As you learned in Exercise Twenty-six, a limited scale of modeling tones can free you from the chore of slavishly copying each of the dozens of values that comprise an object. Reflected light, however, was not included in the scale. The reason is that reflected light is an independent light source all its own. It fluctuates in value according to how light or dark its surroundings are, so it requires a separate tonal scale to accommodate these variations. It works best to limit the range of reflective tones to a bracket between middle gray and black. This way, you'll have the flexibility to show various home value changes and be assured that none of the values in the reflected light will overpower the main source of light.

Excluding the salt and pepper spiciness of highlights and accents, it takes only three dimensions of tone to solidify a form, regardless of the lighting condition. A front or side lit object requires only a light, halftone and shadow to make it appear solid. A back lit item can be adequately portrayed with only a reflected light, shadow and dark shadow. This kind of simplicity can be found in the paintings of Camille Corot and Edward Hopper. Both of these artists took painstaking effort to trim their subject down to the barest essentials. In so doing, they forged works of timeless beauty and left us with sterling proof that less can be more.

PREPARATION— The subject for this next exercise can be a potpourri of any objects you have around the house provided each of the items has a recognizable texture. Set up the objects on the floor on a white piece of cloth or drapery. The reason for the floor setup is to keep your vision fresh by not duplicating any of the still-life arrangements from earlier exercises. After grouping the objects into an interesting composition, illuminate the entire setup with a strong light from either the left or right.

ASSIGNMENT— The key to the success of this exercise lies in following the right procedure, so take your time and try to execute each of the following steps in the order given. Tone your canvas with a pale raw sienna wash. Next, mass-in a thin tone of cerulean blue over the entire shadow area. When dry, begin laying in thicker paint and indicate the different home values and colors of each of the objects in shadow. Move on to the lights, again defining each of the home values and colors of the various items.

This next step of laying in the halftones and reflective lights is tricky because if overstated, the painting becomes a confusion of busy tones and colors. If understated, the three-dimensional quality of the forms will be lost. Beginning anywhere, paint the halftone with a value about midway between the previously stated tones of light and shadow. Remember, it's here that the richest color and texture lie, so make sure the passage surpasses the intensity of the colors surrounding it. As you develop the halftone, try to emphasize the unique texture of the form, using the edge treatment that works best. After completing two or three of the objects, step back and notice how the addition of the halftones has given the forms a dimension lacking in the others.

■ *Both Camille Corot and Edward Hopper took painstaking effort to trim their subject down to the barest essentials, and in so doing, they forged works of timeless beauty and left us with sterling proof that less can be more.*

Now begin laying in the reflected lights, playing up any subtle textures you see and making any necessary tone and color changes to accommodate the influence of the white drapery. Be careful not to pitch the value any lighter than a middle gray. Stop again at mid-point. You should begin to see a noticeable transformation. The completed areas should be taking on a luminosity. Keep developing the painting until each of the forms is complete.

USING HALFTONES TO SOLIDIFY A FORM

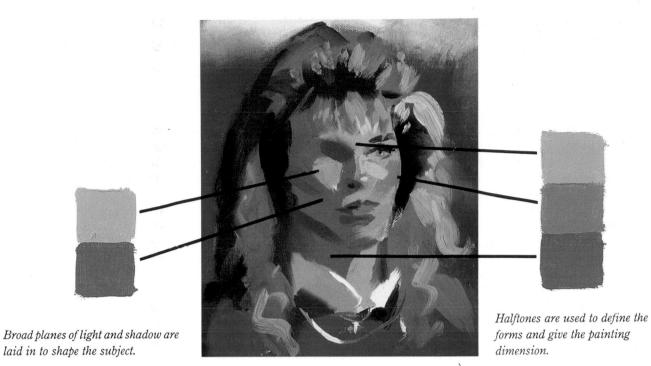

Broad planes of light and shadow are laid in to shape the subject.

Halftones are used to define the forms and give the painting dimension.

USING REFLECTED LIGHT TO GIVE DIMENSION AND LUMINOSITY TO A FORM

Weaker reflected light contains only a small amount of the reflected color.

Strong reflected light will contain a substantial amount of the color reflected into it.

Showing Different Kinds of Texture

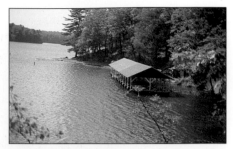

Photograph of the subject.

SAND LAKE, WISCONSIN

12″ × 16″, oil on canvas, collection of the artist.

I used both brushes and a palette knife to capture the rugged terrain of this northern Wisconsin resort. Working on top of a thin underpainting, I started with the background by keeping the texture minimal. Even though the middleground is where the center of interest lies, I kept most of the material a medium texture. To call attention to the area, however, I played up the light and shadow contrast and put my most intense colors on the children swimming. The large pine tree in the foreground was an important element in the composition and needed adequate definition. If I made the tree too important, however, it would conflict with the center of interest. I solved the problem by painting the lights and shadows less contrasting but emphasized the texture by piling on plenty of paint—first with a brush and then overpainting with a palette knife—to make the area appear to come forward.

Smooth Medium Rough

The last phase of the painting involves subordinating the final three tones of highlight, dark shadow and accent. Many of the objects may already appear complete and need little or no additional modeling. Others may require a highlight, dark shadow or accent to solidify them. This is mostly a matter of individual taste. Some painters feel a painting is complete only if each form is carefully rendered. Others like to incorporate the vitality and gusto of a looser treatment into their finished work.

APPLICATION — Knowing what makes up the essence of a form, distilling it down to its most basic essentials, and fashioning it into a personal image are what painting a picture is all about. So keep it simple and when in doubt, leave it out.

SILVERMINE TAVERN
16" × 20", oil on canvas, collection of GTE, Stamford, Connecticut.
I painted this picture in my van on a cold, wet and rainy spring morning. During or just after a rain can be one of the best times to paint because everything appears as if it's been given a coat of varnish. When wet, the road became a glossy spectrum of sparkling color. I moved the puddle around to show a more interesting reflection. By using such reflective devices as puddles and windows as compositional aids, it's surprising how much depth can be added to a picture.

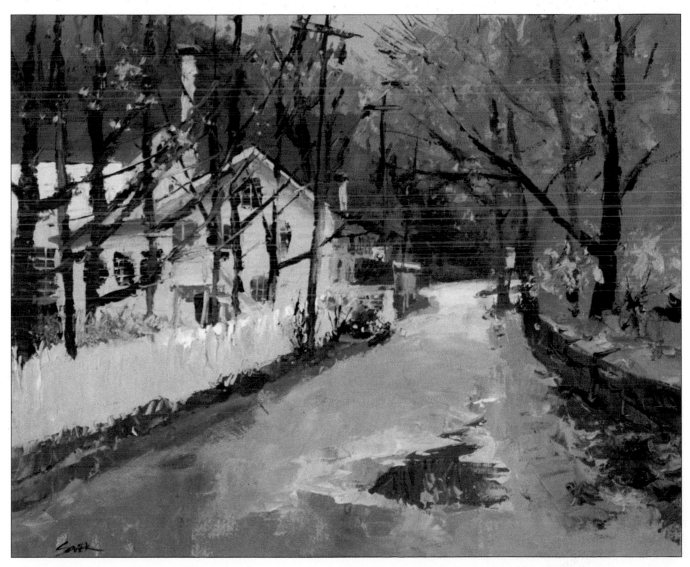

Individual taste in color varies so much from one artist to the next that it's difficult to set down a list of rules without hampering the free play of spontaneity so necessary in bringing a picture to life. Like every other aspect of painting, however, a working plan can help save a lot of time and frustration. Using color should be an alive, sensuous experience. When thought of as a vehicle for personal expression more than a skill to be mastered, learning becomes more pleasurable and the quality of your work will improve.

OBJECTIVE—Essentially, there are four basic approaches in using color to unify a subject: limiting your palette, playing complements against one another, contrasting different temperature changes, and patterning the picture surface with a decorative design. Think of these broad categories as the heads of great households, each with vast numbers of offspring, yet all retaining some of their family's unique characteristics. Which of these particular approaches to draw on is mostly determined by the demands of the subject. Yet all approaches, at one time or another, could be useful solutions for a problem.

The first of these four devices is limiting your palette. This means paring down a full palette of colors to include only those which relate to the subject. The most popular variation of this method is "the old master effect." Named for the brownish quality dominating most of the pictures painted before the availability of spectrum colors, the approach relies on the inherent harmony of earth colors to unify a composition. The works of Rembrandt, Hals and Velazquez are all fine examples of this basically tonal approach. Other variations could include limiting your palette to purple, blue and black to capture a moonlight effect; red, orange and yellow for a desert motif; or a variation of greens for the interior of a wooded landscape.

The second method is playing complements against one another. This approach entails building up the entire picture within a limited color range and then contrasting the masses with a note of complementary color. Andrew Wyeth occasionally uses this device by detailing an entire landscape or dilapidated building with warm greens, browns and tans and then jolting the viewer with the introduction of a blue door or piece of clothing. Any bracket of analogous colors could form the basis for such an effect, so long as the complement is adequately defined and the size of the area it occupies small enough not to conflict with the overall masses.

The third approach involves contrasting different temperature changes and manipulating them into workable compositional shapes. Like the massing of light and shadow patterns detailed in Chapter Three, the success of this method lies in how effectively you stage the patterns of the two different areas. Subscribed to by many

■ *Essentially, there are four basic approaches to using color to unify a painting: limiting your palette, playing complements against one another, massing contrasting temperatures, and patterning the picture surface with a decorative design.*

location painters, this approach is ideal for quickly locking up a fast-moving lighting effect. The most common procedure is to begin a painting by first reducing the subject to simple light and dark masses of warm and cool color, and then building the entire composition on the basic shapes and patterns these passages suggest. The great Spanish beach painter Joaquin Sorolla achieved dazzling results using this approach, weaving together complex arrangements of water, boats, figures and animals with lightning speed and flawless dexterity.

The final unifying effect involves discarding the use of any spatial devices and focusing instead on the decorative aspects of the picture. Oriental painters often favored this method, as did Pierre Bonnard, Edouard Vuillard, Henri Matisse and American painters Maurice Prendergast and Fairfield Porter. Innovated by the French impressionists to minimize the attention paid to any one part of a composition and force the viewer to take in the whole effect, this device has a wide range of possibilities and can often transform a mediocre subject into an exciting quiltwork of colorful images, a quality sometimes missed in the more realistic treatments.

ASSIGNMENT—The aim of this exercise is to explore all four of the possibilities discussed. Divide your canvas into four equal sections. Lay out whatever selection of subjects you feel would be most appropriate for each of the various approaches. As you work, try to free your mind of everything but the particular scheme you're focusing on. A short break after the completion of each of the sketches is a good way to maintain this attitude. Also be sure to thoroughly clean your palette after each of the studies so as not to muddy up the colors of the next sketch.

A word about underpainting. You may want to explore toning your canvas with a thin wash of color. There are

no rules here. One picture may look better if underpainted with a color analogous to the subject; another could work well toned with a complement. Whatever your choices, be careful not to turn the approach into an inflexible formula.

There are as many ways to unify the color in a picture as there are artists to dream them up. The four methods mentioned here only hint at the vast number of possibilities. Rather than thinking of the exercises as a set of directives to be strictly carried out, imagine them instead as a springboard from which to develop whatever imaginative variations your subject inspires.

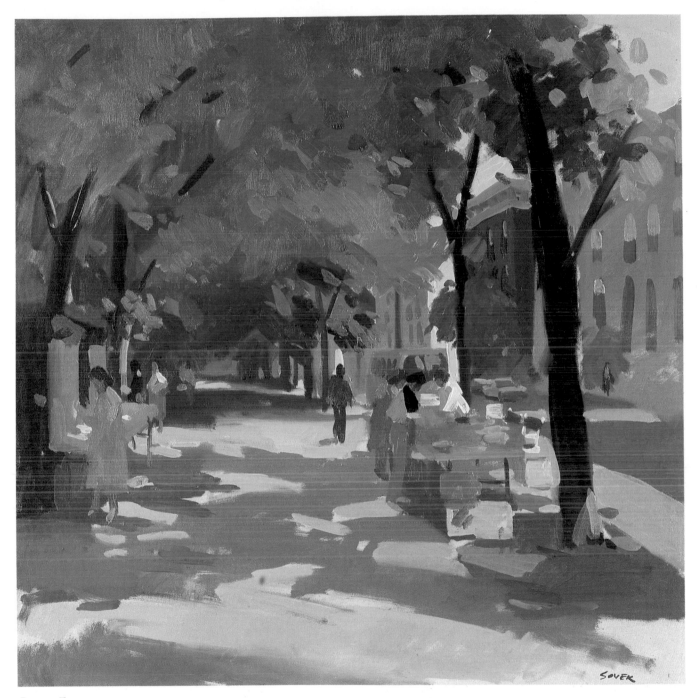

BOOK FAIR
30" × 30", oil on canvas, collection of Mr. and Mrs. Sam Anastasia, Westport, Connecticut.
I began this painting with the determination to carry it to a colorful yet carefully detailed finish. After working for five or six hours, however, an entirely different kind of imagery began to emerge. Trusting my intuition, I discarded my original plan and decided to go with the flow. From here on, I improvised as I went along. The result was a painting I never expected to do yet one that far surpassed my original expectation. Knowing when to stop work on a picture is a decision every artist has to resolve his or her own way. The only advice I can offer is when the "shoulds" start replacing the "why nots" it's time to start thinking about signing your name. "Book Fair" was painted in a single fourteen-hour session.

Four Ways to Use Color to Unify a Composition

LIMITING YOUR PALETTE

Black

Viridian

Yellow ochre

USING A COMPLEMENT AS A CENTER OF INTEREST

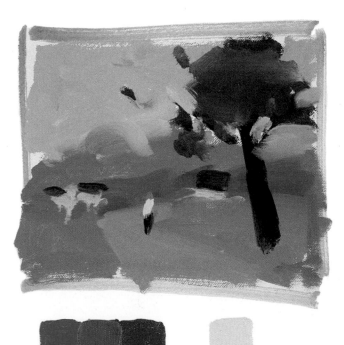

Burnt sienna, cadmium red light, cadmium orange, cadmium yellow medium, yellow ochre, and cerulean blue.

Ultramarine blue, cobalt violet, thalo red rose, and cadmium yellow pale.

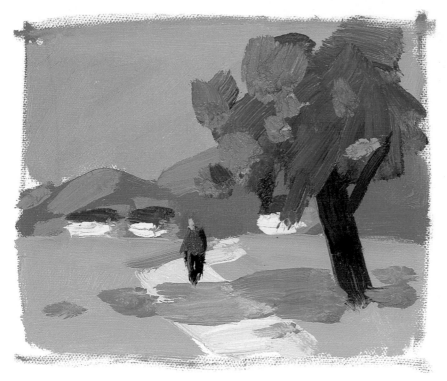

Brown madder

Thalo red rose

Cadmium red light

Cadmium yellow medium

Cadmium yellow pale

Permanent green light

Viridian

Cerulean blue

Ultramarine blue

CONTRASTING TEMPERATURE CHANGES

EMPHASIZING DECORATIVE PATTERNS

Black

Cobalt violet

Cadmium red light

Cadmium orange

Cadmium yellow pale

Permanent green light

Thalo blue

Filling a picture with light can be one of the most satisfying aspects of painting. However, unless the complexity of the limitless number of observable effects is simplified to manageable terms, the experience can turn into one of frustration rather than joy. When there is a single source of illumination, it can't help but unify a subject. But when there is more than one light source, developing visual unity in a subject is more difficult. But once understood, light, like any other aspect of painting, provides still another tool for both tying a picture together and adding a radiant glow of life to your work.

Beginning with Caravaggio, the litany of artists who used light to unify their compositions could read like a who's who in the history of painting. Van Eyck, Rembrandt, Chardin, Vermeer, Constable, Turner, Manet, Monet, Pissarro, Seurat, Van Gogh, Sargent, Homer, Potthast, Pearlstein, and Thiebaud are only a small number of the countless painters throughout the ages who stressed various kinds of lighting arrangements to help shape their pictures.

OBJECTIVE— The key to harnessing light and turning it into a workable pictorial device is in understanding the numerous ways it affects a subject. This is most easily done by simplifying the effects of sunlight at different times of day, weather conditions and seasons into four basic lighting conditions. Each has the potential to alter the mood of a subject. These are backlight, sidelight, toplight and frontlight. Within each of these is the potential for numerous variations. Sidelight, for example, could include three-quarter front or rear and range anywhere from low in the sky to high. All four conditions could also be applied to artificial light, candlelight, moonlight or any other source of light you may choose.

One good way to compare the features of the various approaches is to imagine an identical subject lit by each of the four different effects. A single building set in a rural landscape, for example, presents nothing special in the way of provocative shapes, exotic color or engaging patterns. When displayed under the right lighting condition, however, it could turn into a pictorial gem.

If staged under *backlight*, the sky in such a scene would be the brightest and warmest area of the composition. Most of the forms would appear in cooler, shadow passages and fall into a range between middle gray and black. Although a few areas of the landscape and building that are exposed to the sun would be painted lighter and warmer than the shadows, these too would appear deeper in tone than the sky. The ground plane would grow increasingly lighter in tone and warmer in color as it recedes back into the picture and becomes closer to the source of illumination. The resulting effect of this backlit condition would reduce the subject to a series of dark shapes silhouetted against a light sky. A favorite of the nineteenth-century Hudson River school of painters, backlight can imbue a scene with a blissful sense of tranquility and turn a hodgepodge of unrelated parts into a satisfyingly integrated whole.

Sidelighting is probably the most popular of all the conditions to work under. Its sharp contrasts of light and dark reveal the form and texture of a subject and offer a wide range of descriptive cast shadows to help define the areas surrounding the object. Under this condition, the light-struck portions of a subject will be on whatever side the light is coming from. The sky and ground plane will also be affected. Each would deepen and cool in color as it gets farther away from the light. Sisley and Pissarro made excellent use of sidelight in many of their country vistas by employing the long cast shadows unique to this condition to help describe the character of the different roads, streets and fields they were painting.

■ *A single source of illumination, by its very nature, can't help but unify a subject.*

Now imagine the same scene under *toplight*. What appeared earlier as two different versions of a tranquil scene under back and sidelight now becomes a study in sharp, severe contrasts. The effect of the harsh glare from the noonday sun shrinks the long, descriptive cast shadows so characteristic of sidelight to a meager collection of stublike shapes. The lightest and warmest areas of the subject will be restricted to those forms that are at right angles to the light. There will also be a "hot spot" in the middleground, caused by the fact that the sun is directly above. Not many artists choose this effect because of these very limitations. Aside from a few painters like Edward Hopper, who occasionally capitalized on the glaring severity of toplight to emphasize the lonely isolation of a piece of architecture, most artists shy away from this condition unless a subject specifically calls for it.

Another form of toplight can be found on overcast days when the sun is obscured by clouds. In this case the sky becomes the outdoor equivalent of a ceiling filled with cool, soft fluorescent lights. Because of the filtering effect of the blue-gray clouds, the temperature of the light is

Backlight

Sidelight

Toplight

Frontlight

Moonlight

Artificial light

Candlelight

113

reversed, with cool color bathing the lights and warm predominating the shadows. Cast shadows look softer under this condition and appear as dark, undefined halolike shapes gently radiating from beneath the various forms. One advantage overcast light has over bright sunlight is that the painter can work all day under an unchanging source of illumination. This was one of the reasons Sargent often preferred the soft, yet descriptive qualities of overcast light when painting many of his genre scenes.

The final effect is *frontlight*. Here, the light comes from behind the artist, making the sky appear darker. The foreground of the picture appears the lightest, with the tone and temperature deepening and cooling as the forms roll back into the distance. Another quality of frontlight is the predominance of light over shadow. This gives the artist an opportunity to use a warmer, higher-keyed palette and underplays the three-dimensional quality of a subject by eliminating most of the shadows so essential for solidifying a form. This "flattening out" effect can be useful in stressing the colorful shapes and patterns of a subject and

was often used by painters like Bonnard and Vuillard, who were more concerned with design than dimension.

Each of these conditions can be easily duplicated indoors under artificial light and can be equally appropriate for still-life setups, figure compositions or interiors. The secret to capturing any of these effects is to base every tone and color on the position of the light and how it reveals the subject you're painting.

ASSIGNMENT—The assignment for this exercise is to paint four sketches, incorporating each of the various conditions described. You'll get more out of this lesson by choosing an identical theme for each of the sketches and more yet if you work from life rather than photographs.

Unifying a painting with light can add a remarkable degree of believability to a composition. Thoroughly digesting these principles should provide you with a basic vocabulary of lighting effects that can be added to with each new encounter with light.

OCRACOKE ISLAND
12" × 16", oil on canvas, private collection.
This painting has a strong toplight, coming somewhat from the right.

YOSEMITE, MORNING
6″ × 6″, oil on canvas, collection of the artist.
This and the painting at the right show the changes that lighting can make on the same subject. Studies such as these are invaluable for discovering which condition best suits your needs.

YOSEMITE, LATE AFTERNOON
6″ × 6″, oil on canvas, collection of the artist.
Of the two paintings, I prefer this one because of the dramatic light cresting the top of the mountain. It's up to the artist to investigate the many possibilities.

BACKLIGHT ON FIVE MILE RIVER
12″ × 16″, oil on Masonite, collection of Jane Lincoln, Marstons Mills, Massachusetts.
This is essentially a tonal painting and illustrates the point that choosing the right lighting (in this case backlighting) can go a long way toward the success of a picture.

COMPRESSING THE EXPANSIVENESS OF A SUBJECT INTO THE RESTRICTIVE DIMENSIONS OF A PAINTING

It's an artistic fact of life that if you paint what you see you don't necessarily get what you see. There's no better example of this than the impossibility of squeezing the expansiveness of a majestic outdoor vista into the frustratingly small format of even a large canvas. To graphically illustrate the problem, take an empty picture frame and go out to your backyard, sidewalk, rooftop or any other place that offers a broad view and scan the entire setting from top to bottom and left to right. Hold the empty frame in front of you, look through it and imagine what you see as a painting. What should quickly become evident is how little of the overall scene appears through the frame. Trying to compress the vast expansiveness of subjects like skies, mountains, fields and water to accommodate the comparatively small dimensions of a painting is an enigma artists have grappled with for centuries. The challenge, of course, is how to condense the wide focus of material your eyes take in yet still maintain the spaciousness and grandeur that originally inspired you to choose the subject. If you paint exactly what you see, your composition will probably no more than hint at the bigness beyond the borders of the picture. You could take a wide-angle approach and use a long, narrow format, but you'd be obliged to repeat the same format every time you wanted to paint a similar theme. The best solution to the paradox is to use what artists call compression. This involves laying out your composition the way you would normally see it. But, rather than concentrating only on the particular area you've chosen, you "borrow" from various other tonal and color effects beyond your line of sight and incorporate them into the painting. This gives the viewer some added touchstones of dimension to better describe the vastness of the scene as it originally appeared.

One such "touchstone" is to show the subtle dissipation of light as it moves away from the sun. With artificial light this is quite evident because the light source is so weak that the dissipating effect starts to show itself only a few feet, or sometimes only inches, away from the light. Put a lantern on a beach at night, for example, and notice how the circle of light quickly grows increasingly dark and is soon gobbled up in shadow. Look at the same beach on a sunny day, however, and it will appear as a flat, endless expanse of dazzling light. The reason for the absence of any visible dissipating effects is that the sun is so intensely bright that its illuminating effect stretches many thousands of miles across the earth.

Painters have been compressing and contriving the dissipating effect of light on both indoor and outdoor subjects for hundreds of years. But it's only been since the French impressionists began elaborating on the idea by adding color that the full potential of this useful contrivance has been fully exploited. It would seem that by taking such extensive liberties with nature, the resulting effect would look artificial. Surprisingly, the device actually heightens the feeling of reality.

Whereas tone relies on a progression of increasingly dark values to dissipate a passage of light, color needs what is called prismatic gradation to achieve the effect. A sky, for example, could be painted a deep blue-purple on the left, lightened to more of a blue-green in the center, and lightened even further to a blue-yellow as it begins to approach the sun. Prismatic gradations can be applied to just about anything you paint. A mountain, for instance, could lean toward purple-brown in shadow, shift to a red-brown in halftone and orange-brown in light. Be sure when using this approach to keep the gradations of hue consistent with their position on the color wheel.

■ *Trying to compress the vast expansiveness of subjects like skies, mountains, fields and water to accommodate the comparatively small dimensions of a painting is an enigma artists have grappled with for centuries.*

ASSIGNMENT— For your final exercise of this chapter do a painting incorporating both prismatic gradations and the effects of dissipating light. The subject can be any outdoor motif. The sky should occupy at least two-thirds of the composition, so you may want to use a square or vertical format rather than horizontal. Try to pick a panorama with plenty of sky and an obvious foreground, middleground and background so you can use these devices to their fullest advantage. As you work, keep scanning all 180 degrees of the scene around you, borrowing whatever color and tonal effects necessary to help capture the *total* ambience of the scene. Don't forget, it's not the size of your canvas that determines the effect, but how inventively you can forge the expansiveness of what you see into the limits of your composition.

DISSIPATING LIGHT

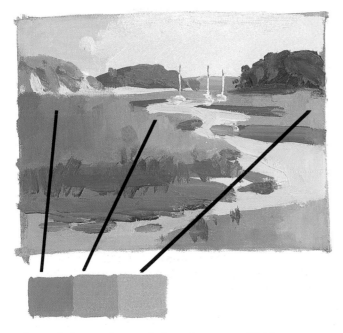

Values darken as they recede from the source of light.

PRISMATIC GRADATIONS

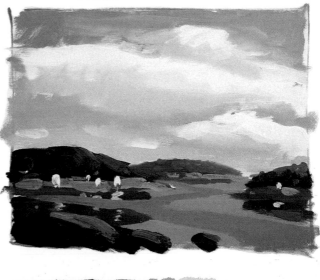

Greens gradate through the spectrum from yellow to blue.

COMBINING DISSIPATING LIGHT AND PRISMATIC GRADATIONS

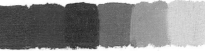

A sky will gradate from a light, warm blue near the sun to progressively darker and cooler colors away from the light.

The green foliage in the middleground dissipates from a light, yellowish green to a darker and cooler blue green. Because the foreground tree and foliage are in shadow, the color and values remain more or less uniform.

Though lighter in home value, the tan passages of earth will also gradate from light warm color to a cooler, deeper hue.

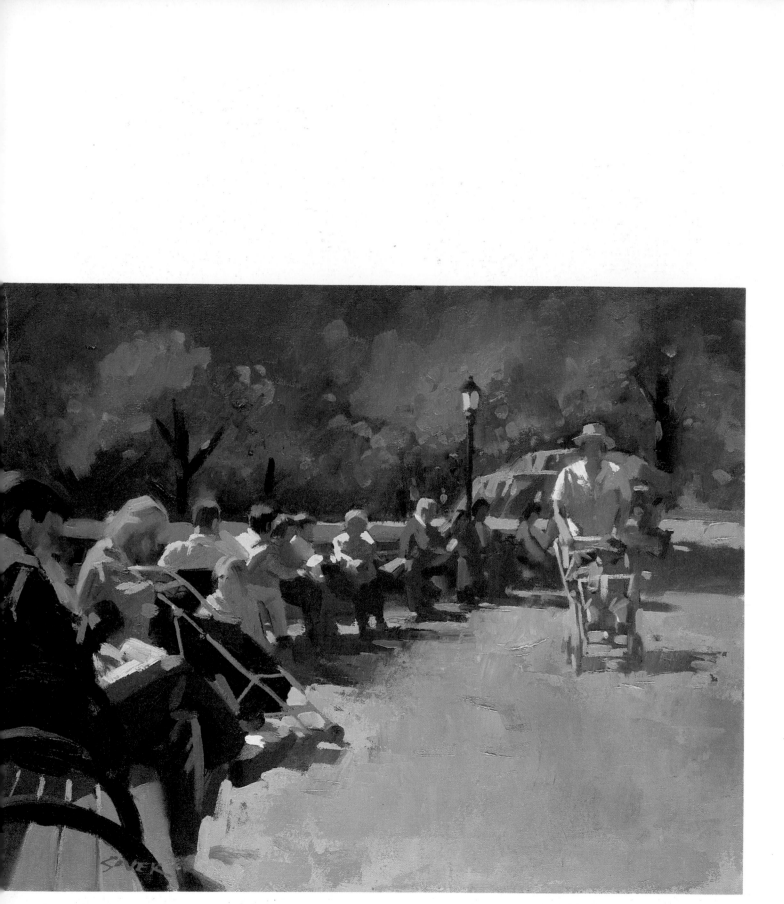

CENTRAL PARK

16" × 20", oil on canvas, collection of Marianne Scilla, Clinton Corners, New York.
A carefully worked out studio composition. After making some location sketches and taking some photos, I did three tonal studies in burnt umber and a full-color thumbnail sketch before tackling the finished painting. I kept the painting simple. Notice, for example, the nearly posterlike treatment of the figures, with only the foreground figures emerging as more elaborately modeled.

118

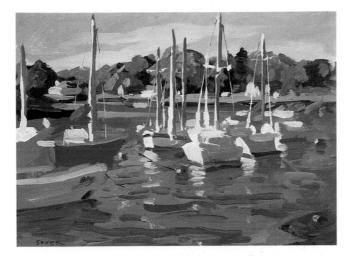

Fall Afternoon on the Five Mile River
12" × 16", oil on Masonite, collection of Ann Gibb, Darien, Connecticut.
Notice how the color of the water appears intense because the clear air has heightened the intensity of the brilliant blue sky. Because skies dissipate in color as they recede into the distance, the sky at the horizon is more neutral. The spidery shapes of the rigging contrast nicely with the more bulky forms of the landscape, boats and water. Also, the minimal treatment of the waves prevents calling undue attention to this secondary area.

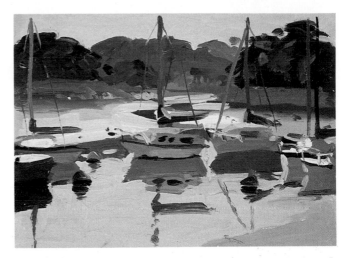

Summer Afternoon on the Five Mile River
9" × 12", oil on Masonite, collection of Gretchen Minnhaar, Grand Rapids, Michigan.
The same scene shown on the left except this time in the hot, hazy and humid atmosphere of summer. The muted orange sky shows in the reflections on the water. The reflections of the boats, owing to the stillness of the air, are near mirrorlike images. The oppressive atmosphere is heightened by the soft edges in the middle and background. Charles Hawthorne once said if you can tell the time of day in a painting that's good. If you can tell the weather conditions, that's even better.

BUILDING ON YOUR STRONG POINTS

Surfaces, edges, temperature contrasts, reflected light, halftones, compression, dissipating light and prismatic gradations—a roster like this could make any student's head spin! Happily, there's no need for such a list because all that's required now is to put them into practice. And this means simply pick up your brush, choose whatever approach you're most comfortable with, and begin painting. If that sounds simplistic, think of the music, dancing or golf lessons you may have taken and remember how pleasurable it was after the endless hours of drills and theory to finally begin applying what you learned. Whatever learning frustrations you may have encountered eventually gave way to the pleasures of involvement and formed the basis for steadily maturing the skill into an expression of your self. So instead of thinking that seeing the big picture means cramming everything you've learned into each and every painting you do, approach it instead as a process of picking and choosing, knowing that you have at your disposal whatever options you need to paint a totally unified statement.

Some artists naturally gravitate toward light and shadow. Others are born colorists, while still others instinctively favor a more textural solution. No single way is either right or wrong for any one artist. It's not really that important which aspect of painting you lean towards so long as it's one you feel at ease with. Therefore, the best way to develop and unify a painting is to build an approach based on whichever combination of methods is most compatible to your emotional makeup. And while you'll probably go through numerous phases, emulating different artists and schools of painting, there will usually be this underlying thread of common interest which will stamp the work as uniquely your own. Perhaps your sole interest at this point is light, an area that you not only feel secure with but also respond to with a deep sense of satisfaction. Once you master a particular forte, you will then begin unconsciously incorporating other fundamentals to finally arrive at a mature approach.

A word about working within the time limitations of the schedule. It would be easy to spend half a day or even a full day developing and finishing many of the more advanced problems found in these later chapters. By keeping within the allotted time frame, however, you'll be forced to focus on only the very essence of each specific subject and avoid the temptation to gloss over any unresolved areas with surface veneer. Don't forget, the idea behind these exercises is to give you a working index of painted notes, *not* a portfolio of finished pictures.

Welding the various parts of a subject into a unified whole can be a rewarding experience. And seeing hurdles dissolve as abilities grow can only add to this sense of accomplishment. Yet all that's needed is to build on your strong points, nurture the weak ones, and let nature take its course.

· CHAPTER 6 ·
PUTTING IT ALL TOGETHER

Be it a ballet dancer executing a flawless *tour jeté* or a professional basketball star slam-dunking two points, it's invariably the smooth amalgam of total performance that makes the event memorable. So too with picture making. Forging the various skills you've acquired into the thrust of a single, unified effort, concentrating on impact and personal expressiveness rather than technique, is no small task. It takes as much unlearning of past methods as it does acquiring a fresh vision. When you are comfortable with these techniques, your vision can again be free to take in the world with the clear-eyed wonder, surprise and clarity of a child on his first summer outing.

To give your newly acquired skills the most ideal conditions to grow under, there will be no listed time schedules for the final six projects. As maturing painters, it's now up to you to chart your own growth. This means taking as much time as you need to understand and apply this last set of exercises.

Learning and digesting the previous thirty exercises

involved many hours of studied concentration, a prime requisite for the *craft* of painting. It's when you start channeling these necessary but as yet unconnected parts into a cohesive whole that you begin practicing the *art* of painting. The final six projects of this book involve learning to think less about juggling the many principles thus far discussed and more about how to trust your natural impulses. The various projects involve brushwork, using reference material, painting from memory, learning from past and present masters, and developing an individual technique. Each of the lessons is designed to help you integrate the scattered collection of seemingly unrelated theories you've acquired into a cohesive whole.

Momentarily set aside the various skills you've put so much effort into learning. It's only when you clear your mind and become totally receptive to the problem at hand that these all-important devices are able to freely interact with each other and surface as a singularly unified point of view. The evolution from learning the fundamentals of

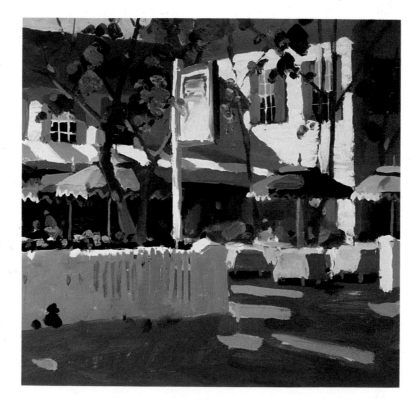

CAFE BLASÉ, PROVINCETOWN #2
16" × 16", oil on canvas, collection of Joan Rudman, Stamford, Connecticut.
I find brightly colored umbrellas a delight to paint. I could say the same about boat sails and awnings. My intrigue with these objects is that they provide a bold, colorful center of interest. To enliven the more grayed-down parts of the painting I mixed some of the intense colors of the umbrellas into my duller mixtures. This unifies the color scheme and adds a heightened punch to the center of interest. A variation of this painting, as well as the notes, color study and photographs I used for both pictures, is shown on page 133.

painting to executing a successful picture is no different than going through the tedious weeks or months of practice necessary to gain enough skill to drive a car, swim, or hit a tennis ball. In each case the resulting mastery of the problem enables you to shift your attention from the mechanics of the performance to the quality of the act itself.

Because self-consciousness is probably the biggest obstacle to overcome, try to approach this final set of exercises with a sureness born of experience. Remember, you've worked your way through just about every building block of theory any representational painter has ever known about. So wipe away any visual cobwebs, realize your self-worth and approach the following projects with a spirit of liberation, confident that the innate talent that has been incubating within you ever since your senses were first stirred by the colorful delights of nature will surface and flow from the end of your brush.

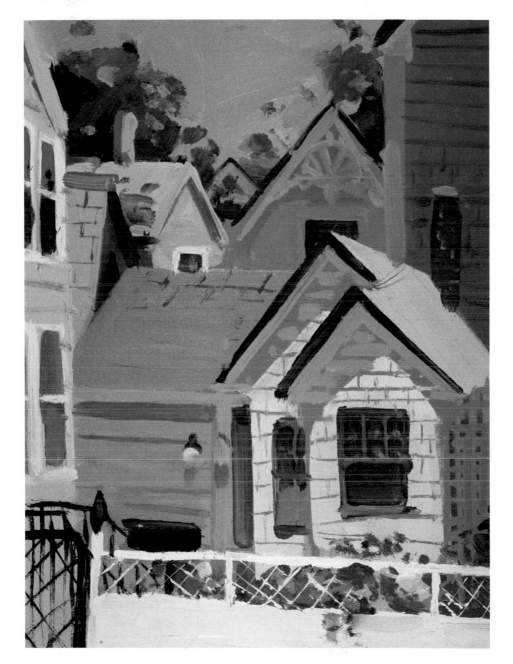

PROVINCETOWN BACKSTREET
16" × 12", oil on Masonite, collection of Doris Koch, West Dennis, Massachusetts.
Taking liberties with nature is as much a part of a successful painting as accurately recording what you see. To emphasize the tipsy quality of Provincetown's old Victorian architecture I intentionally played up the provocative play of angles the buildings displayed. To unify the whole effect, I used an equally interesting pattern of light and shadows. To give the painting a center of interest I overstated the intensity of the cluster of flowers and showed them against the stark whiteness of the fence.

121

PERSONALIZING A PAINTING WITH EXPRESSIVE BRUSHWORK

Making expressive marks on a surface has for ages held the fascination of people from all cultures and walks of life. Whether dashing off a signature on a check or fingering some initials into the wet cement of a newly paved sidewalk, few can defy the irresistible temptation to brand a surface with a unique, personal imprint. Paradoxically, when it comes to painting a picture, just the reverse seems to hold true. The reason for this is not only the natural inhibition we all feel when confronting the pristine whiteness of a fresh canvas but also the often stifling effect of previously learned theories and principles swirling around in our minds. Rather than simply plunging into a painting and enjoying the feeling of color flowing onto a surface, most students approach the experience more as an obstacle course to complete in which each obstruction can only be hurdled by staunch determination and perseverance.

It seems the best way to reclaim your visual uniqueness is to start respecting your impulses. Just as we're all taught essentially the same basic forms when learning how to write and spend a period of time carefully duplicating the style of a teacher, with paint we often begin by copying the strokes of the teacher. Once the writing process becomes second nature, however, individuality resurfaces and after a few years our handwriting becomes as unique as a fingerprint. Many beginning painters tend to fight this natural process by maintaining a rigid attitude about rules and theory. Without realizing it, they sabotage the very goal they are trying to attain.

It helps to become totally familiar with every possible tool that can put paint on a surface. If you have only a limited selection of brushes and knives, go to an art store or pick up a catalog from a major supply house and familiarize yourself with the many kinds of painting tools available to artists. Cezanne used as many as twenty or more brushes when executing a picture, while Renoir preferred to use a mere three. The important thing is not the number of brushes you use but whether or not they best suit your temperament. When choosing a brush rely more on instinct than logic and ask yourself which brushes look most user-friendly in size, shape, weight and spring. Equally important is how you hold the tool. Whatever style of brush you're using, it should be held with the same sensitivity with which you would lift a small bird from a nest. Far too many beginners undermine their work by gripping a brush with the white-knuckled tenacity of a stonemason using a hammer and chisel. Remember, each stroke you apply betrays your frame of mind at the moment of execution.

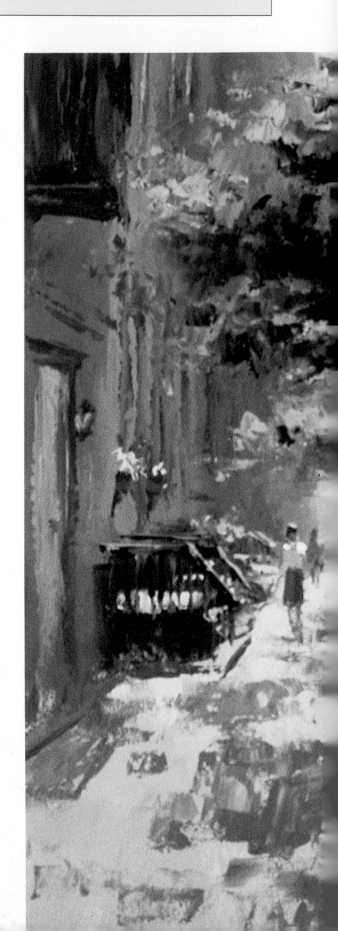

PERRY STREET

24″×30″, oil on canvas, collection of Judy Kerr, Rowayton, Connecticut.
One reason why I chose to paint this picture with a palette knife was to emphasize the effect of sparkling sunlight as it played across the various textures of the subject. Boldly executed, this particular technique is a favorite of mine when I paint cityscapes. Working with a limited palette of cadmium red deep, cadmium yellow pale and ultramarine blue, "Perry Street" was done in one four-hour session.

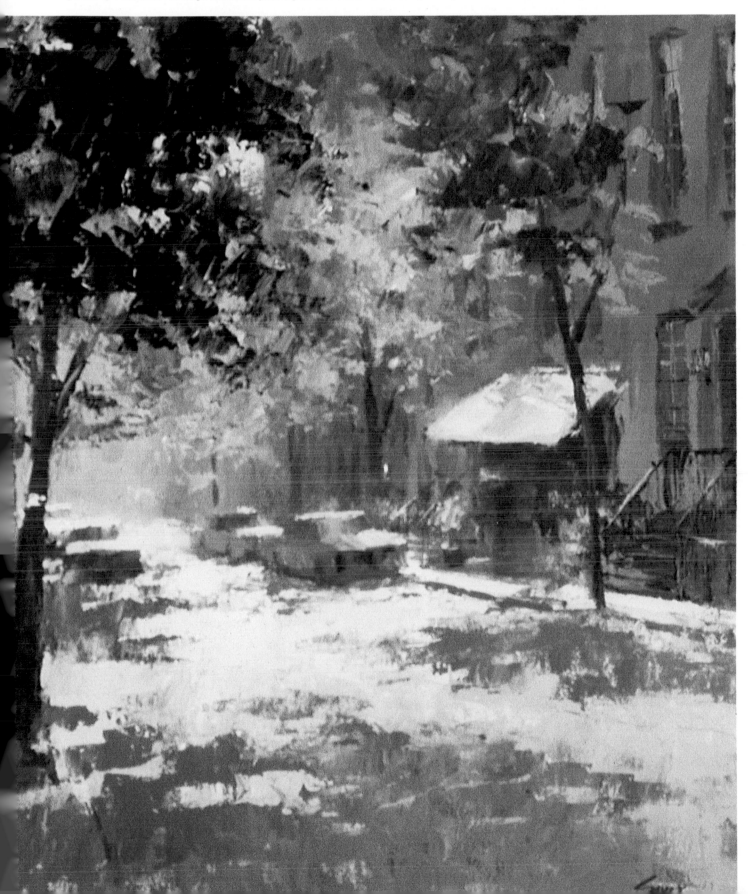

PREPARATION — This exercise involves incorporating your handwriting technique into a painting. Choose a half dozen or so of your favorite brushes and a palette knife and make some doodles on your canvas. Start with your signature, various letters of the alphabet, or any other familiar notations. Working with the casual ease with which you would dash off a grocery list, imagine the brush in your hand to be whatever pen, pencil or marker that you're most accustomed to writing with. After filling half the sheet with cryptic notations, doodle some images that are more complex, such as stick figures or contours of different objects. Finally, start showing some dimensional items like pieces of fruit, buildings or trees, defining the form of the objects with simple patterns of light and shadow. Intentionally blank out any knowledge that you may feel compelled to use. Focus all your attention on watching the forms emerge onto the surface. Each student's solution to this problem should appear unique, with some stressing carefully rounded flourishes, others angular stabs, and still others condensed, wirelike scrawls. Likewise, each of you will proceed at a different pace, which might range anywhere from the nervous quickness of a slash to the slow deliberateness of a lazy swirl. As you work, explore the effects of different kinds of brushes and knives until you've arrived at just the right combination to fill your needs. Keep doodling until the sheet is filled.

ASSIGNMENT — You're now going to apply the same handwriting approach to painting a picture. Using a fresh canvas, choose any subject of your choice. Begin by taking a few minutes to clear your mind of anything but the subject to be painted. As you're studying the motif, say the words *MY OWN HANDWRITING* to yourself over and over until they flow through your mind with their own momentum. Then pick up whatever brush your fingers instinctively reach for and start sketching in the composition. Once the subject is laid out, again reach for whatever brush your impulse suggests and begin massing-in the broad light and dark patterns of the composition. If critical directives like "watch your home values" or "don't forget to cool the shadows" start surfacing in your mind, stop painting until you replace them with the words *MY OWN HANDWRITING*. Once the picture is laid in, start developing each of the various passages, repeating over and over to yourself *MY OWN HANDWRITING*. At no time during your work should you try to consciously draw upon any of the principles you've learned so far. Don't even consider the idea that you're painting a picture. Simply let your brush skate over the surface at its own pace, trusting, just as you do when jotting down a memo, that the results will be a clear, easily read statement.

EVALUATION — If successfully executed, your finished painting should appear as a unified fabric of individual brush strokes, free from any previous inhibitions you may have had. While you may not be completely satisfied with your picture as a polished piece of craft, you should undoubtedly see a vast improvement in the expressiveness with which you've handled the paint. Remember, *if you trust in your ability, everything you've learned will surface when needed*. And just like when diving into a pool of deep water or speeding down a hill on a bicycle, it's the deep-down confidence you have in yourself that makes the experience possible.

■ *Far too many students undermine their work by gripping a brush with the white-knuckled tenacity of a stonemason using a hammer and chisel.*

With practice, you'll soon discover that it's not the actual painting of a picture that's difficult but keeping your mind free of the *shoulds* and *don'ts*. Granted, when trouble arises, every artist needs to consciously call upon acquired methods and techniques to bail himself out. Far too often, however, our minds are so full of preconceived bits of information, images of paintings by various artists we admire, and a self-imposed pressure to perform at our best that we become all but numbed to the initial response that prompted us to paint the picture in the first place.

Expressive brushwork is seldom accomplished by conscious effort. Usually it's the result of a natural evolution. Remember that one of the big differences between the vitality of a work painted by the masters and the generally uninspired pictures done by painters trying to duplicate their style is the personal expressiveness with which these great artists were able to apply paint to a surface. So keep an open mind, a responsive eye and a firm trust in the worth of your own unique brushwork.

SWIFTWATER INN, THE POCONOS
12" × 16", oil on canvas, collection of Shirley Lewis, Bath, Maine. This is a good example of the vast number of ways that paint can be applied to a canvas. Aside from a palette knife, I used about fifteen various-sized bristle and sable brushes to paint this picture. I could have probably gotten along with three or four, but to keep the mixtures clean I used a new brush for every major color passage. It takes only a speck of foreign color to contaminate a mixture.

Lettering on sign indicated with thick strokes from a rigger brush daubed in directly on top of the wet underpainting.

Thin lines made with the side of a palette knife used to indicate window frames.

Tree branch indicated with the thin strokes of a small rigger brush. Cluster of leaves shown by first massing-in the entire shape with a shadow value and then overpainting with crisp, thick strokes of light.

Foreground poles and railings painted with thick, directional strokes.

Small, staccatolike strokes used to indicate fallen leaves.

Middleground building siding and railing painted with thin strokes of light and dark over a middle-toned underpainting.

Driveway painted with broad, directional strokes that follow the contour of the form.

Light-struck areas of lawn are strokes made with the broad side of a palette knife painted on top of thinner underpainting of shadows.

FINDING YOUR OWN DEGREE OF FINISH

American realist William Harnett would often spend hours, even days, hunched over a canvas with a small brush, meticulously refining the form of a single apple. Expressionist Oskar Kokoschka would use five or six strokes to swipe in the same object in a matter of minutes. In each case the result was usually a work of art. What both of these painters had in common was an intimate awareness of what comprised a finished statement. How far to carry a painting is a decision every artist has to resolve his own way. Unfortunately many students have a preconceived idea of what a "finished" painting is, which runs contrary to their natural tendency. This idea could come from a misguided effort to emulate a "famous" artist or a desire for approval by a particular circle of peers. The student feels that only by adapting his approach to fit a known standard will he achieve acceptance and recognition. Sadly, what's lost in the bargain is originality. This need not be the case. Whether your preference lies in defining every last stitch of a lace tablecloth or dashing in a fleeting landscape effect with a few bold strokes of a palette knife, if you're true to your instincts, the finished result will speak for itself.

Many beginners make the mistake of thinking that once they've achieved an acceptable degree of finish they can continue to use that criterion indefinitely. Aside from hampering the growth of the individual, this can easily turn a perfectly valid solution into a repetitive, uninspired chore. A far healthier attitude is to go with the ebb and flow of the various shifts of interest every artist experiences and alter your technique accordingly. This way, each new plateau that's reached will lead to still another, more tantalizing way of approaching a picture, and along with it a new standard of finish.

Another element to be considered is flexibility. A bustling cityscape, for example, would lose a great deal of its vitality if treated with the same degree of careful refinement you might lavish on an antique watch or piece of cut glass. And while everything you paint should smack of personal uniqueness, each subject usually has a different requirement as to the degree of finish that's demanded.

ASSIGNMENT—This next exercise involves painting three different versions of the same object. The item could be anything from a piece of fruit or vegetable to a shoe, handbag or hat. Start by sketching in a large, medium and small version of the form on your canvas. The reason for the different sizes is to show how a change in format can frequently determine just how far you can carry a picture. Before beginning work, take a few moments to ponder the fact that *it's the initial lay-in and subsequent intermediate stages of development that dictate how a painting will be finished.*

Let's say you're painting a plump green pepper. Your concern at first is less with a finished statement and more in simply putting down some basic impressions, so your first marks on the canvas will no doubt be fresh and vital. Before going any further, take some time to reflect on your work, because it's at this stage that the degree of finish is most often determined. Beyond this point lies the all-important juncture where interest can turn into complacency. Continue to work, becoming aware of when you reach this critical point by the increased sensitivity to how you're applying paint and to the motivation behind your effort. The time until this stage varies greatly from one artist to another. Some, ablaze with a passion for what they're painting and along with it a compulsion to get down their impressions as quickly as possible, often burn out if too much time is spent on a work. Other more meditative individuals can apply layer upon layer of paint for days on end without losing the vitality of their original impression. Both ways are valid and between them lie any number of alternatives. So as you proceed, keep yourself finely tuned to that all-important shift in interest when the enthusiasm you originally felt for the subject begins slipping into the impersonalness of determined resignation. If this happens, stop and ask yourself if any more than a few finishing touches are really needed. If you still feel more refinement is necessary, continue work until the results meet with your satisfaction.

■ *Whether your preference lies in defining every last stitch of a lace tablecloth or dashing in a fleeting landscape effect with a few bold strokes of a palette knife, if you're true to your instincts, the finished result will speak for itself.*

This turning point can fluctuate with the sizes of formats. The small version, for example, may need only a few additional strokes to finalize the form. The middle size might require more development and the large version, even more yet. Or it could work in reverse with your impulse nudging you to loosen up the technique on the large painting and tighten the degree of finish on the small one. The important thing is to proceed in a manner that you find best suits your temperament. Whether you take all three of the studies to completion or quit at midpoint is less important than the insight you've gained into not only your manner of approach but also your need for a particular degree of finish. Remember, your aim is to

breathe life into a picture, so rather than aimlessly refining a painting simply because "it should look finished," keep going back to the original impression that inspired you to paint the subject.

Another pitfall to watch for is not mistaking a rendering for a painting. Some artists, particularly those who prefer a high degree of finish, should keep in mind that a painting is meant to filter a subject through the personality of the artist and *imply* a mood, effect or event and let the viewer's imagination fill in whatever details are lacking. A rendering, by contrast, is essentially a diagram in tone and color designed to show each and every detail of how something looks or works and seldom leaves anything to the imagination.

EVALUATION—When finished, study your paintings and ask yourself which of the three studies comes closest to matching your idea of a completed statement. Usually, one of the three versions will stand out as more successful than the others. This can be an important indicator in gauging which size format suits your temperament best. Be honest with yourself about whether you prefer the spontaneity of the intermediate stage or, if you feel that all three versions need hours more development and refinement, accept that too, as a clue to your natural inclination. Whatever your decision, know that you've probably come pretty close to pegging your personal preference as to what constitutes a finished painting.

Edouard Manet summed it up best when he said: "A painting is finished when I have nothing more to say." The statement was an answer given to a critic who asked if he was going to refine any of the bold brushstrokes in his now-famous portrait of Stéphane Mallarmé. We can thank Manet for those words because with them he helped usher in an artistic climate that continues to give validity to whatever form of personal expression an artist wishes to communicate. And just as the handwriting of your brushstrokes can help launch your style of approach, the degree with which you finish a painting can help stamp it with your personal signature.

EVENING LIGHT ON THE FIVE MILE RIVER
12″×25″, oil on canvas, collection of the artist.
Before I began working on location my paintings were careful and precise. That was thirty-five years ago. Today my style is loose and bold. I'm still concerned about being precise in recording the colors and tones that I see, but I now feel that the more spontaneously I apply paint, the more vital my work becomes. Each painter has to decide on his priorities. Mine is in catching the spirit of what I paint. What's yours?

127

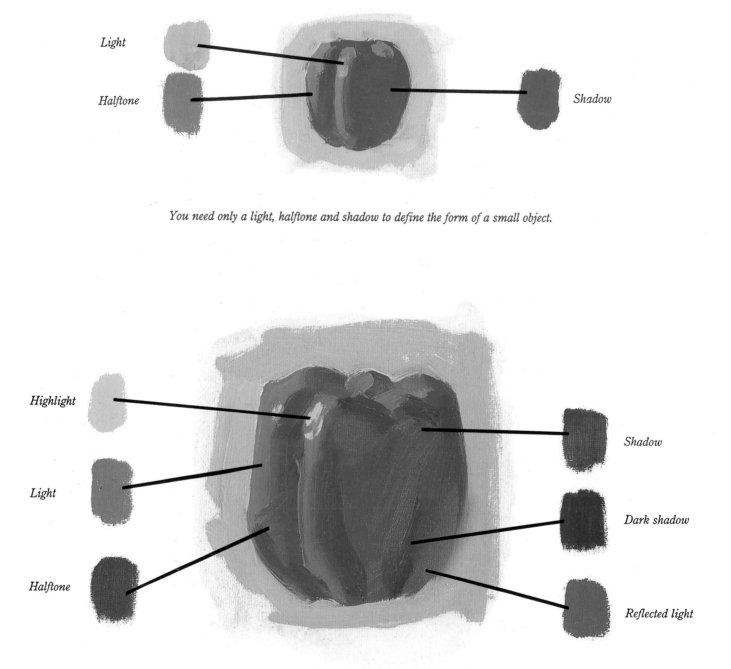

You need only a light, halftone and shadow to define the form of a small object.

Enlarging the size of a form means increasing the number of modeling tones and colors used.

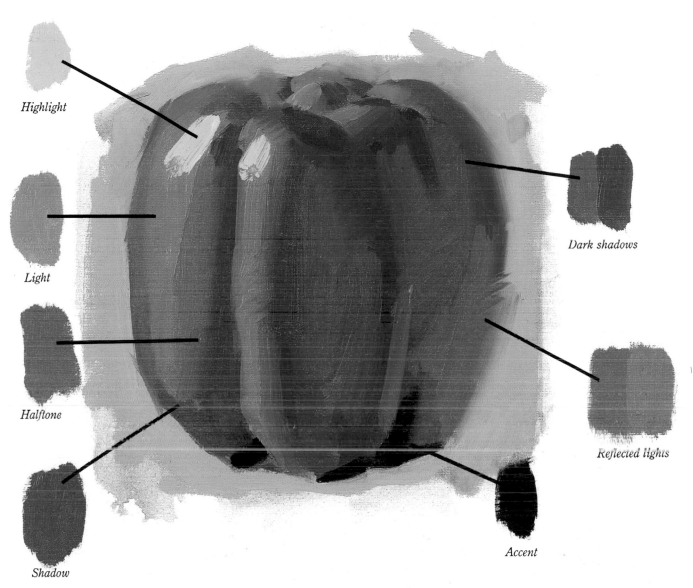

Highlight

Light

Halftone

Shadow

Dark shadows

Reflected lights

Accent

Working even larger means employing still more tones and colors.

USING LOCATION WORK, NOTES, SKETCHES AND PHOTOGRAPHS AS THE BASIS FOR A STUDIO COMPOSITION

Painting a picture is basically the act of recording your personal response to a subject onto a piece of canvas or paper. When working from life, this process is akin to an improvised dance between two partners, with the constant interaction between artist and subject forming the stimulus for the expressiveness of the painting. Contriving a picture in a studio from various kinds of reference material, on the other hand, means accepting the entry of a "middleman" into an essentially two-sided relationship. Some painters are able to hurdle this barrier, using location work, sketches or photographs with fresh inventiveness. Others rebel against any barrier between them and the subject and prefer to work only from life. Between these extremes lie numerous combinations, and it's these that the following exercise will focus on.

Before detailing the lesson, it's important to understand why reference material plays such a critical part in painting certain kinds of pictures. If you've ever set up an easel to paint a teeming street scene or bustling harbor and found the proliferation of moving cars, people, bobbing boats and shifting tides just about impossible to capture, you'll no doubt agree that the experience can be exasperating. Add to this a constantly moving parade of curious onlookers, not to mention the ever-changing patterns of light and shadow and it becomes obvious why many painters often prefer to paint such subjects in the controlled environment of their studios. Drawings, notes, paint sketches and photographs have long helped artists to preserve a moment in time that would otherwise be lost.

The practice of using location works as the basis for studio paintings had its start in early nineteenth-century England when Turner and Constable, among others, began using color studies of different lighting effects as reference material for their large exhibition pieces. Picked up by the French Barbizon School and taken to full fruition by the impressionists, location or *plein-air* painting soon blossomed into an art form uniquely its own. Today, many painters still subscribe to the dictum that working from life is the only way to paint.

Discovering which kinds of reference to use is strictly a personal matter that develops with experience. Before locking into a particular approach, it's a good idea to explore some of the various ways different painters solved this problem. English landscape painter Edward Seago, for example, was at his best when working directly from life and seldom employed any reference material. American realist Ogden Pleissner felt more comfortable executing small, postcard-sized oil or watercolor studies on location and enlarging them to full-size paintings in his studio.

Andrew Wyeth often used not only watercolors done on the spot but also meticulously rendered pencil studies of the various details of a motif as the raw material for his carefully executed egg temperas. Whistler liked to jot down "word" sketches. Other painters, like watercolor realist Carolyn Brady, dispense with life studies of any kind and rely entirely on photographs as a source of inspiration. Each one of these approaches is perfectly tailored to the emotional makeup of each of the artists.

PREPARATION—This exercise involves the development of a studio composition painted from a location sketch, an on-site drawing, a page of written notes and some photographs. The material can be used either singly or in combination with each other.

■ *Drawings, notes, paint sketches and photographs have long helped artists to preserve a moment in time that would otherwise be lost. But because each painter is graced with a different temperament, the use of these reference tools will vary from one individual to another.*

Working from any subject of your choice, begin by making a small, monochromatic study of the motif using the same tactile approach used in Exercise Two. Next, paint a small color sketch of the subject using the same method employed in Exercise Twenty-three. Follow this with a page or two of *written* notes about the subject. These could include definitions like "the hazy, humid atmosphere gives the shadows a light, dewy softness" or "the clash between the red roses and green hedge has the brashness of a Fourth of July parade." Try to employ all your senses when making these notes, jotting down not only your visual impressions but also descriptions of any of the various sounds and smells that may contribute to the unique ambience of the scene. Finally, take a few photographs of the subject, exploring different compositional points of view and focusing in on any important details that could later prove useful.

ASSIGNMENT—Returning to your studio, tack up the material within easy viewing distance of your easel. Working on a fresh piece of canvas scan the various pieces of preliminary work until the memory of the subject is foremost in your thoughts. Sketch in the broad areas of

TAOS, NEW MEXICO
14" × 14", oil on canvas, collection of the artist.
Working on the rooftop of the building facing the subject, I painted this picture after nearly an hour of looking for just the right composition. Being surrounded by new material can often present an artist with the dilemma of not knowing what to paint. Another challenge was the constant shifting of the light from sunlight to overcast. The French impressionists sometimes solved this by laying in both versions and working on them alternately. I chose to capture the sun-lit effect, working on the shadows — which don't change as much as the lights — during the periods of overcast light. Near the end of the painting session some people walked by and since I needed an element of scale, I incorporated them into the middleground.

131

the composition with the same freedom and spontaneity as when working directly from life. *Avoid rotely duplicating the composition of any of your sketches or photographs.* Instead, try to improvise as you paint, using the reference material more as a point of departure to elaborate upon than a visual agenda to slavishly copy. Develop the painting just as if the subject were in front of you. To help recall the flavor of a scene, one well-known artist who does cityscapes makes a tape recording of the sounds at the site he's studying and plays it back while painting in his studio. As you work, study your reference material and ask yourself whether or not you've extracted as much of the essence of the subject as possible. If any of the material seems lacking, make a mental note to emphasize that aspect of your research next time you go out. Keep your approach simple, incorporating the handwriting technique used in the previous lesson. When using photographs, remember that though the images appear realistic, they are really only flat smatterings of colored dye on a sheet of sensitized paper and should be thought of more as a generalized reminder of the scene than any kind of definitive documentation.

APPLICATION— The aim of this exercise is to bridge the gap between location work and studio painting and develop a consistent approach. Whether painting from life, reference material or a combination of the two, your approach and style should be the same. Every painter finds his own way of using sketches, notes and photographs. Since each brings another dimension to a picture, I use them all. Remember, painting isn't a performing art. Whatever devices you use to help you succeed are unimportant so long as the finished result is a statement of quality. A good yardstick to the success of this project is to compare your completed piece with the location works done in some of the previous exercises. If successfully executed, your picture should have the same vitality found in those painted directly from life.

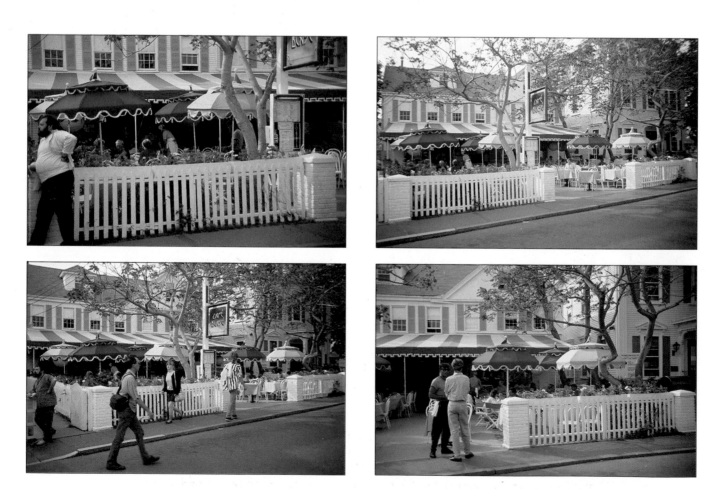

Photographs typical of the kind I use when working in my studio.

Using Reference Material

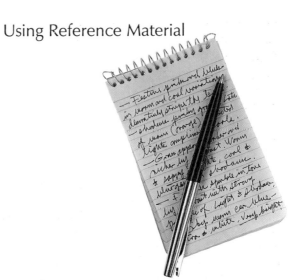

Color sketch painted on location.

A page of carefully written impressions of a subject's tonal and color makeup can be used in conjunction with a painted location sketch or photographs, or as your primary source of reference material.

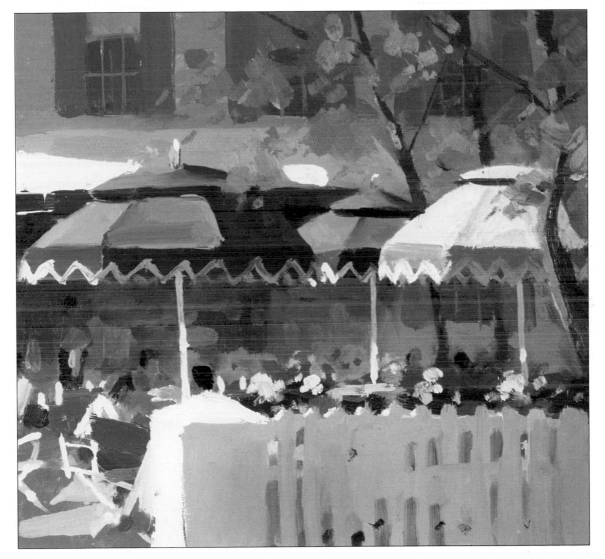

CAFÉ BLASÉ, PROVINCETOWN #2
12" × 12", oil on canvas, collection of James Watterson, Chagrin Falls, Ohio.
Using both reference material and my memory of the subject, I completed this studio painting in a single twelve-hour session. The most difficult thing about doing studio paintings is keeping the feeling of immediacy that is present when working on-site. I'll sometimes play tapes of music that relates to a particular subject. In this case, it was a disco number that had the same kind of brassiness that I wanted my painting to have.

LEARNING FROM PAST AND PRESENT MASTERS

The practice of learning from other artists probably originated in the dimly lit caves of prehistoric times when an elder scribe felt it was time to pass on his unique skills to some of the younger members of the clan. Apprenticeship of this sort continued, growing more formalized with the sophistication of each new culture. Since the Renaissance painters have found inspiration in works from many different cultures and ages. Late eighteenth-century French artists David and Ingres, for example, incorporated the classical lines of Greek art into their austere recreations of mythological life. Cezanne, uncomfortable with the sometimes flimsy compositional structure of his fellow impressionists, looked back to the idealized forms of Poussin and forged a style that was both classical in composition and contemporary in approach. Picasso drew upon the folk art of African masks as a means of personal expression. Today, most painters feel some sort of identification with a past or present artist and in many cases base their direction on this influence.

PREPARATION—This assignment entails painting a copy of any picture of your choice by a past or present master. The ideal condition for copying a painting is to go to a museum, set up an easel in front of a picture and begin work. Some artists, however, find the quiet intimacy of their studios far more conducive to learning than the bustling atmosphere of today's institutions. Museum study was a common practice of art students in past centuries, and while less popular today, some exhibition halls keep up the tradition by providing an easel and drop cloth solely for artistic use. For those unnerved by curious onlookers or who don't live near a museum, good reproductions in the form of prints, art books, magazines or even slides can offer a suitable alternative. Another option is your public library. Many now make available framed, quality reproductions of popular paintings on a monthly lending or rental program.

ASSIGNMENT—Position yourself within easy viewing distance, and begin sketching in a format no larger than twelve inches or so in diameter. The reason for keeping the composition small is that most attempts at a stroke-for-stroke full-sized facsimile can easily turn into a time-consuming chore and make any attempt at analysis difficult. Rather than being concerned with making an exact replica, try instead for a loose interpretation. I think you'll be surprised at the amount of confidence and enthusiasm this can instill.

As you proceed, keep a steady stream of questions flowing through your mind such as: Was the canvas toned prior to painting and, if so, what color? Was the preliminary drawing sharp and detailed or merely a broadly brushed-in sketch? How was the lay-in accomplished? What color palette was used and what were the mixtures for achieving the various effects? What's the tonal makeup

■ *Most painters feel at least some sort of an identification with a past or present artist or school of painting and in many cases base their whole direction on these influences.*

of the picture? How were modeling effects achieved? What was the procedure used in developing the picture? Was the paint applied evenly or in thin to thick layers? and so on. Remember, you're not trying to do a fool-the-eye fake but rather put yourself in the shoes of the artist by simulating many of the same problems he faced.

You could also try enlarging a detail or two, possibly the same size as the artist painted them. This could provide some added insight into the specific technique employed and give you some understanding of the pictorial challenges the artist overcame.

Living in an age when the vast reservoir of styles and techniques of the past decades is as near as a turn of a page or walk to a museum, we have the greatest opportunity in the history of the world to learn about our artistic heritage, as well as the freedom to express ourselves. Today, literally, anything goes. Finding your niche in such a vast sea of possibilities is what being a painter is all about. One of the best ways to help you on your journey is to get to know your fellow travelers.

This paint sketch as well as the ones on the following pages are typical of the kind of copies I've been making from artists I admire ever since I started the practice in art school. The hour or two investment of time has been a small price to pay for the enormous amount of information I've gained.

After Frank Benson.

I made this light and shadow diagram prior to painting the copy to help determine how Benson organized the lights and darks in his composition.

After Edward Seago.

After Joaquin Sorolla. *After Theodore Robinson.*

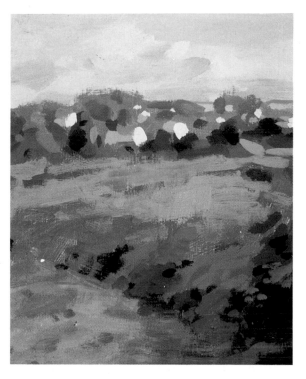

After Walter Scofield.

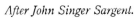

After John Singer Sargent.

After Camille Pissarro.

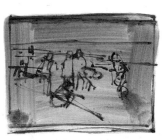

Step 1, preliminary drawing.

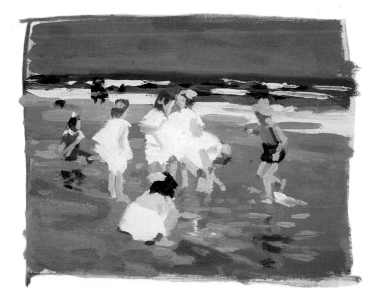

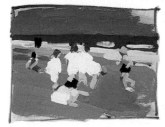

Step 2, laying in the masses.

After Edward Potthast.

137

MEMORY PAINTING

Have you ever glanced in a rearview mirror while driving or looked out the window of a bus or train and seen such a spectacular scene go by that hours later the afterimage still continued to taunt your memory? "If only I could capture that effect in a picture," you may have thought. Well, you can.

The intrigue of painting from memory has occupied the minds of artists throughout the ages. From Tiepolo's imaginative ceiling frescos to the whimsical fantasies of Paul Klee, this provocative approach to picture making continues to tantalize many painters from all schools of thought. Free from the shackles of constant comparison to a motif, even the most trivial recollection, remembrance or wisp of a dream can become a valid source of inspiration.

There are a number of ways to approach memory painting. The most direct is to have an impression in your mind, go to your easel, and paint it. Another method is first to study a subject, make a conscious effort to retain the image in your memory, and then paint a reconstruction of the impressions you retained. Still another way is to use writing, music, dreams or the recollection of a vivid emotional experience as the stimulus for an imagined work. As in any other aspect of art, memory painting takes practice and, like the fictional young spy in Rudyard Kipling's "Kim," who could recall for his superiors uncanny amounts of specific information about enemy encampments, the capacity to remember lies in your ability to concentrate. If the idea seems beyond you, think of the hundreds of times you've turned your eyes away from a subject and relied solely on the image in your mind to guide your hand as you concentrated on brushing in a stroke. With some discipline, these short bursts of recall can be stretched into increasingly longer segments until feats once thought impossible are accomplished with surprising ease.

Many students are under the false impression that a picture painted from memory should have the same clarity and degree of finish as one done from life and find themselves stymied when their results don't meet up to these expectations. But by thinking of memory work as an art form uniquely its own, you'll open the door to the possibility of discovering an unknown side of yourself.

Memory painting also encourages an artist to try more poetic and lighthearted solutions to a problem than he would otherwise. Because of this, it can be an ideal restorative for balancing out any overly pensive habits that often accompany more calculated approaches.

PREPARATION—To give your memory some fresh material to work with, the first part of this assignment is to spend half an hour taking a leisurely walk around the neighborhood in which you live. An alternative is to go to an unfamiliar part of your city or town. If confined to your home, wander around the various rooms you live in, especially places like an attic, garage, cellar or any other area that contrasts your usual day-to-day routine. The important thing is to see if you can experience your environment with a fresh eye. As you walk, try not to let anything disturb the immediacy of the sights you take in. Relying on *all* your senses to guide you, imagine your surroundings as ones you've never seen before. Try to feel the concrete or dirt beneath your feet. Reach your hand out and touch the trunk of a tree, a wall or the side of a building. Bend down and let your fingers dip into some water, touch some grass, or stroke a friendly dog or cat. Sniff the air and listen to the sounds around you. Accept both the jarring siren of a police car and the melodic warble of a bird with the same open receptiveness. Keep your pace slow and leisurely, heading in whichever direction your impulse takes you.

■ *By thinking of memory work as an art form uniquely its own, you'll open the door to the possibility of discovering an unknown side of yourself.*

ASSIGNMENT—Once back in your studio, put a fresh canvas on your easel, pull up a chair, and spend a few moments studying it. Look at the blank whiteness of the surface and imagine it a movie or television screen ready to come to life. Now let your mind wander back to the area covered in your walk. Summoning up whatever images you found most striking, brush in some colorful masses of light and dark and loosely approximate the picture in your mind. You may want to do two or three compositions rather than just one. Either way, keep your brushwork simple and the forms playfully suggestive. Like a distant ship coming out of a fog, let the painting slowly develop, matching the images in your mind. Avoid any intrusion of the many theories and principles you've learned. Instead, try to sustain an almost dreamlike state, trusting that your brush will do the right thing. Don't be discouraged if your first efforts result in nothing more than a crude approximation of your mental images. In time, your memory will learn to retain ever larger chunks of material. For now, simply get down whatever you can. All during the painting session keep playing back the information your senses recorded, letting the impressions swim leisurely across your mind's eye.

When finished, you may want to make a return visit to the subject just to see how it compares to your interpreta-

tion. Don't be startled if the scene looks entirely different than you imagined it. This is because every painter filters what he sees through the prism of his own personality. How dreary painting would be if everyone worked alike.

If you are interested less in factual re-creations and more in purely imaginative work, an alternative to this project could be to take your stroll through the inner landscape of your dreams and fantasies. This is most easily done by assuming a comfortable position, closing your eyes, and letting the stream of your consciousness parade its images across your mind. When painting these impressions, use the same procedure as when recalling a more tangible subject, allowing each of your senses to make its singular contribution.

Memory work of any kind can be an exhilarating experience, and, whether you're trying to re-create the character of an old barn you once stumbled across or materializing some gossamer threads of a dream, it provides an excellent alternative for creative expression.

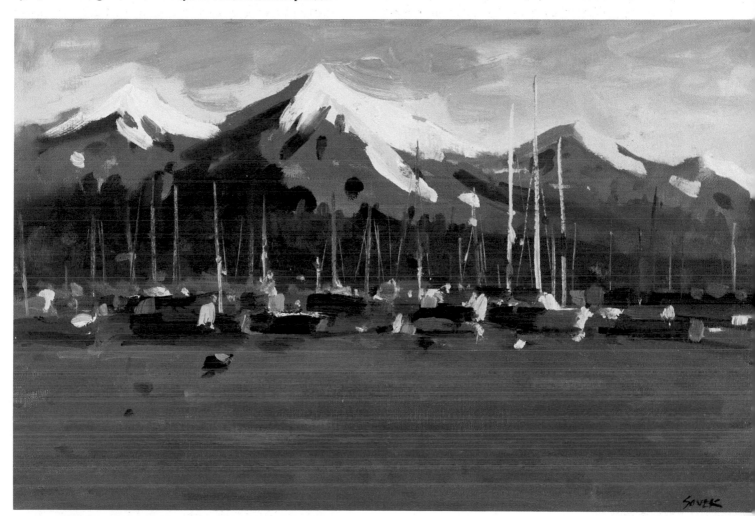

HOMER, ALASKA
16" × 24", oil on canvas, collection of Rene E. Perret, Westport, Connecticut, in memory of his wife, Colette.
This painting started with a small color sketch done on location while fighting a strong wind and a temperature of seventeen degrees. After I arrived home my recollections of Alaska were so vivid I immediately began a painting using my sketch as inspiration and trusting my memory to fill in the details. Notice how the boats are made up of spots of light and dark tones and colors and how the masts are reduced to a series of thin, vertical paint strokes. Without this kind of simplification it would have been easy to get bogged down trying to remember particulars and thereby missing the spirit of the locale. One advantage to memory painting is that the artist is forced to focus on the effect or mood rather than any elaborate details. It also frees a painter from determining the worth of his picture by comparing it to the subject.

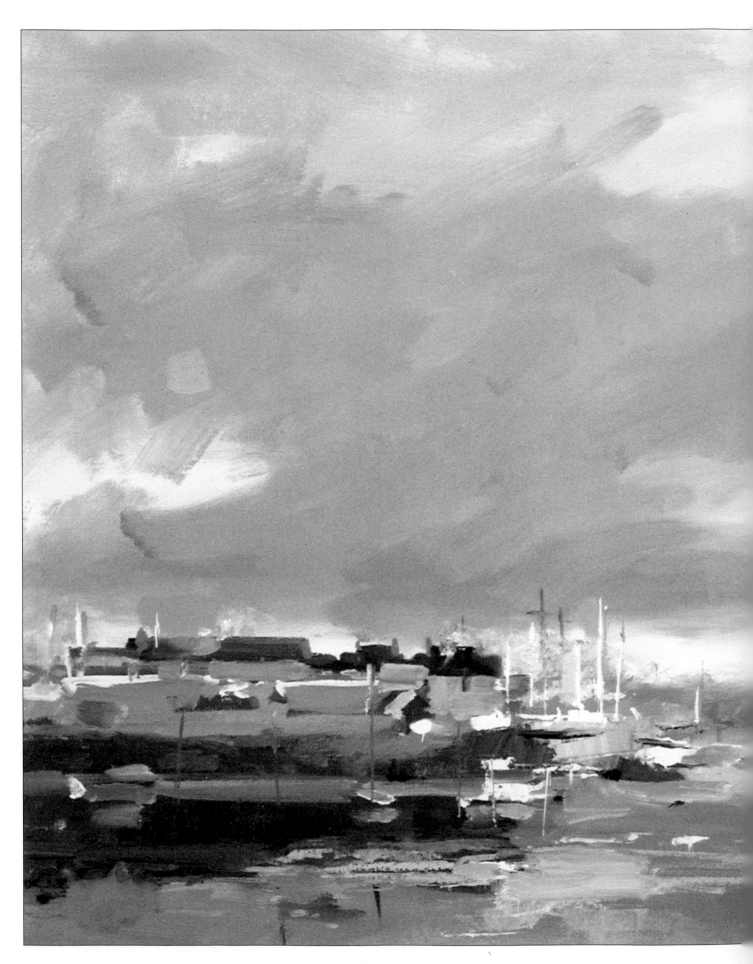

When you explore a subject put all your senses into play. Make notes on the smells, sounds and other sensory input that make the place unique. Think of your mind as a blank tape ready to be filled with the unique ambience of the material around you.

SIGHT
What colors and tones do you see?

SOUND
What do you hear?

SMELL
What odors do you smell?

TOUCH
What are the textures of the objects around you?

TASTE
How does the air or food taste?

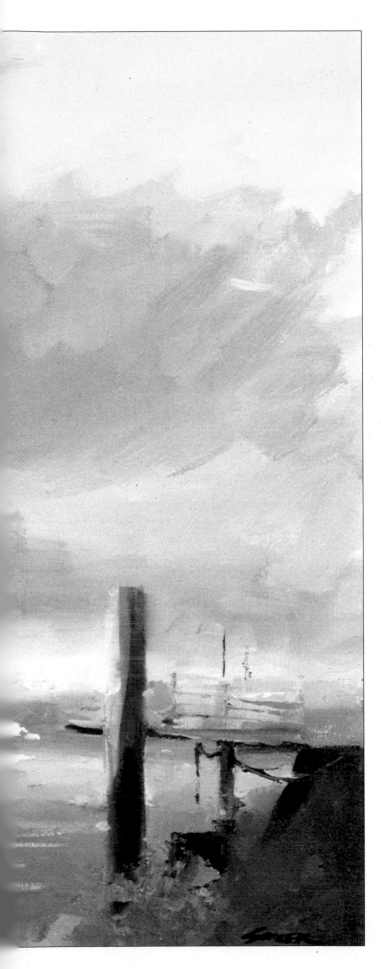

HARBOR LIGHT
20" × 24", oil on canvas, private collection.

141

DEVELOPING A PERSONAL FORM OF EXPRESSION

The uniqueness that sets you apart as an individual was there long before you ever thought of picking up a brush. Your hometown, childhood experiences, family, friends, jobs and emotional ties have all played a part in shaping your personality. Beneath our outward differences lie even deeper longings and urges that form the impetus for creative expression. Obviously, painting is something that interests you or you wouldn't be reading this book. Coming into your own as a mature artist, like any other worthwhile endeavor, takes time, patience and, most importantly, a belief in what you're doing. The need for self-expression that provides the energy to carry you forward, however, has been with you from the moment you first decided to paint. Applying this energy to making a picture is the subject of this final exercise.

Because each of you gravitates toward a particular aspect of painting, this last project will present four different alternatives which are designed to help reveal your particular form of expression. Keep in mind, however, that these are only meant to serve as a starting point and by no means should be considered the only options available. The first approach is *naturalism*. The work of John Constable, Claude Monet and John Singer Sargent could all qualify as naturalistic because their chief aim was a purely visual representation of a subject as revealed by the effects of light, tone and color. The main goal of these artists was to capture a faithful likeness of what their eyes perceived. The next category is *classicism*. Such diversified talents as Camille Corot, Piero della Francesca and Grant Wood could all be considered classical painters because rather than documenting what they saw, they instead chose to refashion the forms of a subject to match the more stylized version in their minds. In a painting of a water pitcher, for example, the basic concept of this approach would be to subordinate the unique characteristics of the form to an ideal or "classical" version of a pitcher. The third category is *expressionism*. The darkly evocative seascapes of Alfred Ryder and the heroic figure compositions of Eugène Delacroix would be examples of this approach as would the volatile imagery of Vincent Van Gogh. The chief interest of all three of these painters was to express the drama or romance they found in a subject. The final category is *diversification*. Here, the artist belongs to no one discipline but instead utilizes all three in whatever combinations best suit his needs. Georges Braque, John Marin and Georgia O'Keeffe all exploited this manner of approach by forging together various schools of thought as a means of getting away from more predictable procedures and exploring new methods of self-expression. The motto for this eclectic way of painting might read "anything goes."

ASSIGNMENT—Working from any subject, sketch in four identical formats on a single canvas. Since the first problem deals with naturalism, the best approach would be to work on location. Develop and complete the sketch with the single purpose of trying to capture the natural effect of the scene before you. Employing everything you've learned about light, shadow, values and color, try to show as objective a representation of the subject as possible.

Moving on to the classical approach, you can either stay with the same motif or work from a new one. This time, all your efforts should be on form and composition. Disregarding any transient effects of light and shadow, try to reconstruct the subject in solid, simplified terms. A still life of some fruit lying on a piece of drapery, for example, could be reduced to nearly basic geometric forms. Remember, the chief concern of a classical painter is to use a subject only as an inspirational base on which to impose the idealized version stored in his memory. So keep your forms sleek and clean and the modeling solid.

For the third sketch, you'll need to switch from the cool detachment of the classical approach to the more expressive side of your personality. Again, you could either stay with the same subject or try something different. If you're painting a landscape at sunset, for example, you might emphasize a billowy cloud formation by exaggerating its movement with some bold, playful brushwork. Or you could raise the intensity of a pale rose sliver of light rimming the edges of the clouds to a fiery red. Stress gesture, color and movement, exaggerating whatever areas are needed to give the painting a pulsating life of its own. Remember, a true expressionist isn't afraid to let himself get caught up in the romance of a subject and gives his all to inject his painting with the same enthusiasm. Memory work and dream interpretations also fall into this category and could be a perfectly suitable alternative to a real subject.

■ *The need for self-expression is the energy that carries you forward and has been there from the moment you first decided to paint.*

The final sketch should use whatever combination of the three previous methods that best suits your purpose. A lot of spontaneous improvisation will be required here, because the essence of diversification is to let the subject dictate how the picture should be painted. Let's say you're doing a harbor scene. The lay-in could be done naturalistically, with the aim being to capture the interesting play

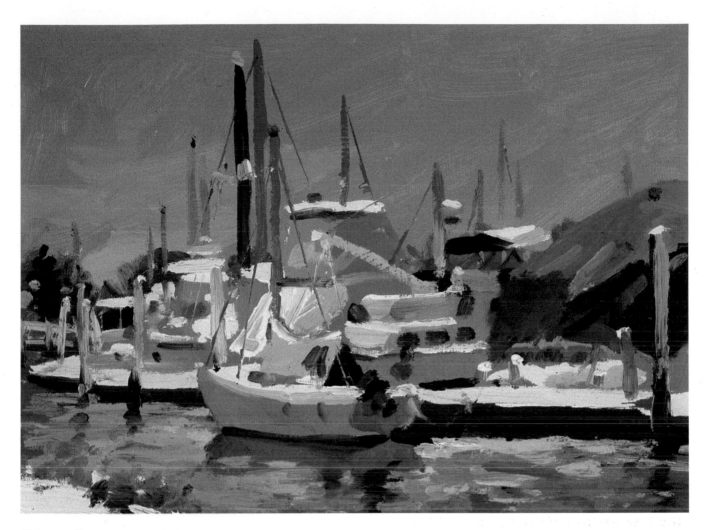

WINTER DOCK
11" × 14", oil on Masonite, private collection.
Painting this picture I spent three tedious hours in my van with the windshield wipers on. The mood, however, was too good to pass up. To solve essentially a tonal problem, I limited my palette to cadmium red deep, cadmium yellow pale, Thalo green and Thalo blue. Snow can be fun to paint under any kind of lighting condition. In this case, the new-fallen snow under the overcast light transformed this usually drab winter subject into a quiet, chamber-music-like orchestration of warm and cool grays.

of light and shadow permeating the scene. Using this as a basis for the main shapes of the composition, you could then switch to a more classical treatment for the boats. This would substantiate the forms yet still keep the volumes generalized enough so as not to overpower the rest of the composition. The water, on the other hand, could require more of an expressionistic treatment, with bold, descriptive brushwork defining the lapping waves as they meet the shore. Your goal in this approach is not to think of yourself as belonging to any one school of painting but instead *using* any or all the various methods at your disposal to bring the composition to life.

When finished, study the sketches and ask yourself which you found most pleasurable to execute. Which one best sums up your feelings about painting? Show some fellow students or friends your results and see if they have the same reactions you did. Because developing as a painter demands growth and open-mindedness, it's probable that your point of view will go through any number of shifts and changes. Experiments will be tried with some succeeding and others not. It's all part of the process of growth. In time, your individuality will surface and the hum of creative accomplishment will ring in your heart. Above all, be honest in your appraisal of what you do, knowing that it's by remaining faithful to your instincts that true artistic expressiveness will become yours.

INDIAN CORN
16" × 12", oil on canvas, collection of Tom Beattie, Ontario, Canada.

NATURALISM
Naturalism involves capturing the surface appearance of a subject. The focus here is purely visual. Little, if any, artistic license is exercised to stylize or embellish the painting. A picture's success lies in how closely it resembles the subject depicted.

VITAMIN C
5" × 3", oil on Masonite, collection of the artist.

CLASSICISM
Simplicity, objectivity and proportion make up the classical approach. The superficial trappings of objects are reduced to their basic essentials. The brushwork is smooth, textures are minimized, and light and color are used only to enhance the sleekness of the idealized forms.

STILL LIFE WITH WINE BOTTLE AND VEGETABLES
12" × 16", oil on canvas, collection of the artist.

DIVERSIFICATION
Relying more on intuition than principle, diversification means using whatever method yields the best results. Incorporating diversified points of view into the same painting involves devising a technique flexible enough to encompass various approaches without fragmenting the picture. This is usually accomplished by either employing a carefully unified color scheme or applying a consistent brush or palette knife technique over the entire surface of the painting.

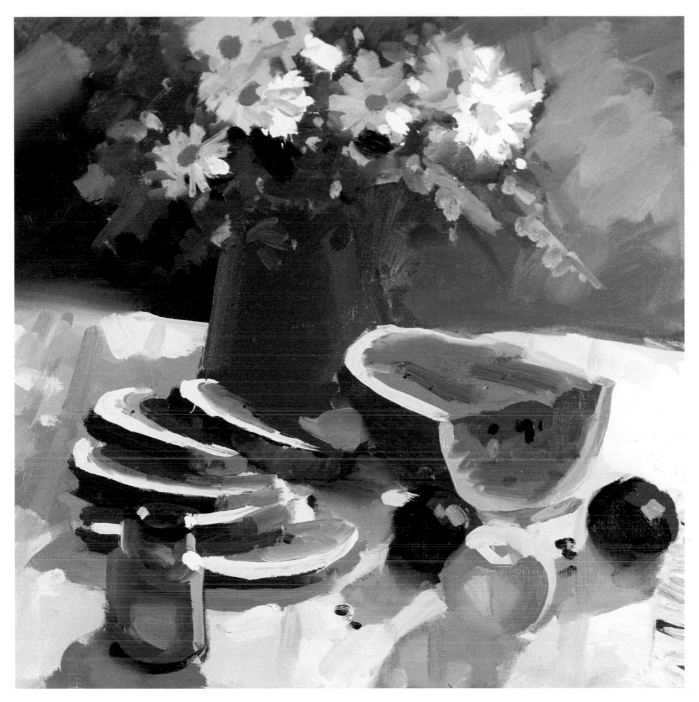

SUMMER STILL LIFE
*16" × 16", oil on canvas, collection of Nancy Sullivan, Cincinnati,
Ohio.*

EXPRESSIONISM

How you feel *about what you're painting is what counts to an
expressionist painter. Shape, tone and color exaggerations take pre-
cedence over the natural appearance of a subject. There are no rules
here. The painting evolves in much the same way a jazz musician
uses his impulses to guide him when improvising variations on a
musical theme.*

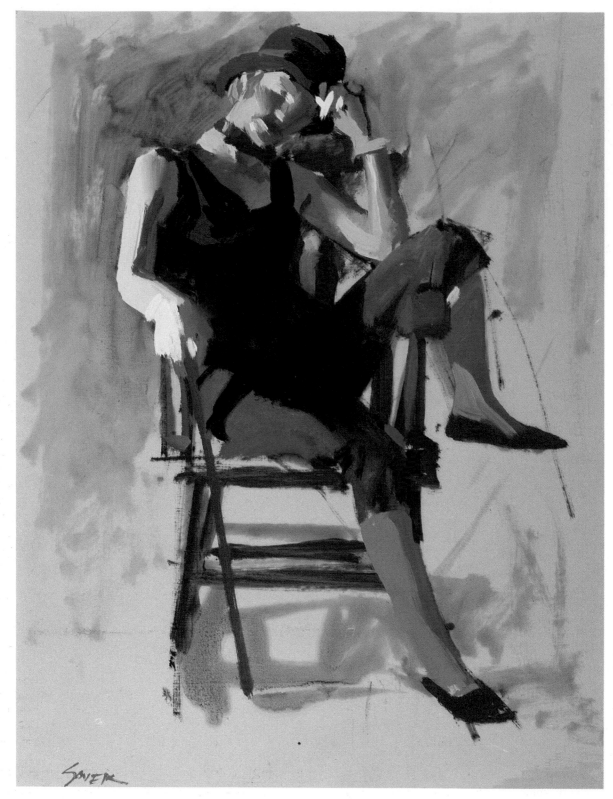

MIME

18" × 14", oil on Masonite, collection of the artist.

Characters are always fun to paint and when the model showed up dressed in all black with a red bow tie I knew the session would be rewarding. Usually I mix colors like alizarin crimson and Thalo green to get a colorful version of black. In this case I opted for pure black because it not only helped accentuate the fleshtones but also imparted a certain theatrical quality to the color scheme.

LETTING GO AND BEING YOURSELF

Whether you're doodling on a notepad while engaged in a phone conversation or listening to the news as you drive to work, the skill needed to carry on more than one activity at a time is seldom considered. You simply do it. So too with painting a picture. Attempting to consciously juggle each and every principle, theory and method given throughout this book could be a nearly impossible task; even if accomplished, just the sheer logistics of remembering all the material presented would probably stifle even the most basic attempt at creative expression. Letting go of anything that is hard-earned takes courage. In painting, however, the more you rely on your instincts the stronger your style will become.

Being a painter takes skill and a sensitivity to tone and color, edges and surfaces. It takes the ability to simplify, reconstruct and improvise where needed. But most of all it takes caring a great deal about what you're doing. Whether painting is approached with the orderliness of an accountant or the unpredictability of a meandering beachcomber, unless you really believe in yourself, it's unlikely anything worthwhile will result. Most of you are conscientious students with a strong desire to learn all you can about painting. Rightly so. The wisdom passed on by a good teacher or instructive book can often crystallize an idea that might otherwise remain unclarified. Sometimes, however, a quest for more and more information can undermine personal growth by providing a convenient excuse for not accepting your own artistic worth.

Some students feel that to be a "real" painter they have to take on a certain lifestyle commonly associated with being an artist. These are only superficial trappings and have little to do with the inner person. Being an artist is really a state of mind, an attitude, that allows you to get totally absorbed in something as seemingly insignificant as a patch of light playing across a brick wall.

Setting aside the daily pressures of life and focusing all your concentration on painting a picture is no easy matter. And whether you paint full-time or just a few hours a week, it's the degree of your commitment that measures the ultimate success of your work. Maintaining the delicate balance between creative expression and day-to-day living varies greatly from one individual to another. Some artists grow stale after any more than four or five consecutive days of work and need a movie, some physical activity or a visit with some friends to get their batteries recharged. Others can cloister themselves in a studio for weeks on end and still be able to approach a subject with freshness and vitality. It's not important in which of these directions you lean. What is important is that you understand your capabilities and build your routine around them.

Outside influences such as reactions from friends, clients or galleries that follow your work, acceptance or rejection in shows, and exposure to the work of other artists can also have a bearing on your development. Keeping these things in balance means not feeling worthless if a painting doesn't invite a compliment or win a prize and not assuming you're a superstar if it does. It also means not letting the work of other painters intimidate you into adopting it as your own standard. Often a promising artist will paint a few pictures that happen to catch the eye of a collector or gallery. Perhaps a sale is made with a good possibility of more in the future. Naturally, this can be quite a compliment to a painter not only in the form of a monetary reward but also as a verification of his worth as an artist. If the individual continues to mature, injecting new waves of life into his work as he grows, such an opportunity could eventually lead to a full-time career. However, if an artist is still in the formative stages of his development, it's possible a gallery or even a client could try to persuade him into following a certain set of standards. Such a situation could certainly be enticing because of the steady stream of sales that could result. On the other hand, it could also mean jeopardizing the individuality that originally gave the work its appeal.

Erich Fromm once said, "The price paid for consciousness is insecurity." For a painter, these words might read, "The price paid for artistic autonomy is uncertainty." I believe that doubt and uncertainty are a healthy part of every artist's makeup, for without them the whims, hunches and accompanying misgivings that form the germ of a creative act could easily wilt into the blandness of formalized craft.

In the final analysis, succeeding as a painter means believing in the magic that can happen when your brush touches a canvas. It also means realizing that whatever message you impart to your work can become part of the universal language we call art. Confronting a blank canvas with only yourself responsible for the outcome can be a terrifying challenge. It can also be one of the most exhilarating events a painter can experience. So what are you waiting for?

SUGGESTED READING

Aside from the wealth of ideas to be found in the vast number of volumes available to the public, a book or reproduction can often be the best alternative to going to a museum or visiting the studio of a respected artist. Particularly in your learning stages, books can be valuable learning tools. Whether you borrow them from a library or treat yourself to an occasional purchase, they can often provide the needed motivation to try a new technique, explore different subjects, or clarify some unanswered questions. The following list, organized in the sequence of the chapters, should help elaborate upon any additional material you may want to pursue.

GETTING STARTED

The Artist's Handbook by Ralph Mayer. New York: Viking, 1981. Everything you always wanted to know about painting materials.

A Way of Working edited by D. M. Dooling. New York: Parabola, 1986. The spiritual mechanics of practicing a craft.

The Courage to Create by Rollo May. New York: Bantam, 1957. A landmark work on the nature of creativity.

If You Want to Write by Brenda Ueland. Saint Paul, Minnesota: Graywolf, 1987. A book about art, independence and spirit.

No More Second Hand Art: Awakening the Artist Within by Peter London. Boston and Shaftesbury: Shambhala, 1989. The psychology of opening your mind to creative expression.

A FEELING FOR THE MASSES

Brackman: His Art and Teaching by Kenneth Bates. Noank, Connecticut: Madison Art Gallery, 1951. A tactile approach to painting by one of its most successful practitioners.

Drawing on the Right Side of the Brain by Betty Edwards. Los Angeles: J. P. Tarcher, 1979. Of particular use for students struggling with proportion.

Michelangelo by Loretta Santini. Rome: Plurigraf-Narni-Terni, 1974. A feeling for the masses taken to monumental heights.

The Natural Way to Draw by Kimon Nicolaides. Boston: Houghton Mifflin, 1979. Probably the best book ever written on learning how to draw.

The Zen of Seeing by Frederick Franck. New York: Vintage Books, 1973. Freeing your mind to draw what you see.

LOOKING AT THE WORLD THROUGH COLORED GLASSES

Hawthorne on Painting by Charles W. Hawthorne. New York: Dover, 1960. An inspirational gem on learning to interpret any subject into artful spots of color.

Interaction of Color by Josef Albers. New Haven and London: Yale University Press, 1975. The science of color through the eyes of a contemporary painter.

Making Color Sing by Jeanne Dobie. New York: Watson-Guptill, 1986. Imaginative lessons on color in any medium by a perceptive teacher.

The Painter Joaquin Sorolla by Edmund Peel. London: Philip Wilson, 1989. Color and light as interpreted by a master impressionist.

Techniques of the Impressionists by Anthea Callen. London: Chartwell, 1982. A scholarly description of the working methods used by the French impressionists.

THE DRAMA OF LIGHT AND SHADOW

Andrew Wyeth The Museum of Fine Arts, Boston. Boston: 1970. A sensitive artist using light and shadow as a means of expression.

The Human Figure by John Vanderpoel. New York: Dover, 1958. A light and shadow approach to drawing the figure.

The Art of Ogden M. Pleissner by Peter Bergh. Boston: David R. Godine, 1984. Masterful use of light and shadow patterns to unify a composition.

Winslow Homer by John Wilmerding. New York: Praeger, 1972. Timeless examples of how light and shadow can turn any subject into a personal artistic statement.

Rembrandt by Otto Benesch. Switzerland: Skira, 1957. One of the original innovators and a must for every student.

A PAINTERLY SENSE OF VALUES

Carlson's Guide to Landscape Painting by John Carlson. New York: Dover, 1973. An in-depth study of various tonal approaches by a teacher whose students include many of today's most accomplished painters.

Corot by Jean Lemarie. New York: Rizzoli, 1979. Naturalism with just the right blend of classicism. The artist's small location studies alone are a singular artistic achievement.

Edward Seago by Ron Ranson. London: David and Charles, 1987. One of the best location painters ever to set up an easel. An inspiration to all artists interested in light and color.

Manet by Georges Batille. New York: Skira, 1955. The painterly approach by a born natural.

John Singer Sargent by Carter Ratcliff. New York: Abbeville, 1982. Portraits, landscapes and genre works by a realist with perfect tonal pitch.

SEEING THE BIG PICTURE

Catching Light in Your Paintings by Charles Sovek. Cincinnati: North Light, 1986. An in-depth study of the tonal and color makeup of natural and artificial light.

Edward Hopper: The Art and the Artist by Gail Levin. New York: Norton, 1980. Strong imagery through intelligent simplification.

Light: How to See It, How to Paint It by Lucy Willis. Cincinnati: North Light, 1988. Not only a fine learning tool but also a colorful portfolio of various interpretations of different lighting conditions.

Painting Interiors by Jenny Rodwell. New York: Watson-Guptill, 1989. The myriad of possibilities offered by indoor subjects.

Painting with a Fresh Eye by Alfred C. Chadbourn. New York: Watson-Guptill, 1987. An excellent example of how any subject can be worthy of a painting if the colors, shapes and patterns work.

PUTTING IT ALL TOGETHER

Drawing and Painting by Anthony Toney. Englewood Cliffs, New Jersey: Prentice-Hall, 1978. A gifted teacher and painter shows how to discover your own visual language.

Fairfield Porter: Art in Its Own Terms by Rackstraw Downes. New York: Taplinger, 1979. A survey of past and present trends through the eyes of a twentieth-century realist.

The Painter's Eye by Maurice Grosser. New York: New American Library, 1956. In-depth comparisons of different approaches, ways of seeing and points of view. A primer for all artists.

Seeing with the Mind's Eye by Mike Samuels, M. D. and Nancy Samuels. New York: Random House, 1984. The history, technique and use of visualization to help develop a sense of personal imagery.

Seeing with a Painter's Eye by Rex Brandt. New York: Van Nostrand Reinhold, 1984. Developing a sense of awareness to different ways of approaching a subject in any medium.

LETTING GO AND BEING YOURSELF

The Art Spirit by Robert Henri. New York: Harper and Row, 1984. Wisdom and inspiration by one of America's greatest teachers.

Fire in the Crucible by John Briggs. New York: Saint Martins, 1988. A comprehensive look at what goes into the makeup of a creative artist.

On Not Being Able to Paint by Joanna Field. Los Angeles: Tarcher, 1957. Understanding the nature of the creative process within yourself.

The Shape of Content by Ben Shahn. New York: Vintage, 1960. Six revealing essays on the prctice and purpose of art.

Vincent by Himself by Bruce Bernard. Boston: Orbus, 1985. An insight, via letters, drawings and paintings, into the creative workings of a great artist.

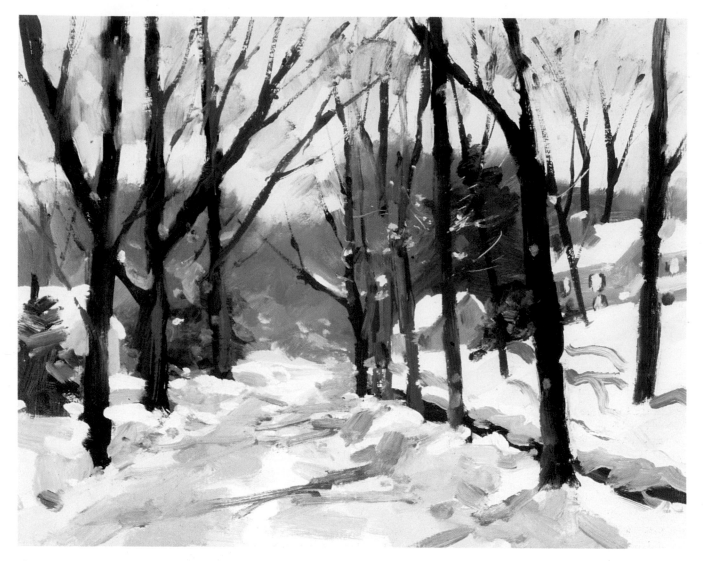

AFTERNOON SNOW
11"×14", oil on Masonite, collection of Lee Everett, Allentown, Pennsylvania.

Robert Henri once said that it's a lot easier to paint a good picture than a bad one. I think what he meant was that when you're so caught up in a subject that you're not even aware of how you're applying the paint or organizing the composition, the picture seems to paint itself. It's a state of mind we all strive for, and when it happens all our failures are forgotten and painting becomes the magical experience we would always like it to be. This little winter scene was such a picture. The light was right, my brush did what it was supposed to and for a few hours, time was suspended and life became art.

INDEX